WHEN IS
HIGH MOON?

Baby Tattoo Books

Los Angeles

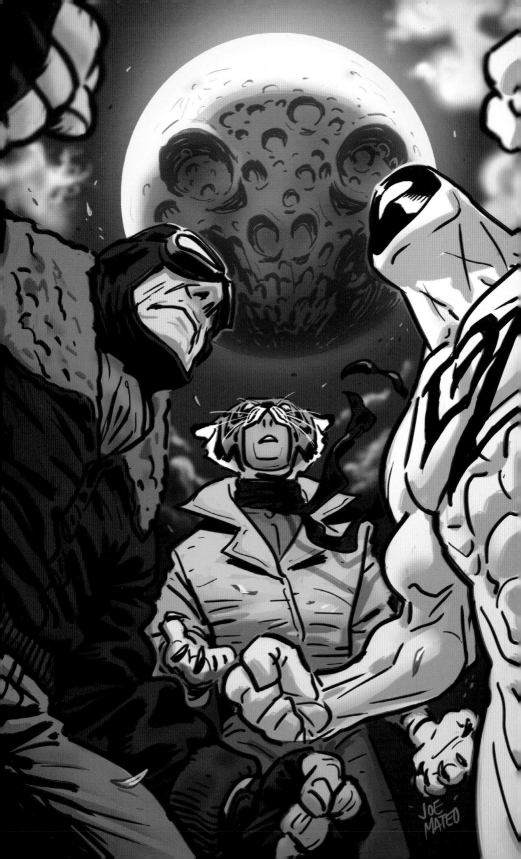

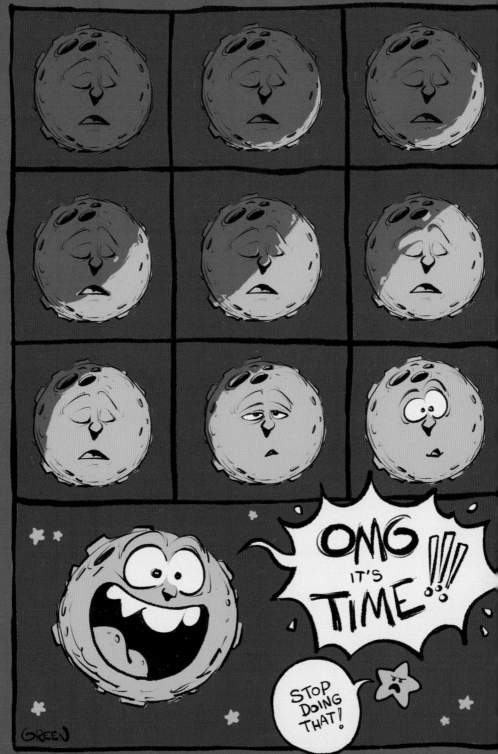

ARTIST BIOGRAPHIES..............258

ACKNOWLEDGEMENTS.............274

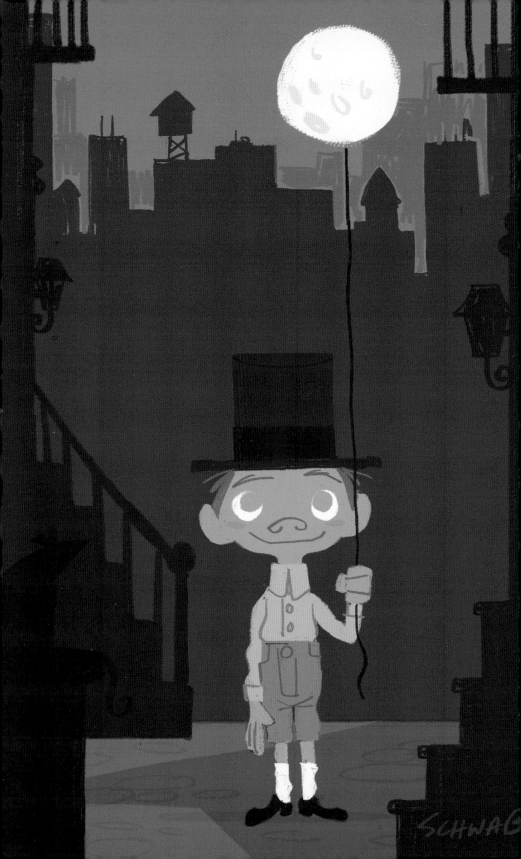

INTRODUCTION

Over the years, there has been a secret tradition of after-hours passion projects privately created by talented artists responsible for developing stories and visuals for animated motion pictures.

A diverse group of entertainment industry professionals, who work collaboratively in teams during the day, burn the midnight oil pursuing personal artistic goals as a way to hone their skills and broaden their horizons. From time to time, these free-thinking visionaries focus their individual efforts on one mutually agreed upon theme as a method to ignite their imaginations and juxtapose their kaleidoscopic points-of-view.

In the past, you might never have had a chance to get a book like this (personal, quirky, independent, and creatively unrestricted) unless you were a studio insider. Now, one of these unofficial, off-the-radar story collections is being quietly offered to collectors by Baby Tattoo Books, and you are invited to partake in this secret society of artistic storytellers and narrative art lovers. From the hearts, minds, and pens of dozens of women and men who work (or have worked) in the Story and Visual Development departments at major animation studios comes an anthology of short stories in graphic novel form that reflects on the question, "When Is High Moon?".

Bob Self
Ringmaster
Baby Tattoo Books

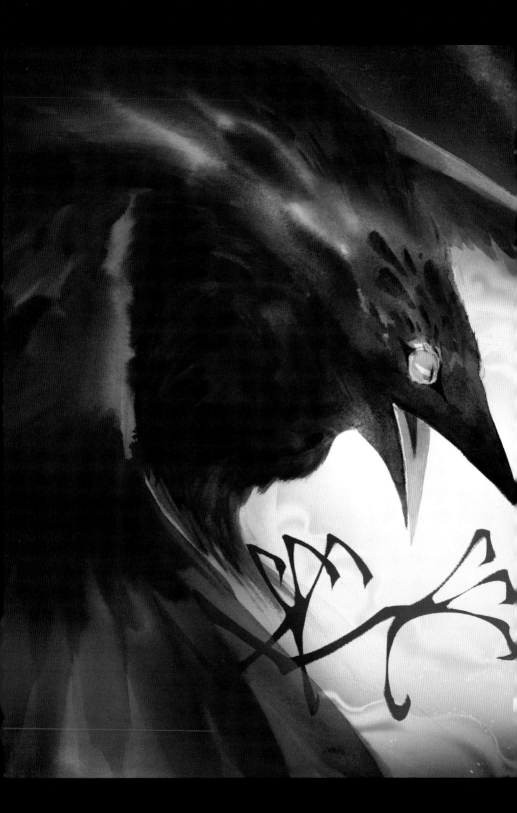

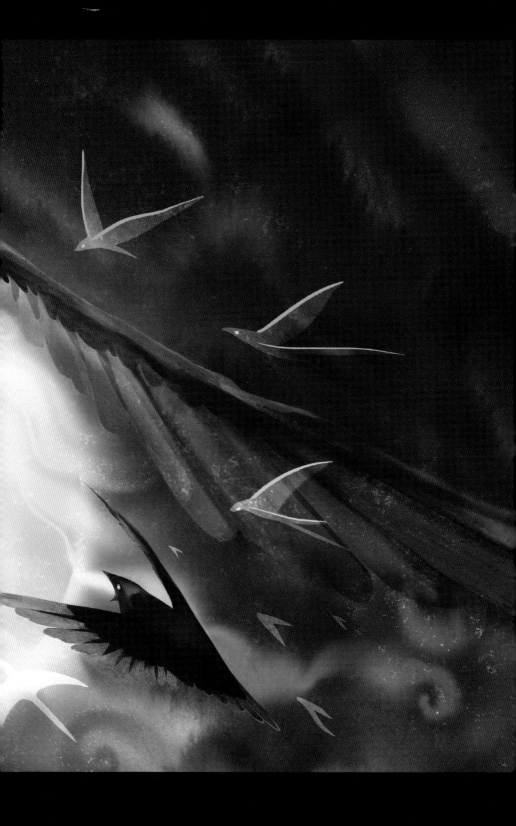

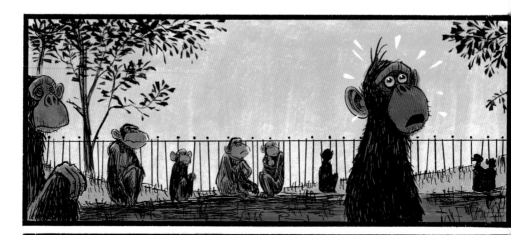

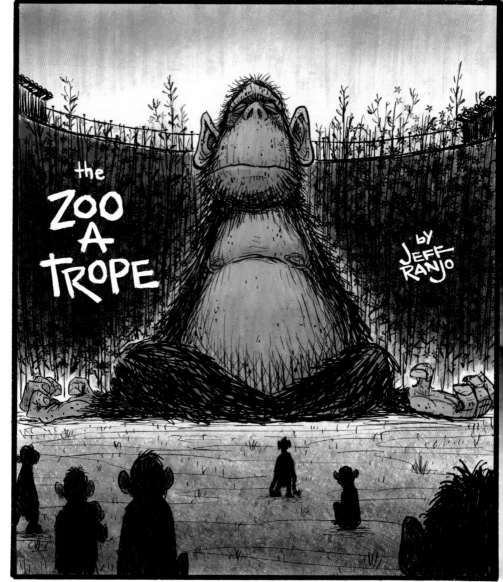

the
ZOO
A
TROPE

by JEFF RANJO

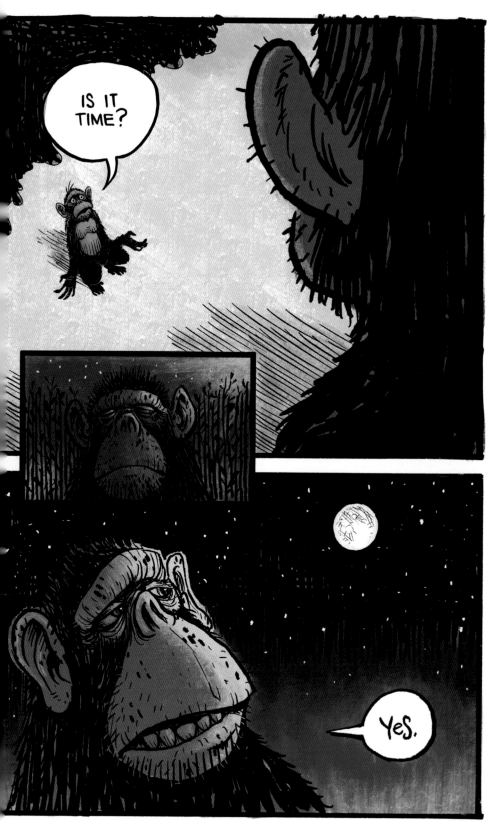

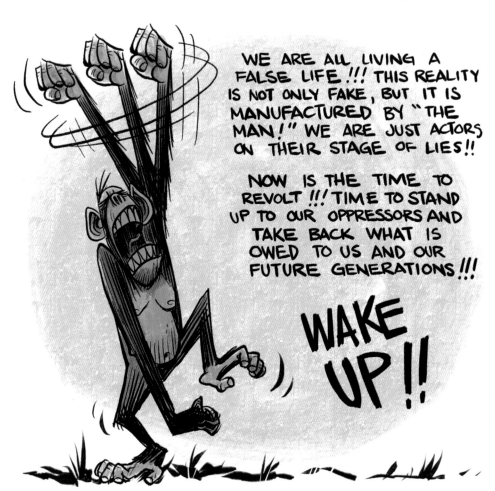

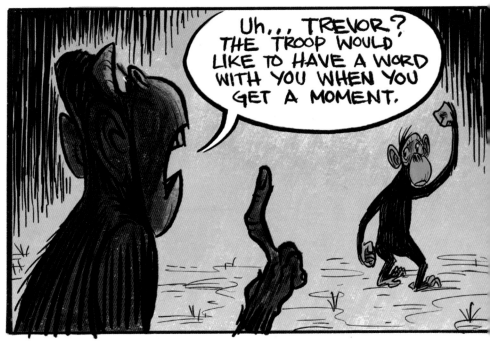

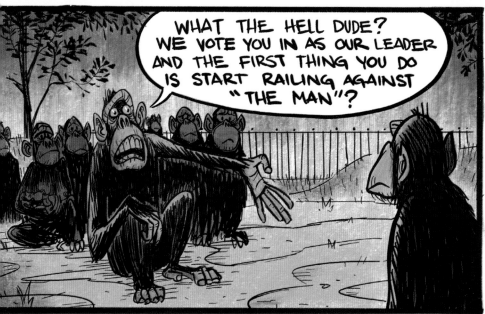

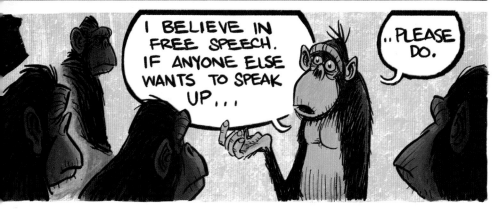

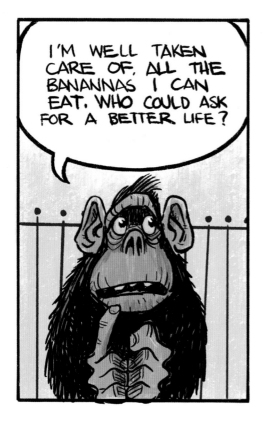

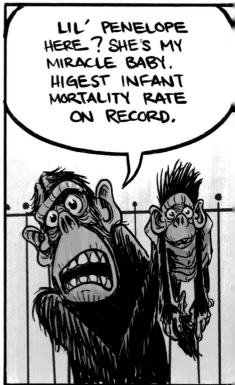

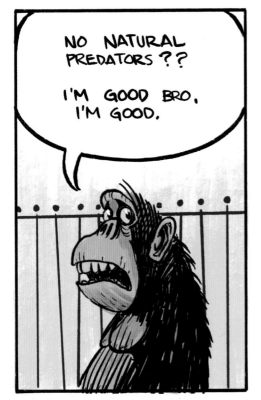

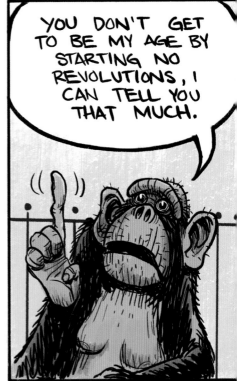

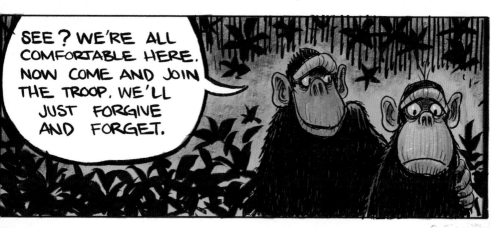

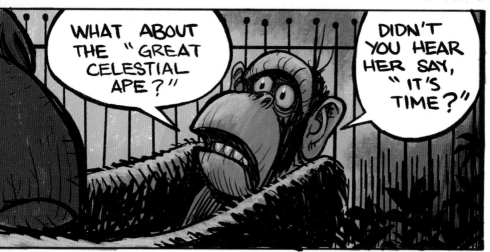

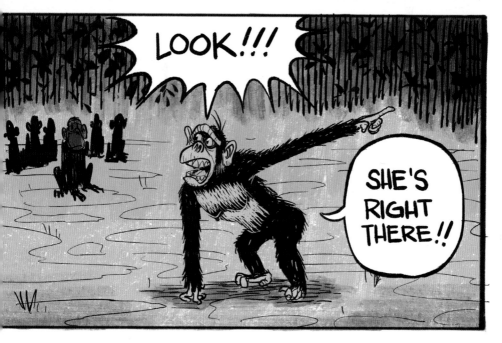

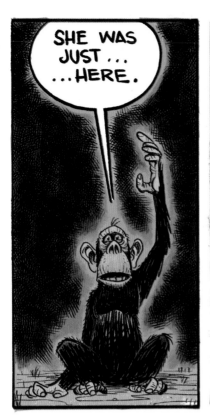

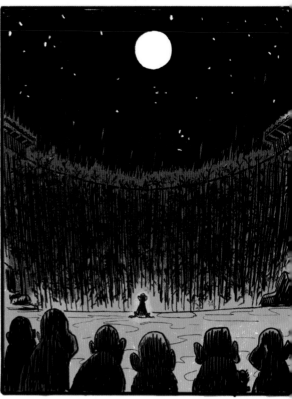

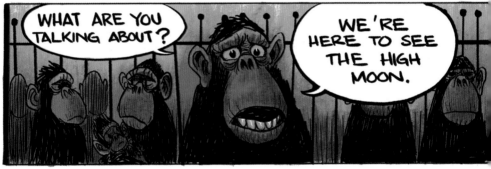

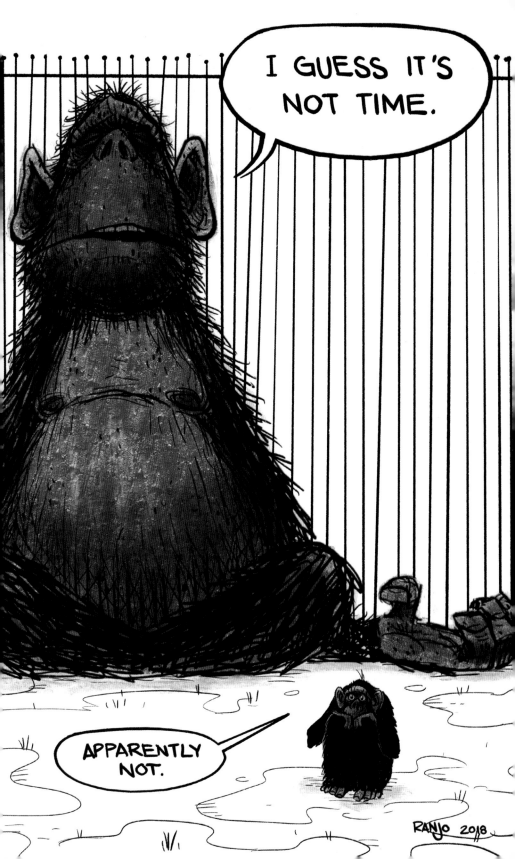

"MOON KILLER"

BY CHRIS UR

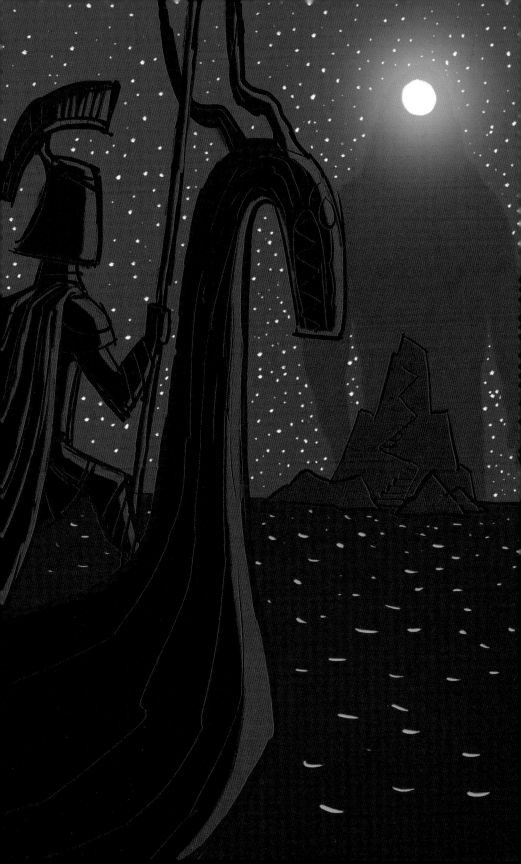

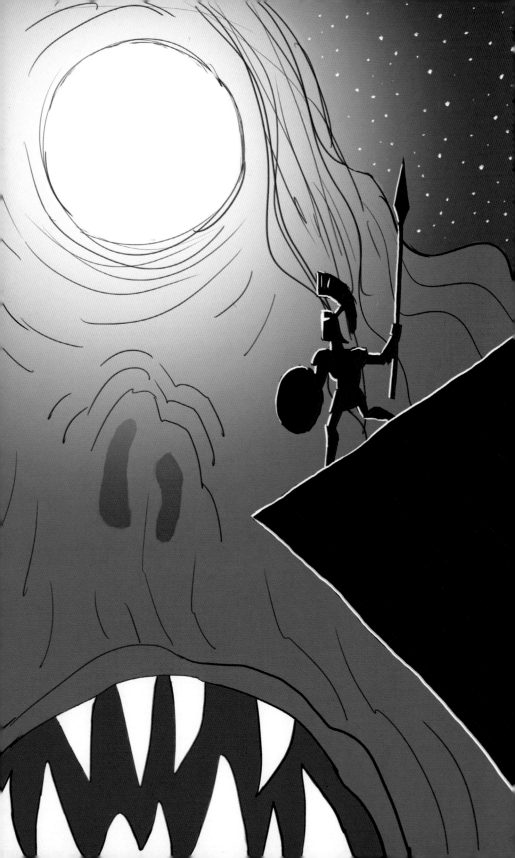

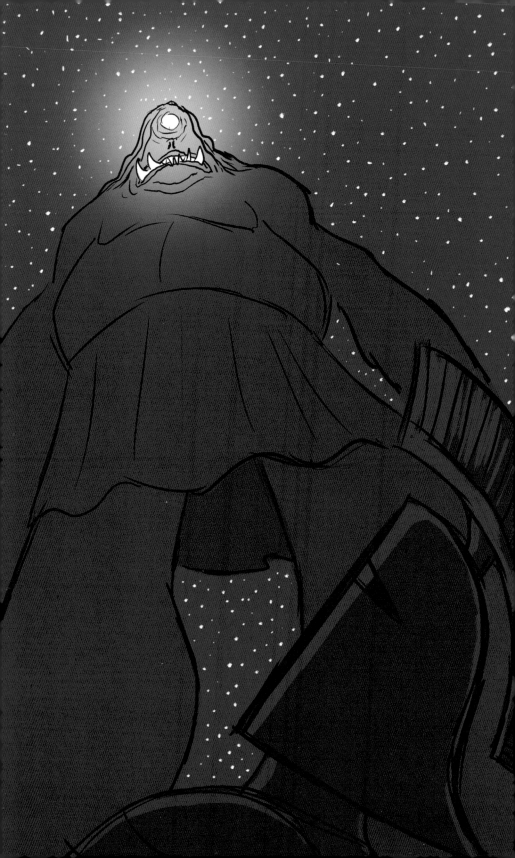

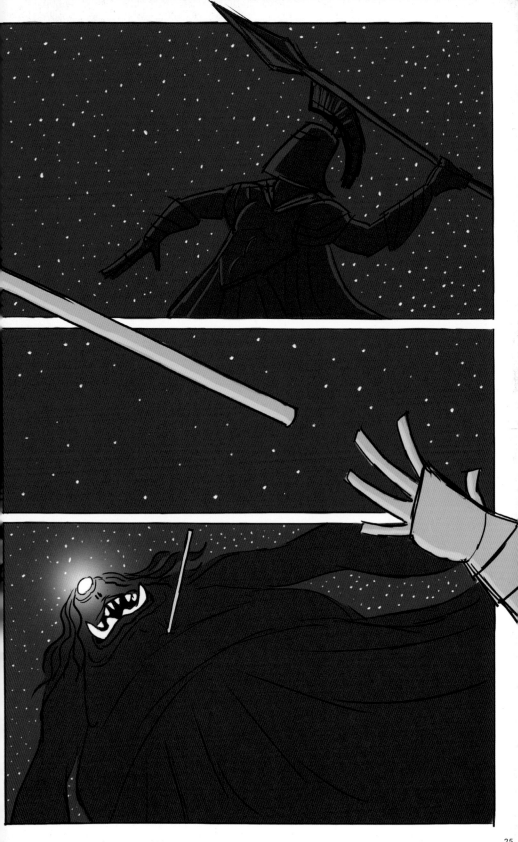

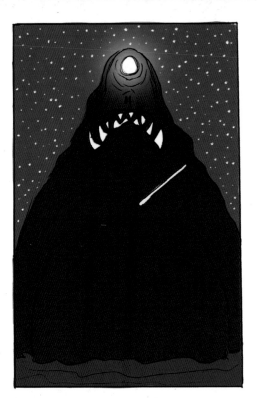
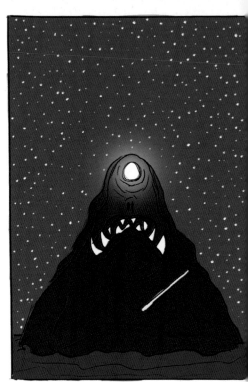
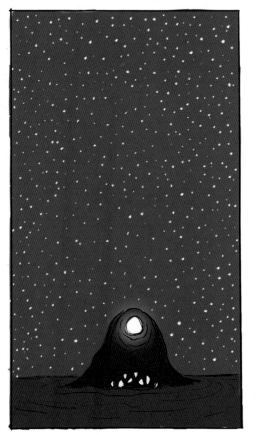

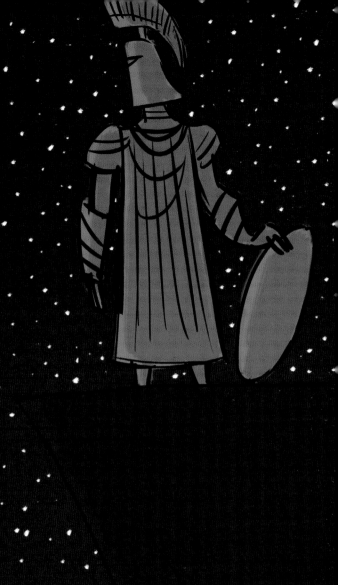

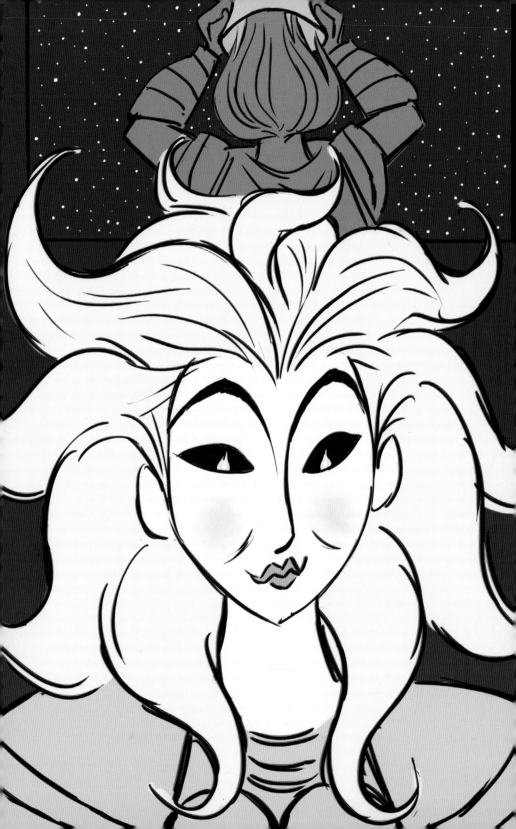

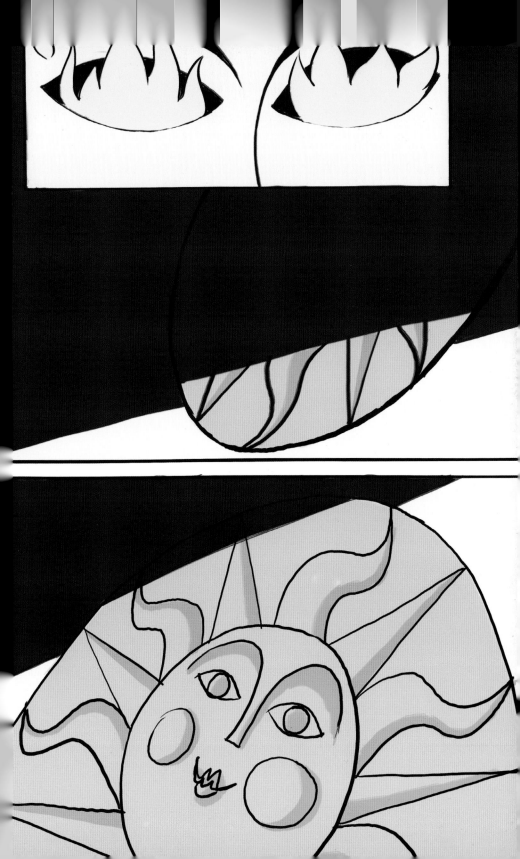

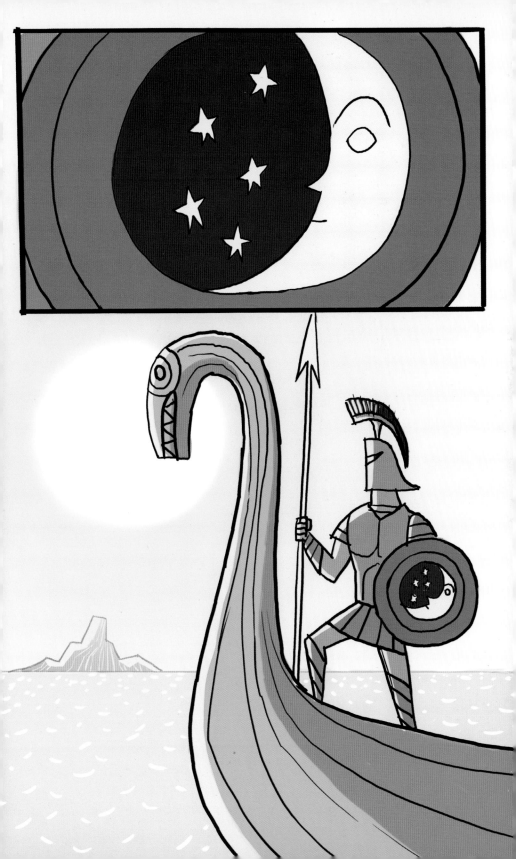

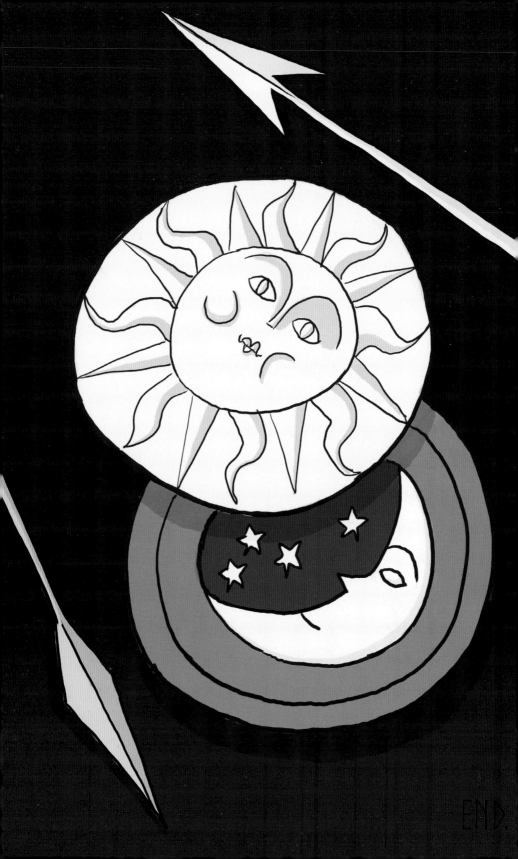

HIGH MOON.

BY LISSA TREIMAN.

33

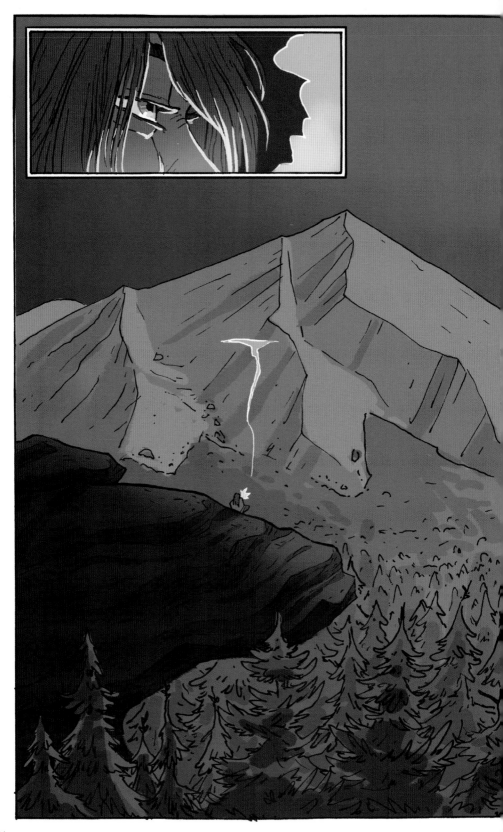

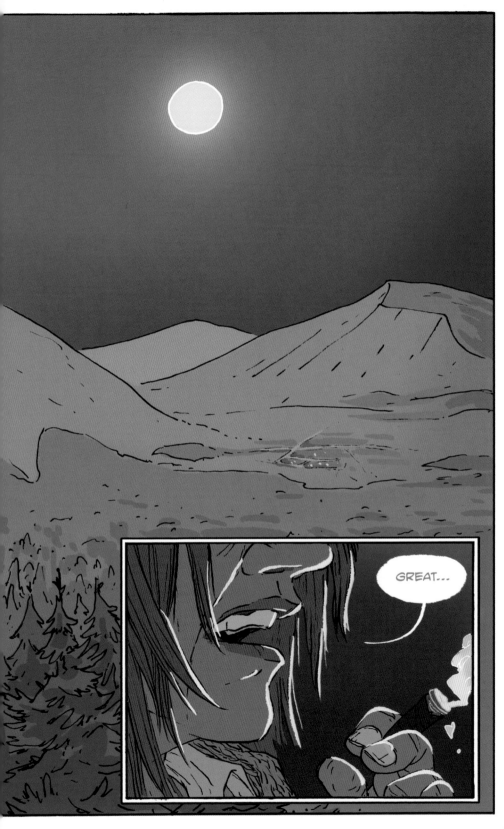

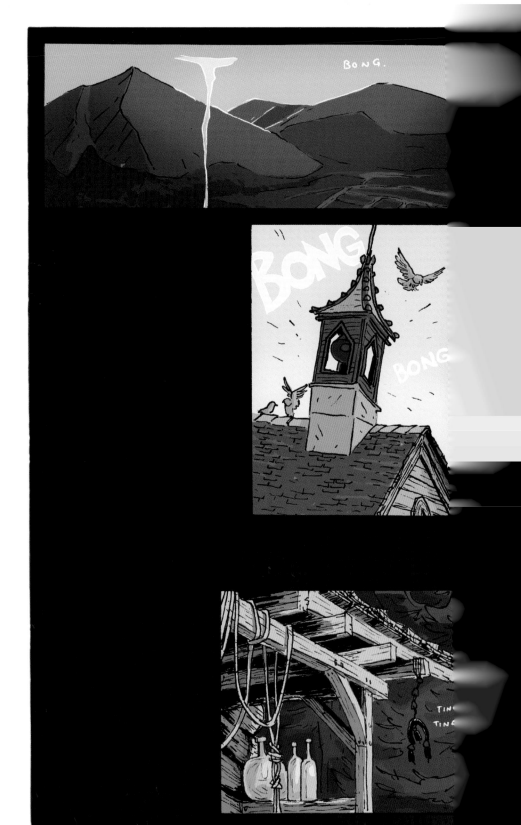

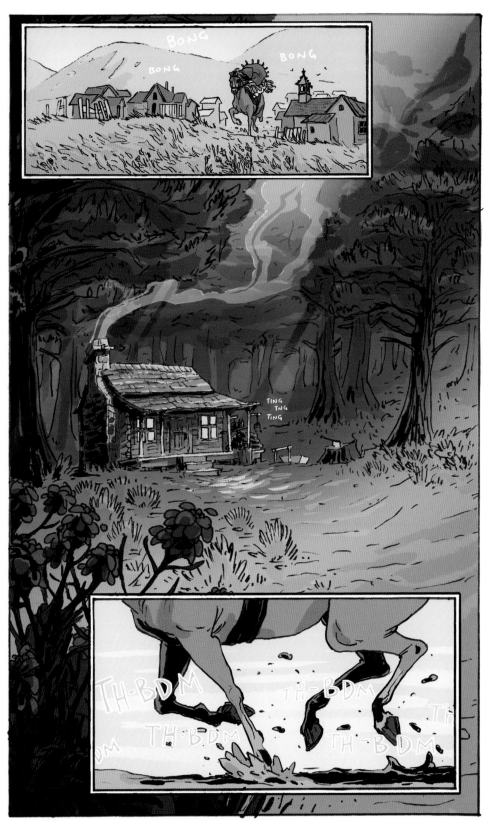

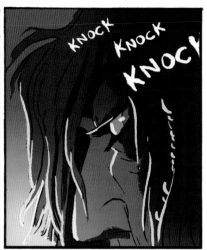

KNOCK KNOCK KNOCK

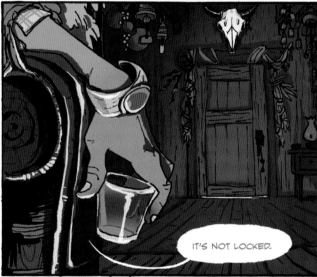

IT'S NOT LOCKED.

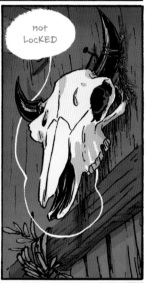

not LocKED

TING TING TING TING TING

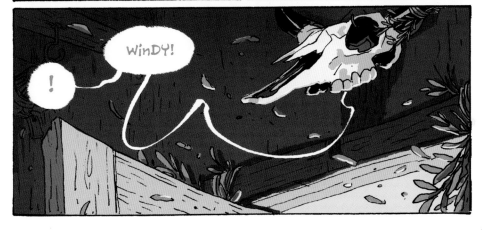

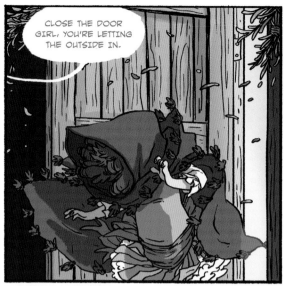

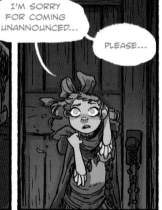

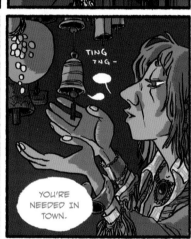

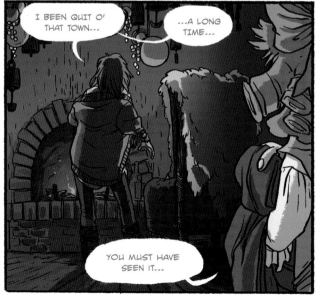

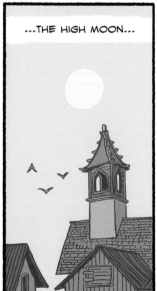

40

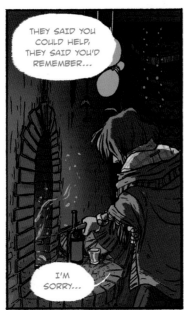

THEY SAID YOU COULD HELP, THEY SAID YOU'D REMEMBER...

I'M SORRY...

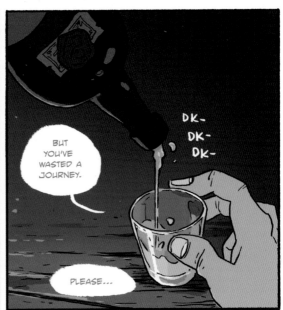

BUT YOU'VE WASTED A JOURNEY.

PLEASE...

DK-
DK-
DK-

TING
TING
TING

BAM
BAM

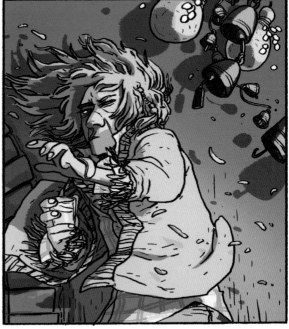

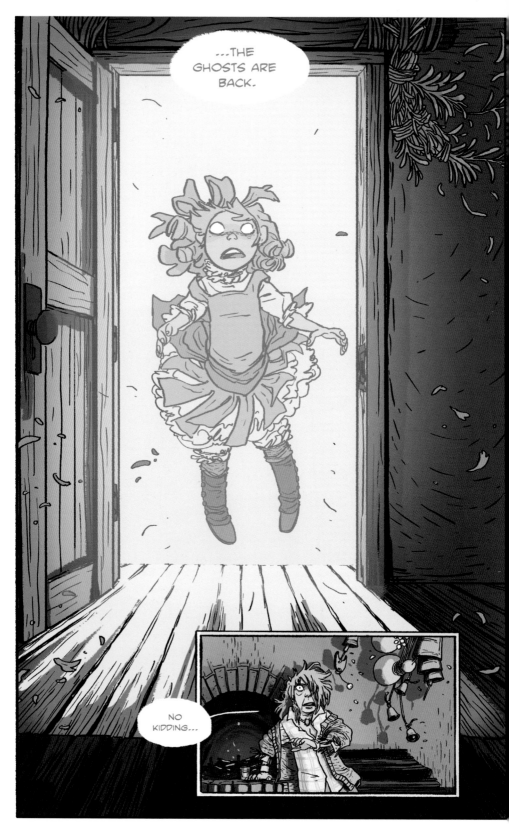

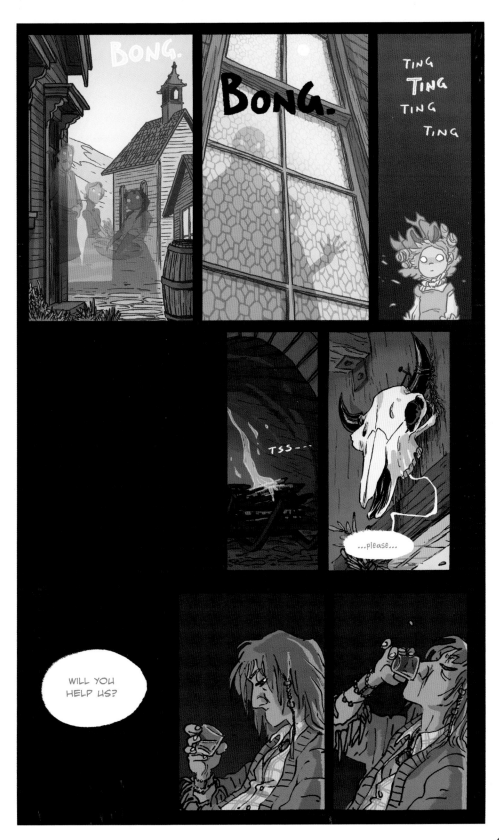

NO.

·

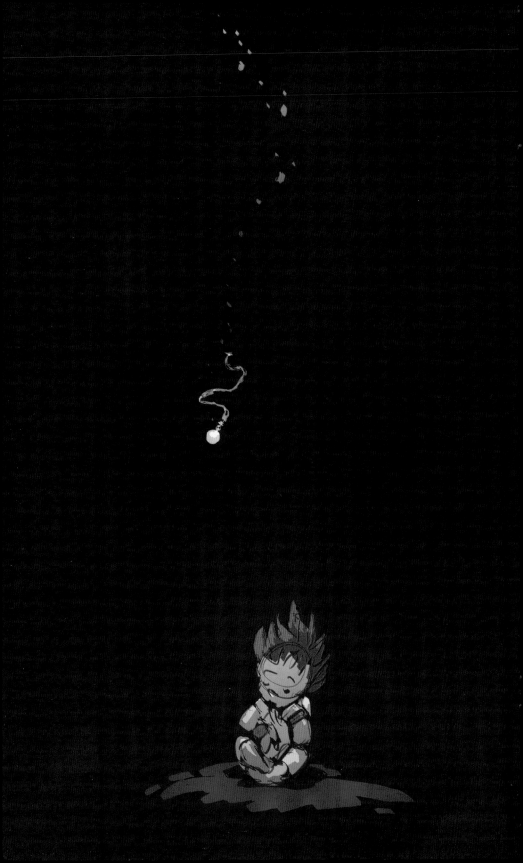

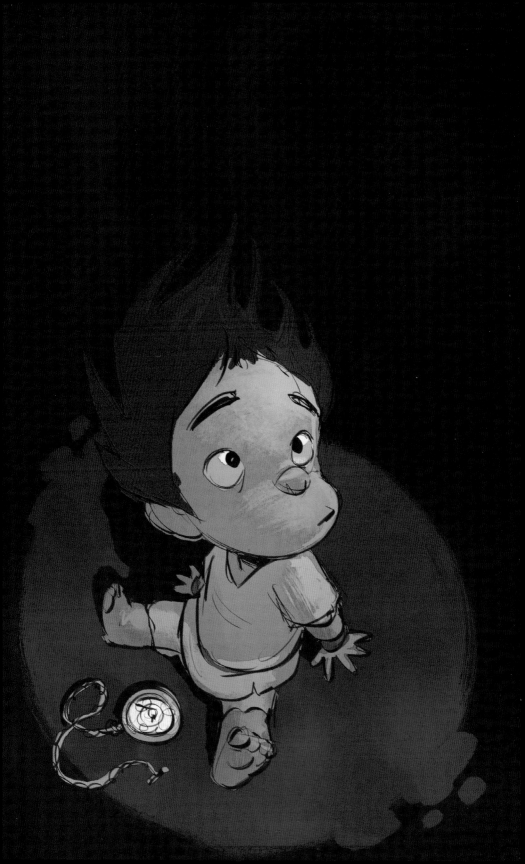

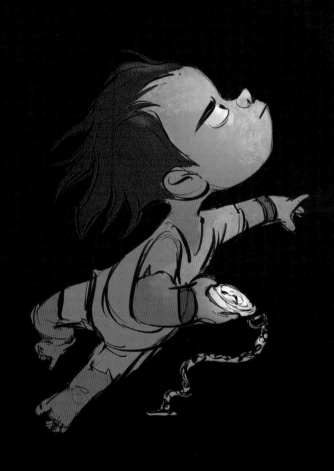

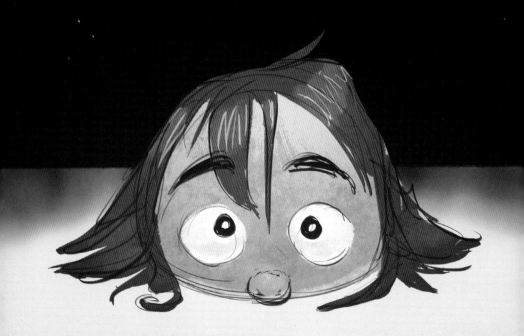

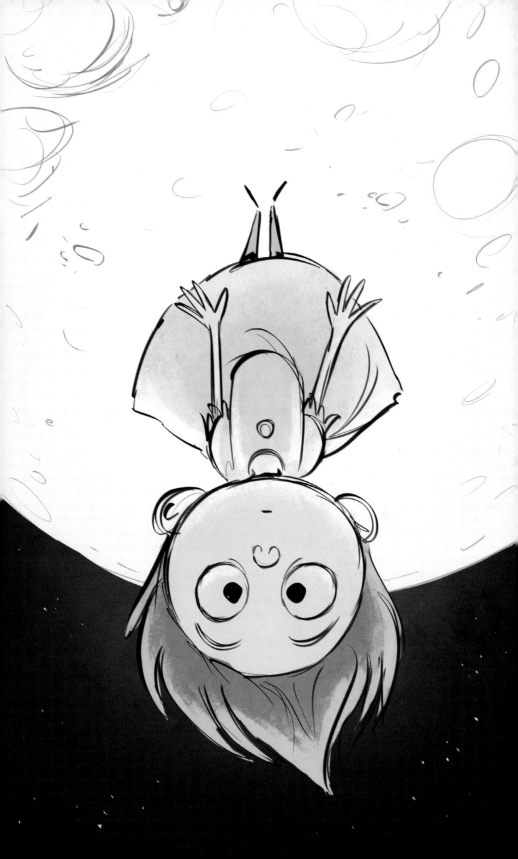

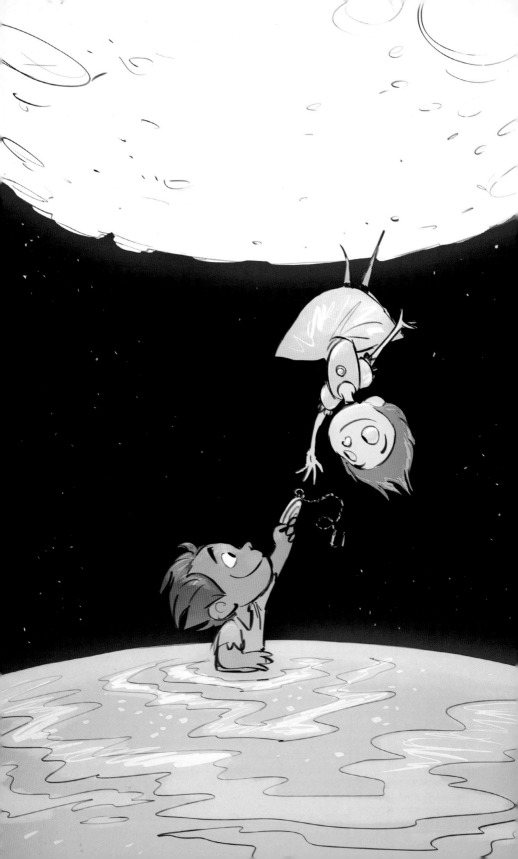

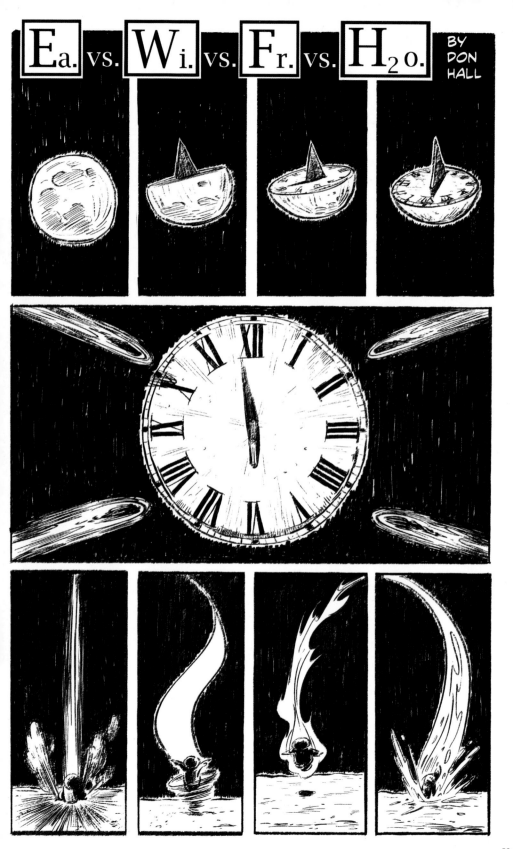

53

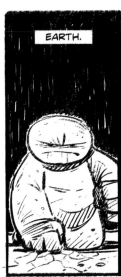

EARTH.

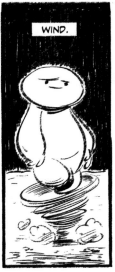

WIND.

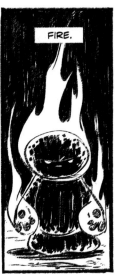

FIRE.

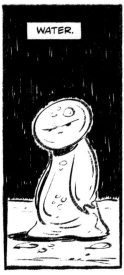

WATER.

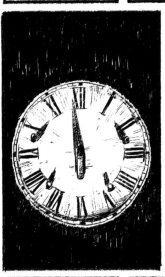

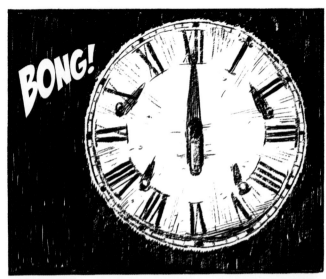

BONG!

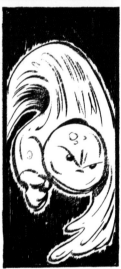

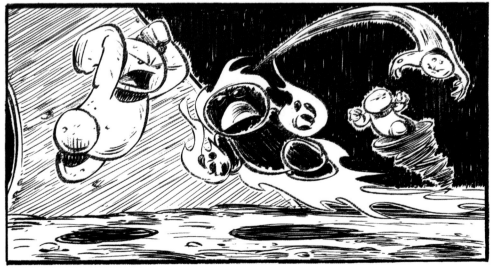

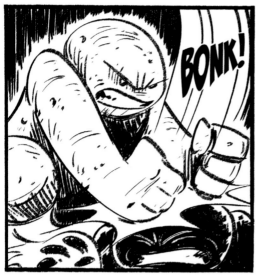
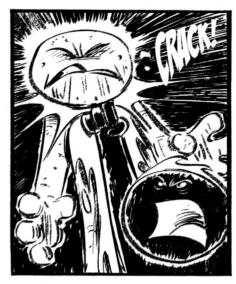
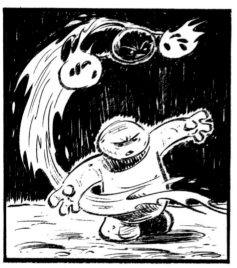
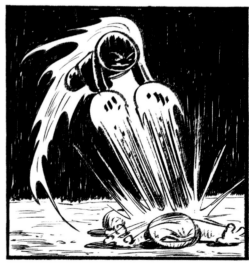

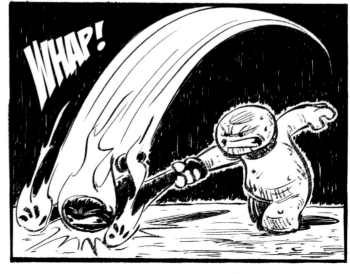

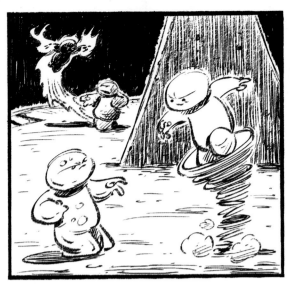

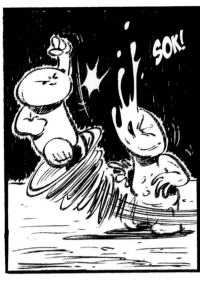

SOK!

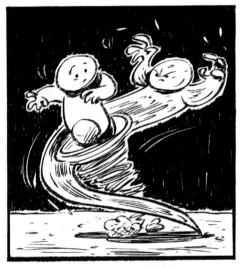

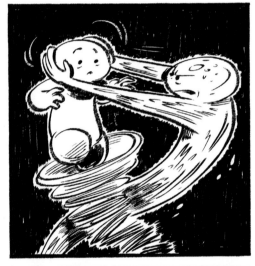

SPLOSH!

SPLAT!

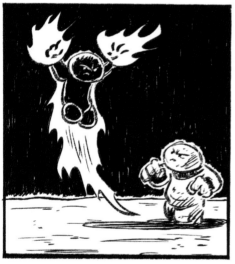

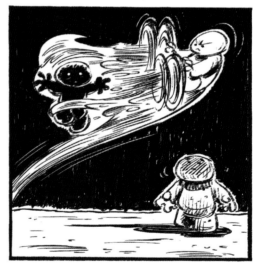

BAP!

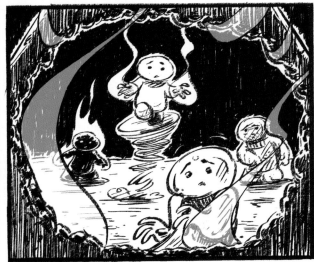
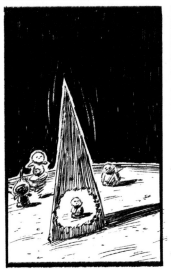
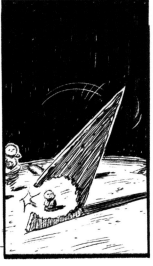

KLANG!

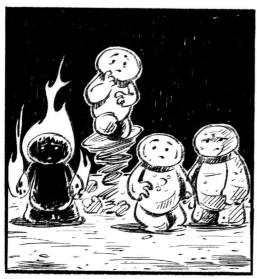

ZIP!

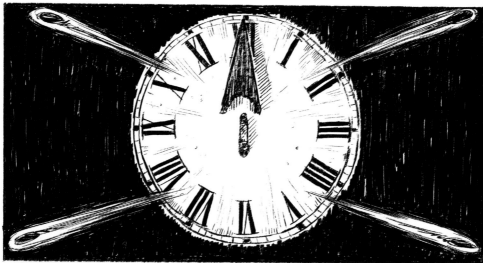

END.

THE SIRENS
OF
HIGH MOON

Alishea Gibson

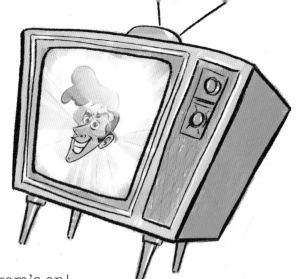

Hurry the program's on!

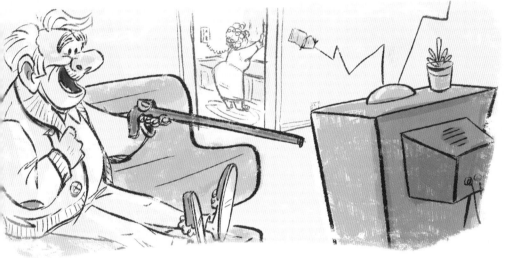

Please help me give a warm welcome to the hypnotic vocals of the *Sirens of High Moon!*

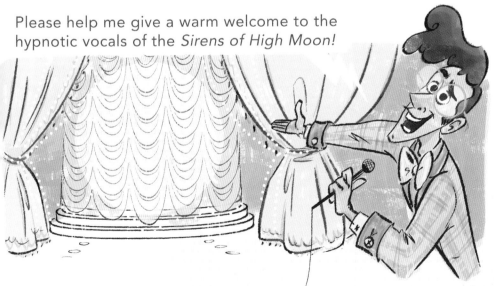

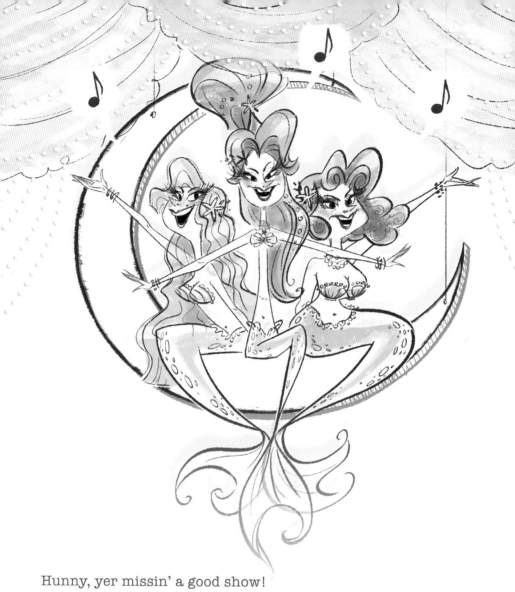

Hunny, yer missin' a good show!

That's nice, dear.

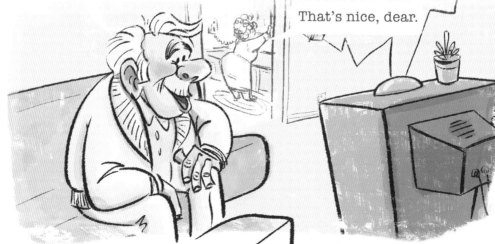

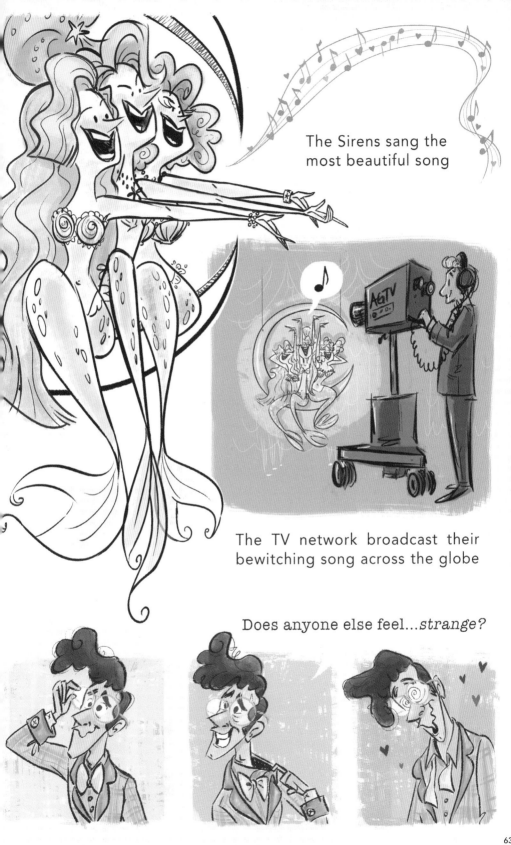

The Sirens sang the most beautiful song

The TV network broadcast their bewitching song across the globe

Does anyone else feel...*strange?*

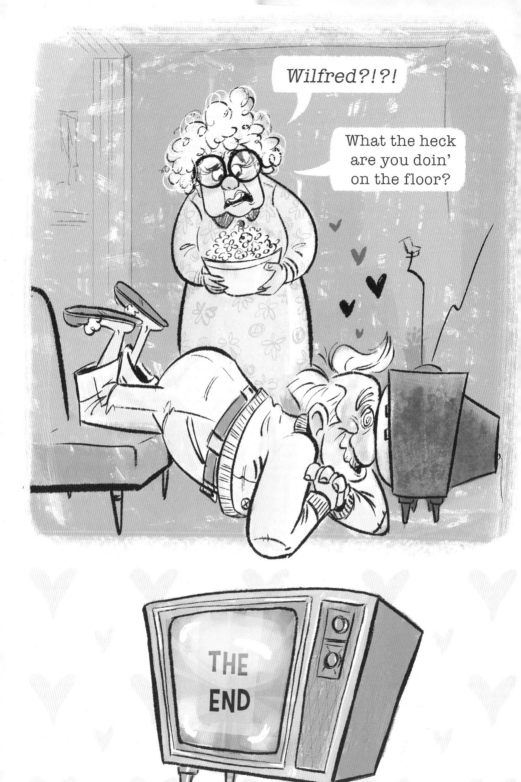

64

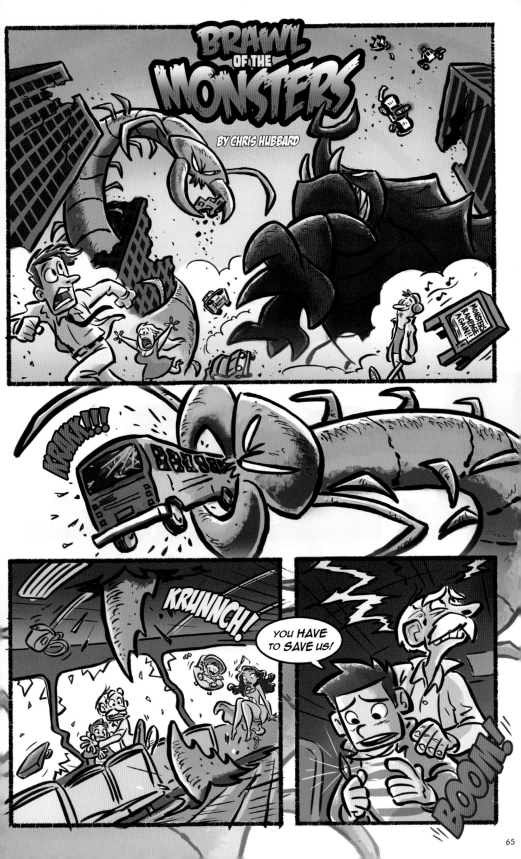

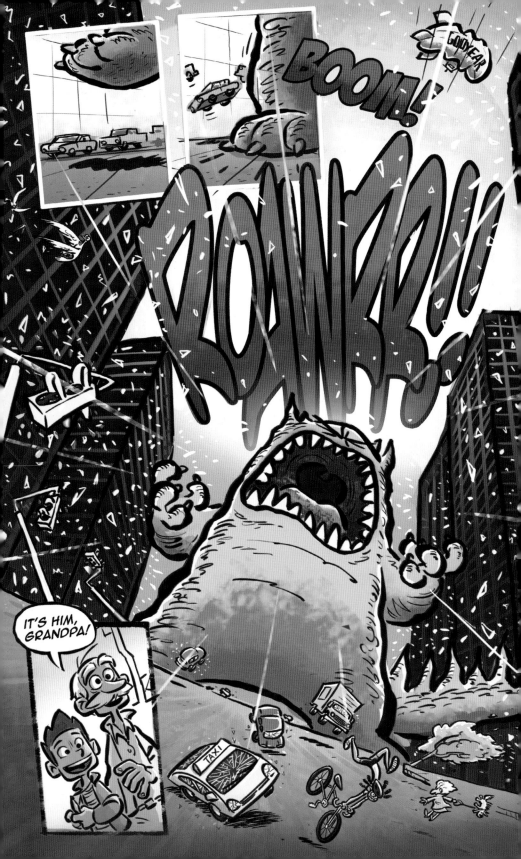

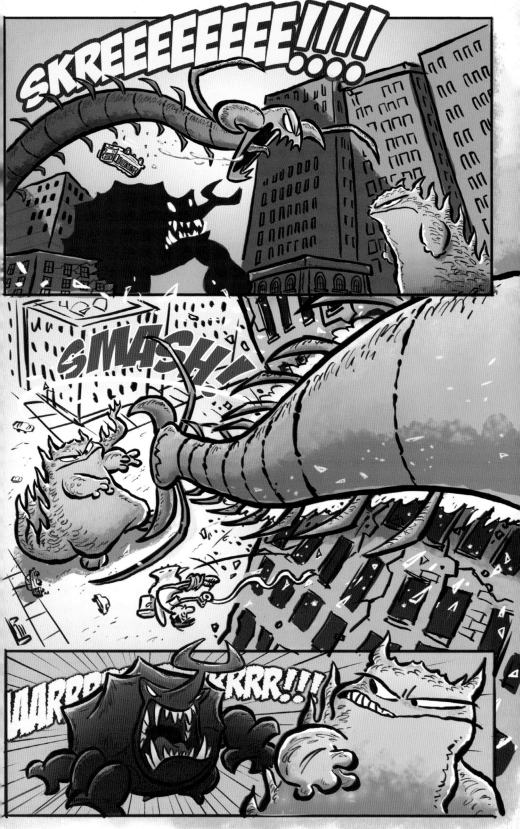

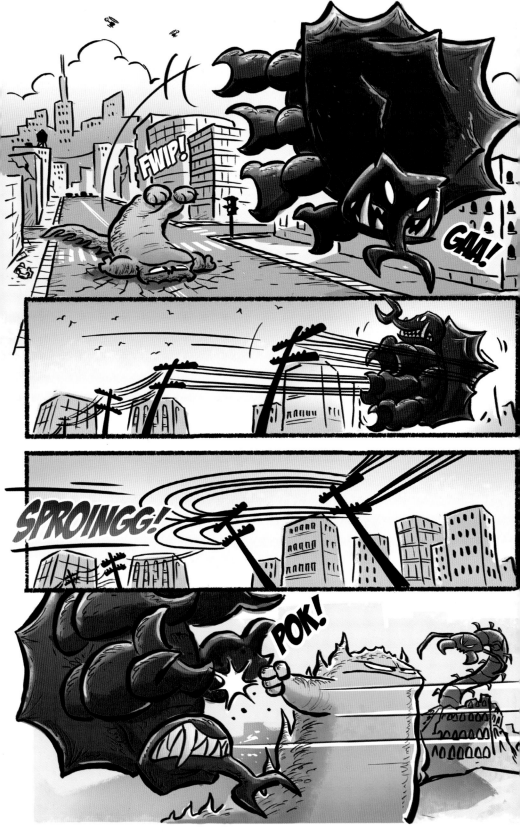

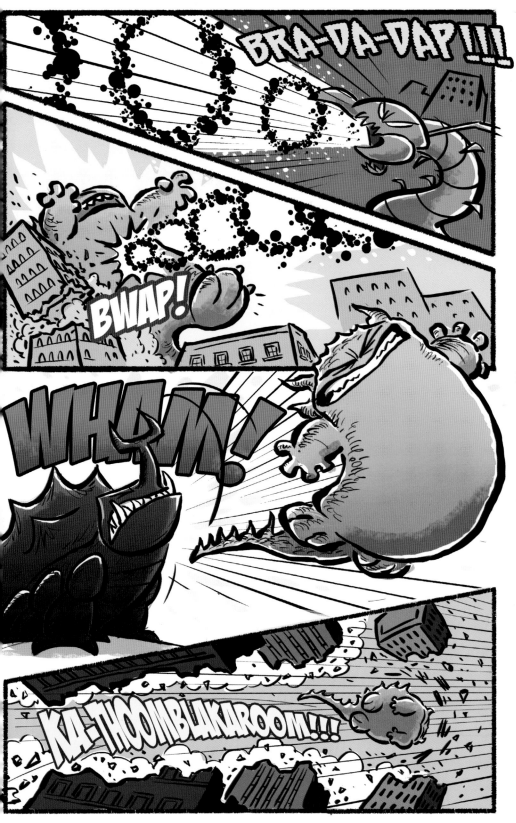

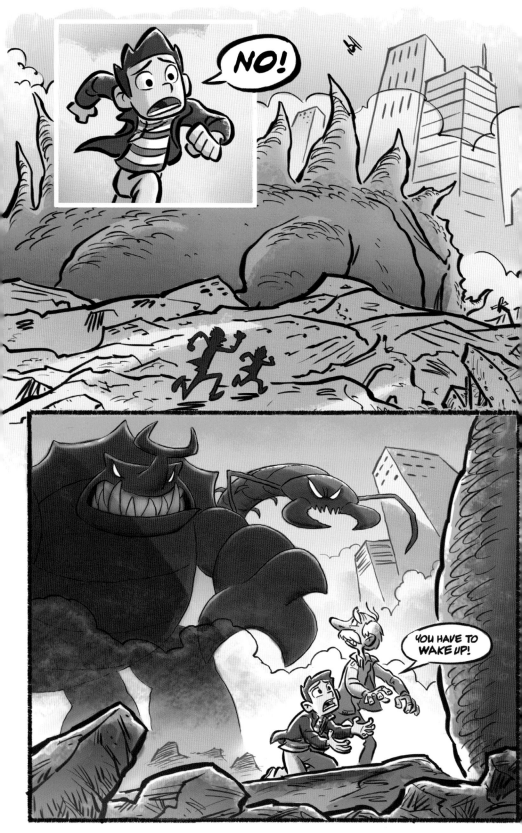

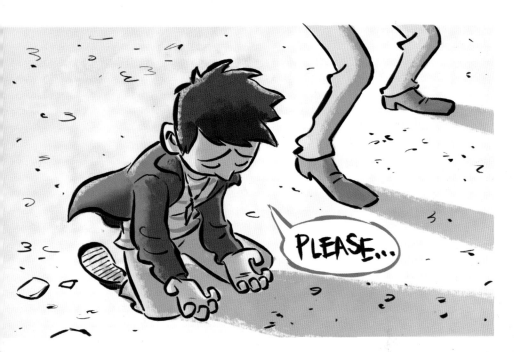

PLEASE...

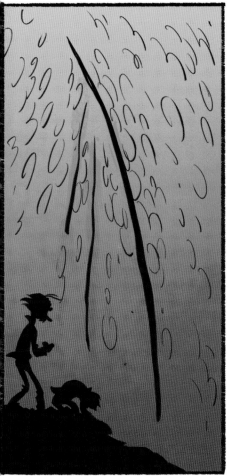
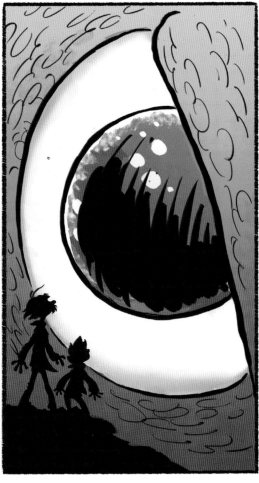

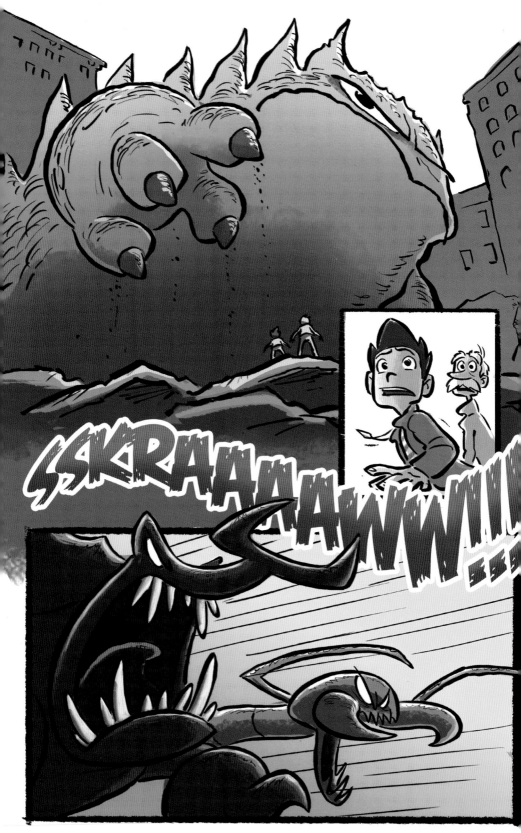

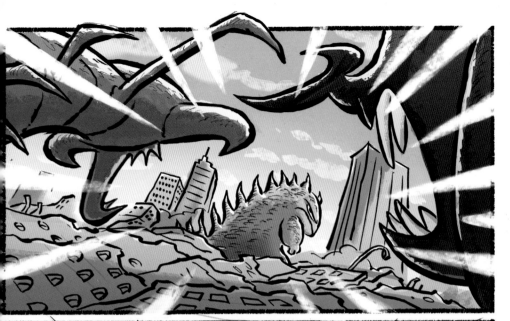

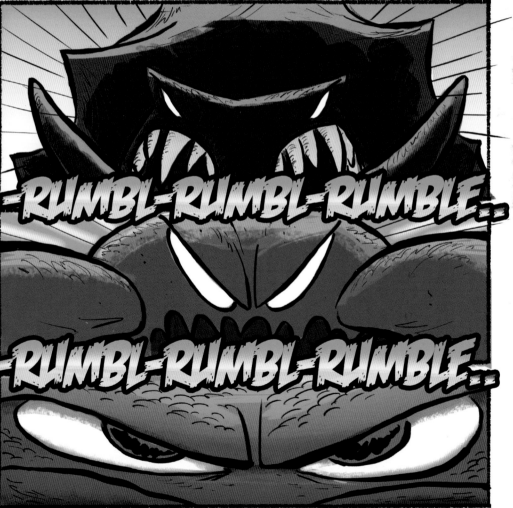

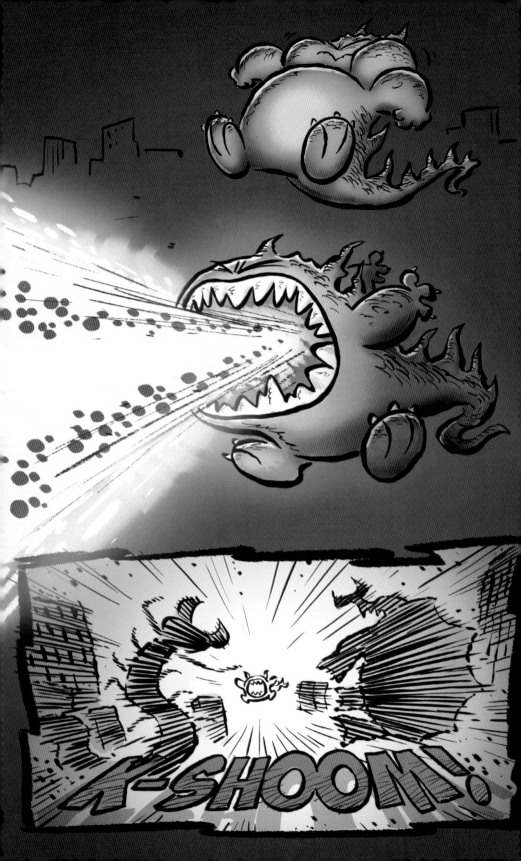

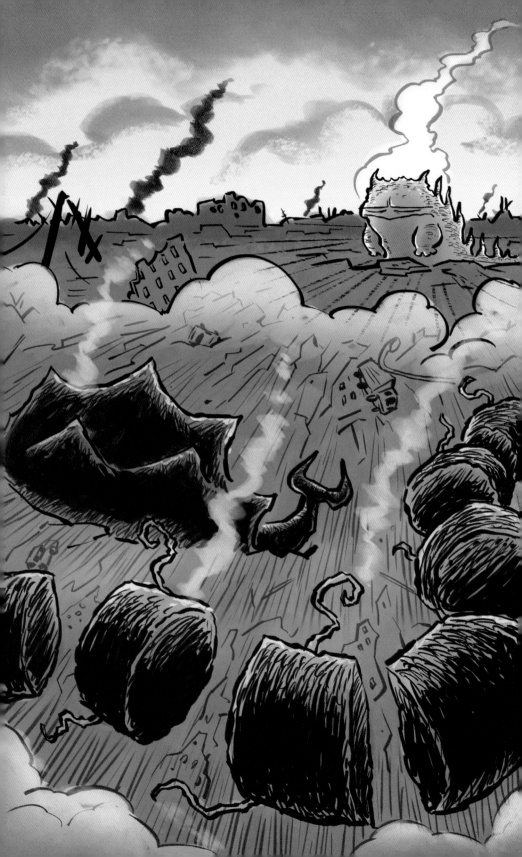

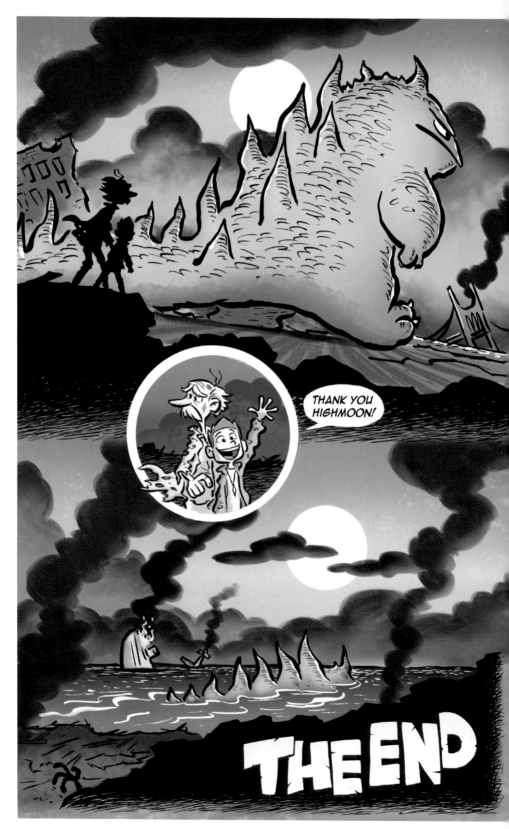

RUDOLF MAXIMILIAN HÖLL

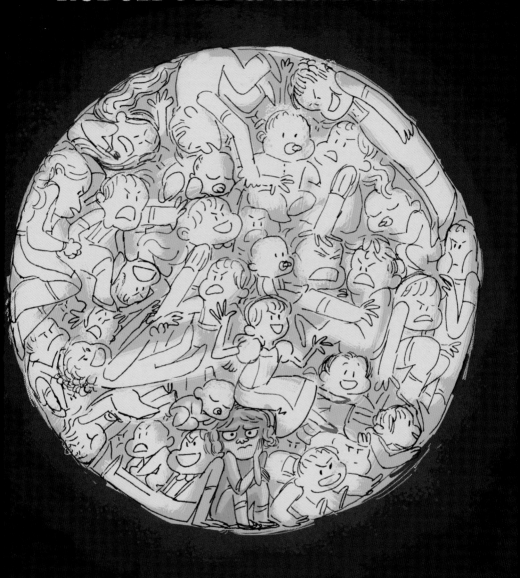

was one of twenty-two children.

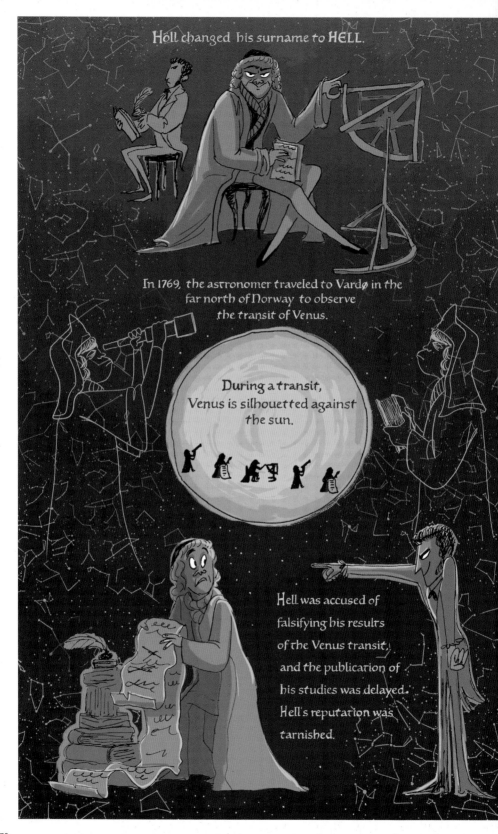

Höll changed his surname to HELL.

In 1769, the astronomer traveled to Vardø in the far north of Norway to observe the transit of Venus.

During a transit, Venus is silhouetted against the sun.

Hell was accused of falsifying his results of the Venus transit, and the publication of his studies was delayed. Hell's reputation was tarnished.

Hell was exonerated a century after his death.
A crater on the moon bears his name.

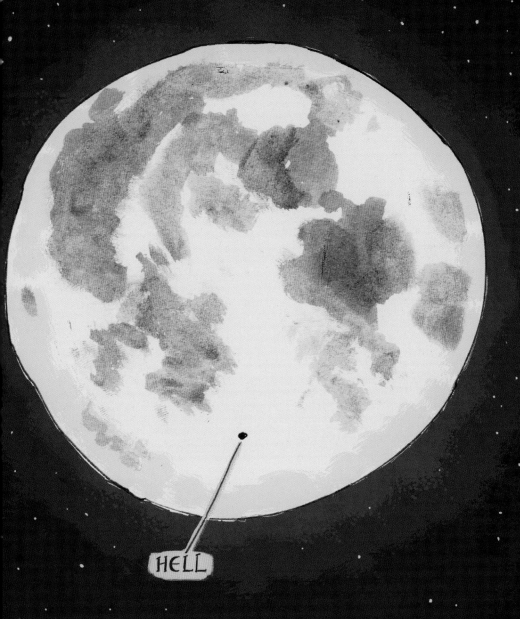

HELL

Hell was also immortalized on a 1970
Czechoslovakian postage stamp.

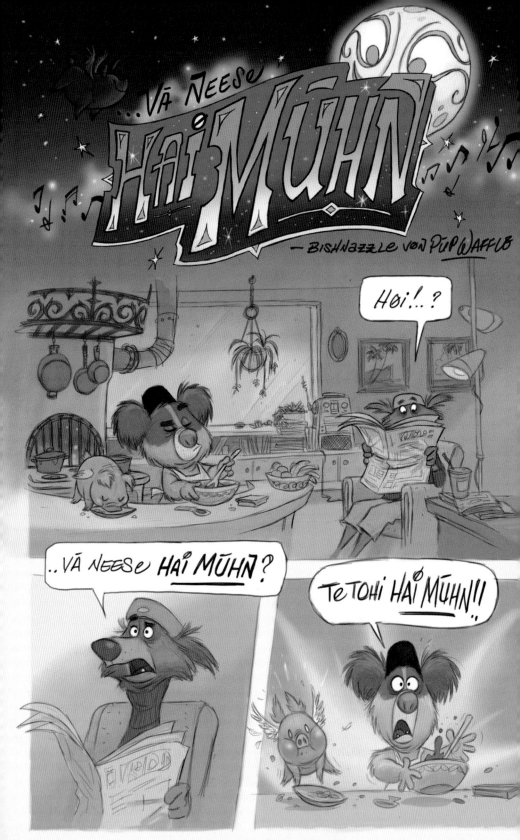

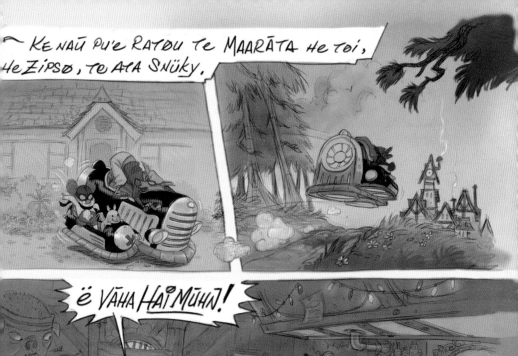

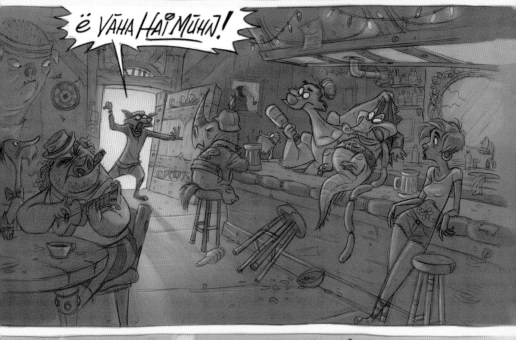

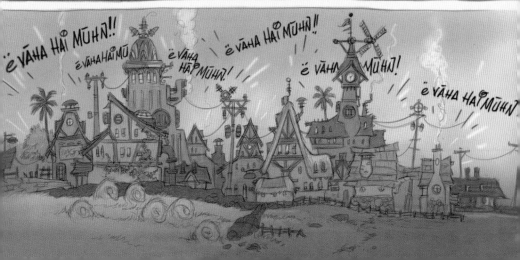

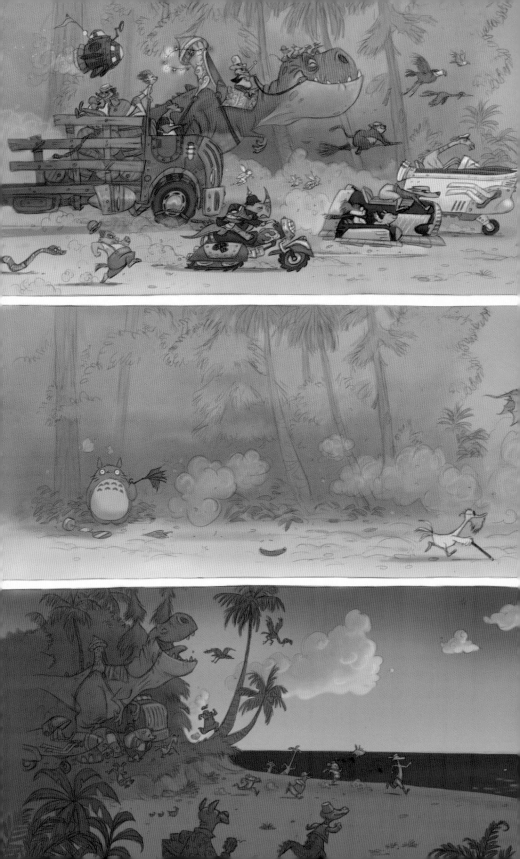

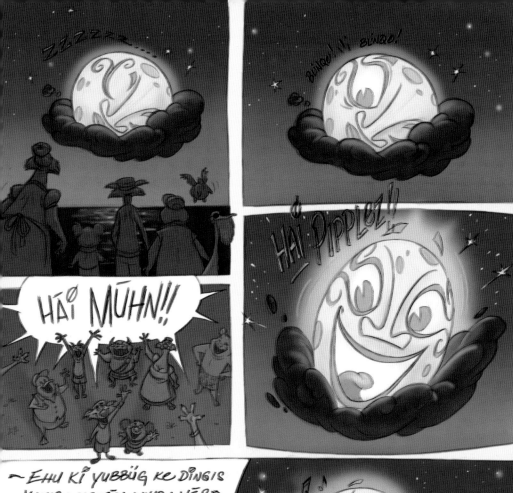

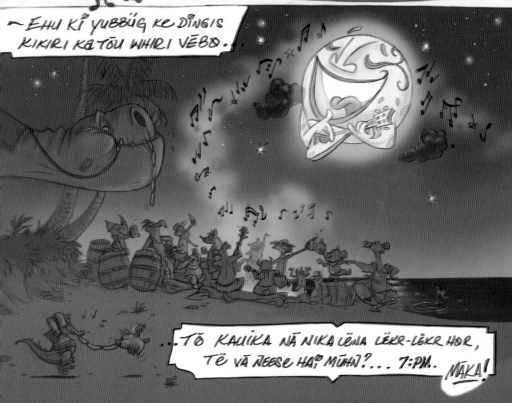

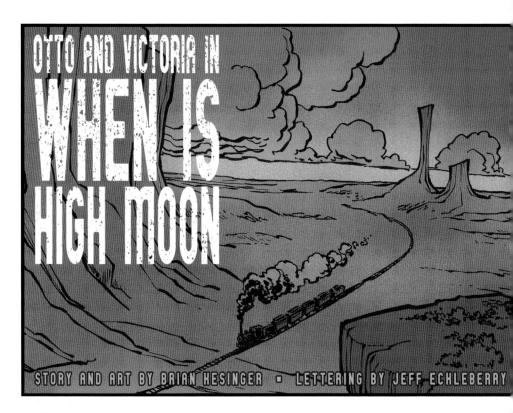

OTTO AND VICTORIA IN WHEN IS HIGH MOON

STORY AND ART BY BRIAN KESINGER • LETTERING BY JEFF ECKLEBERRY

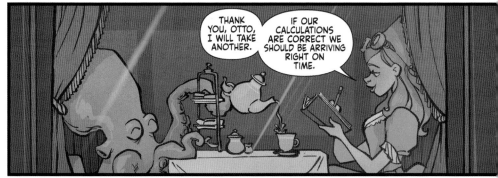

THANK YOU, OTTO, I WILL TAKE ANOTHER.

IF OUR CALCULATIONS ARE CORRECT WE SHOULD BE ARRIVING RIGHT ON TIME.

THUD THUD THUD

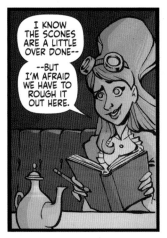

I KNOW THE SCONES ARE A LITTLE OVER DONE--

--BUT I'M AFRAID WE HAVE TO ROUGH IT OUT HERE.

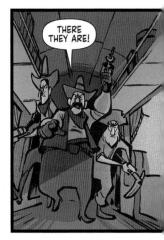

THERE THEY ARE!

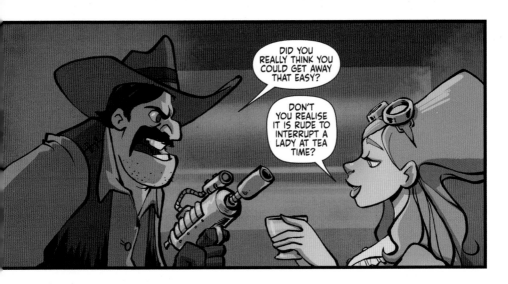

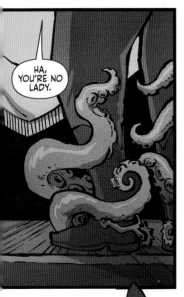

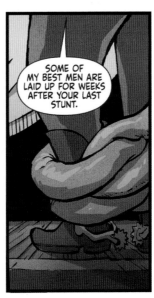

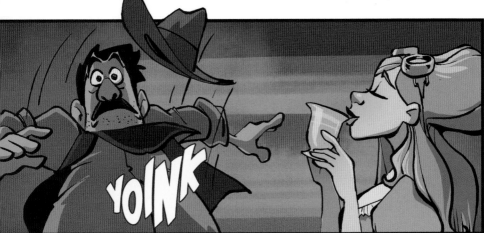

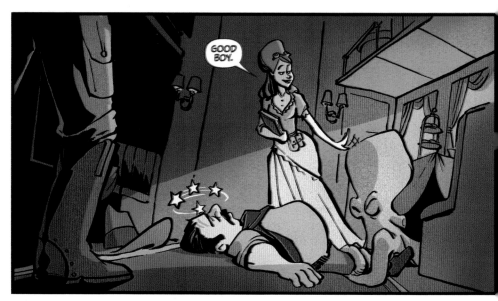

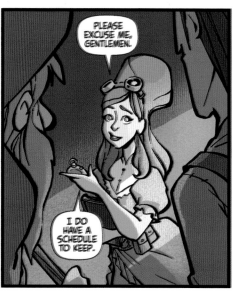

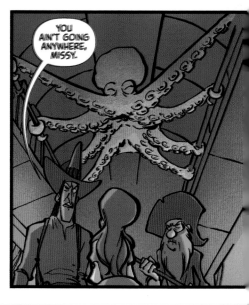

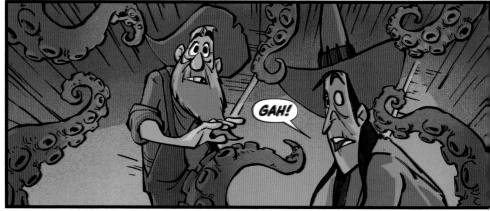

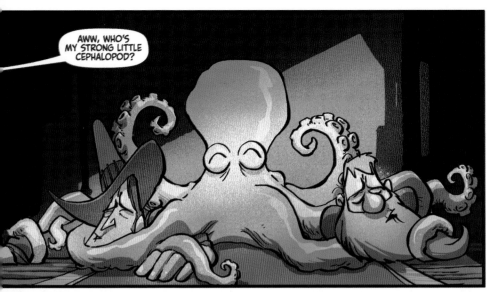

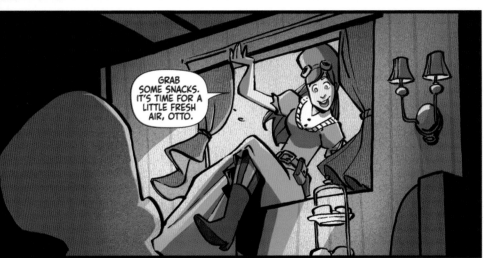

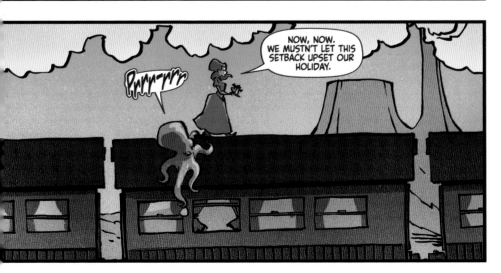

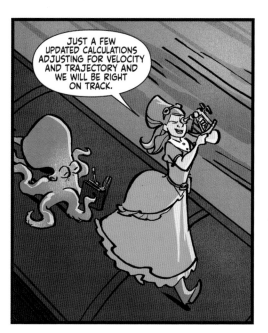

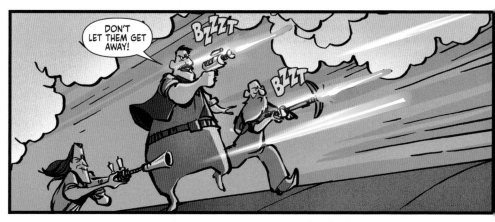

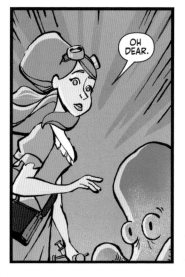

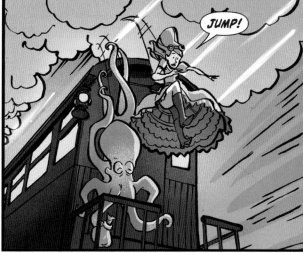

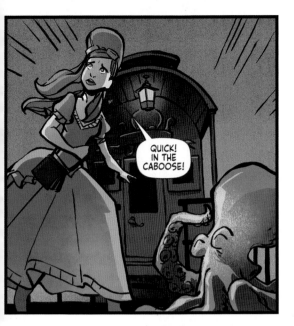

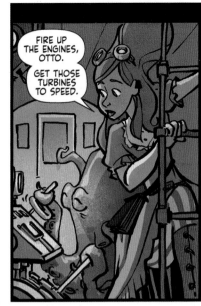

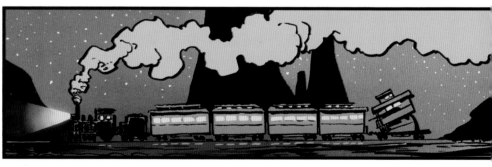

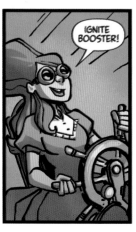

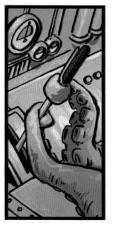

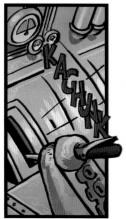

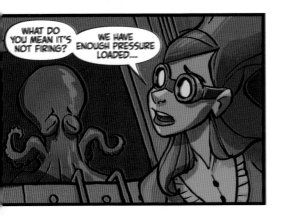

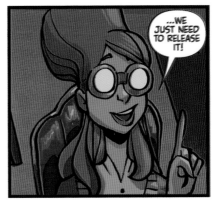

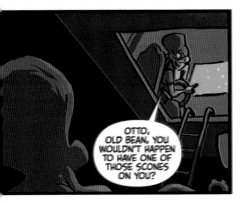

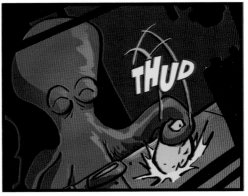

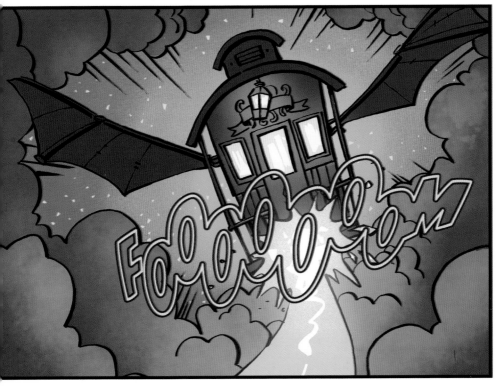

THE CURSE

OF THE

HIGH MOON

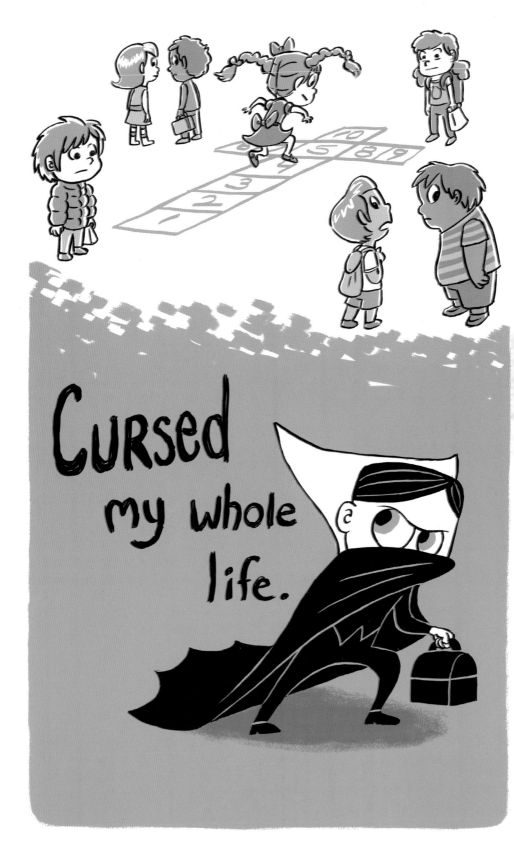

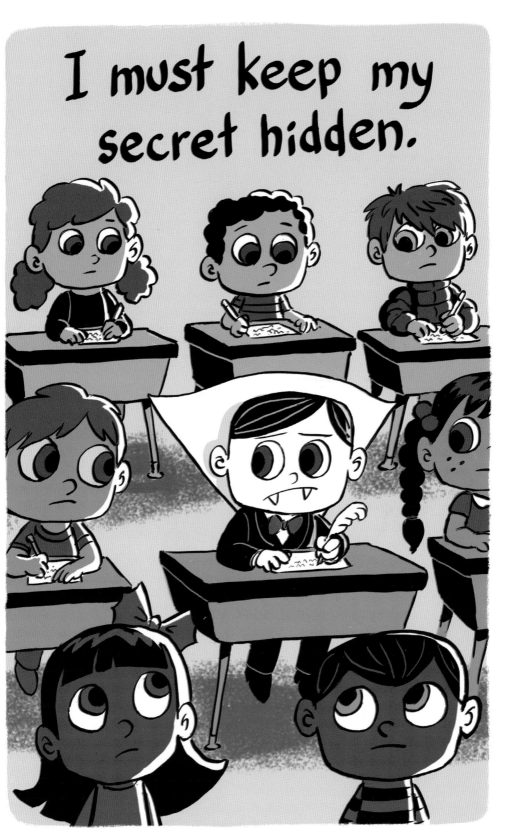

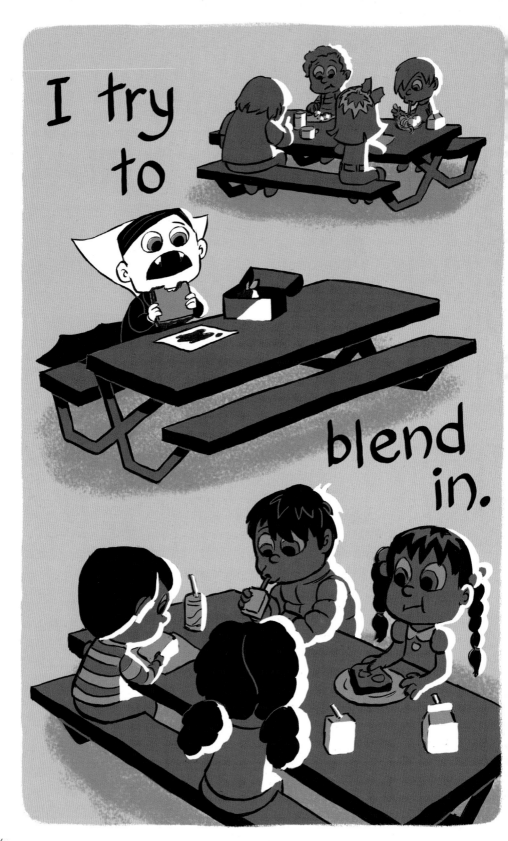

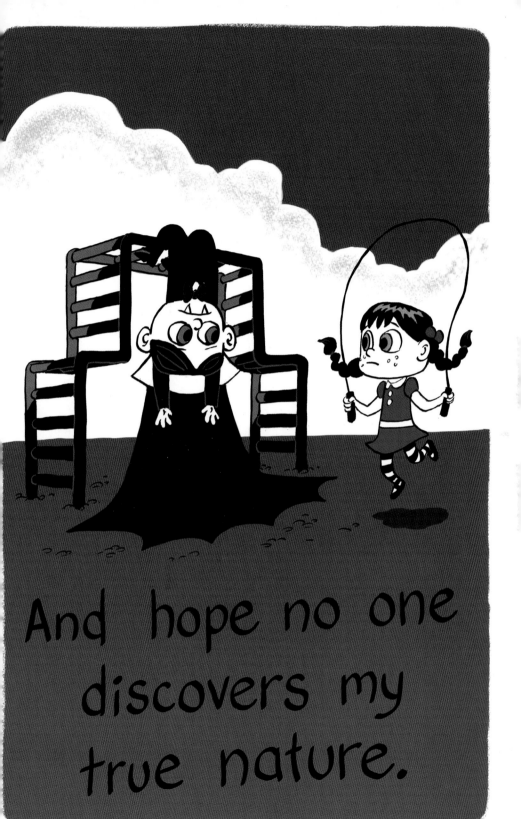

And hope no one discovers my true nature.

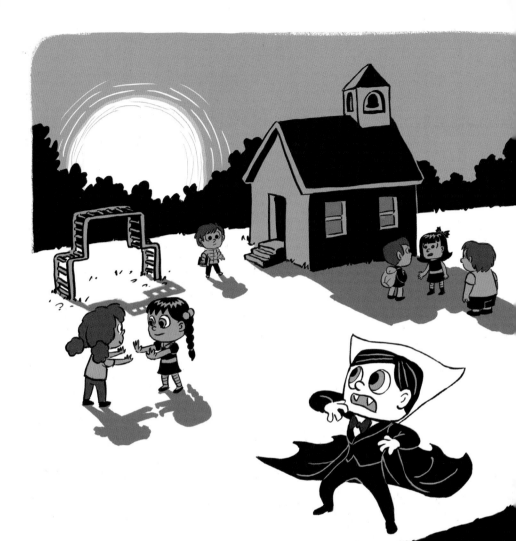

But there is no escaping

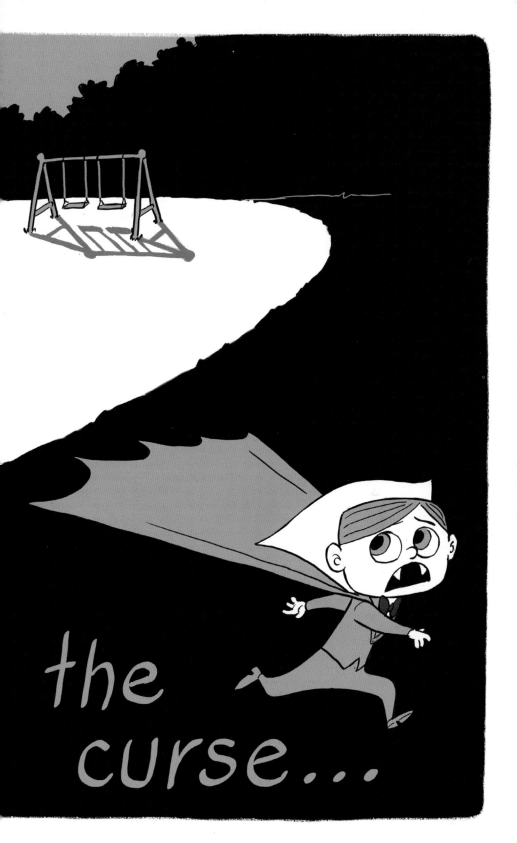

the
curse...

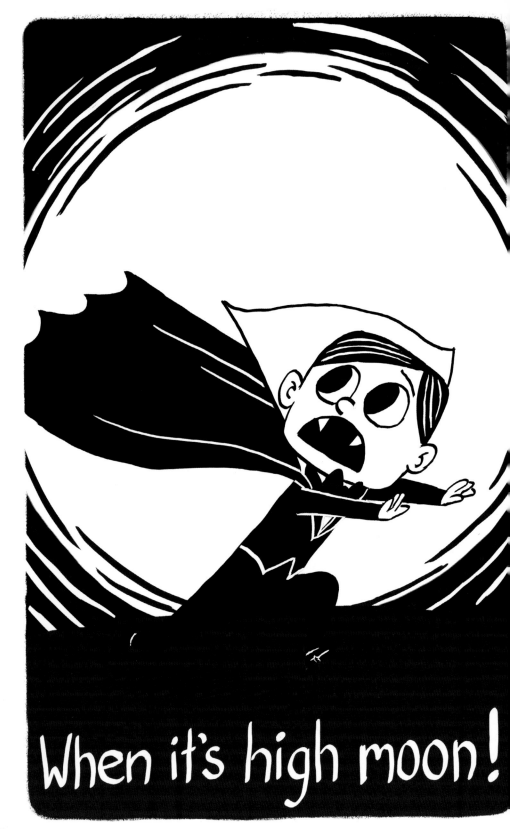

When it's high moon!

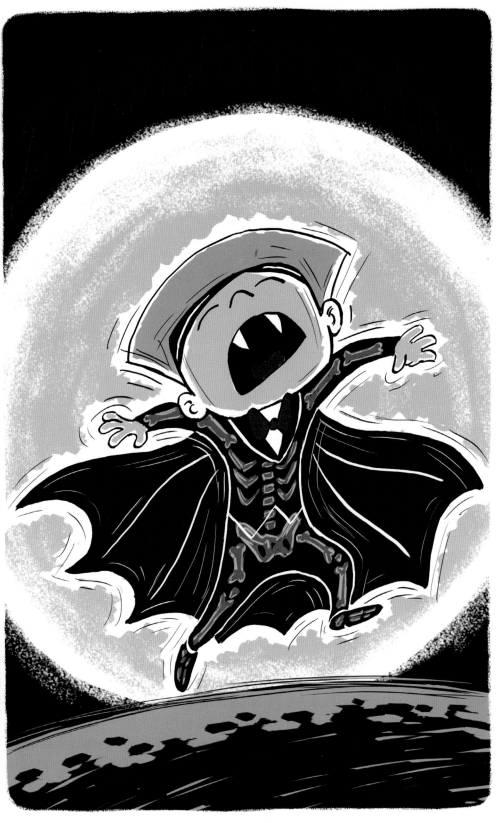

A MONSTER!

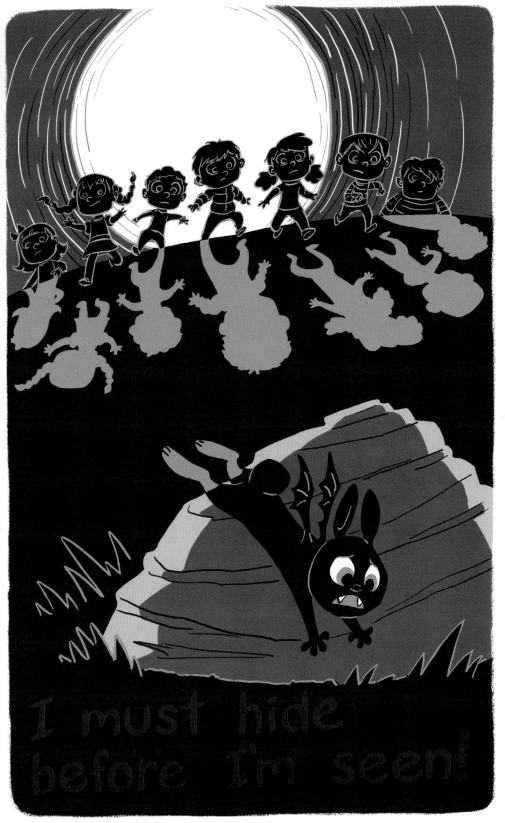

103

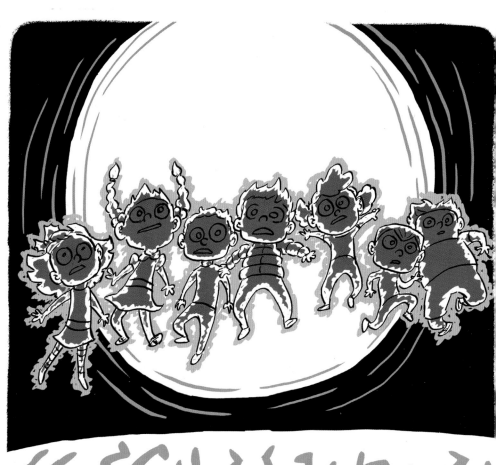

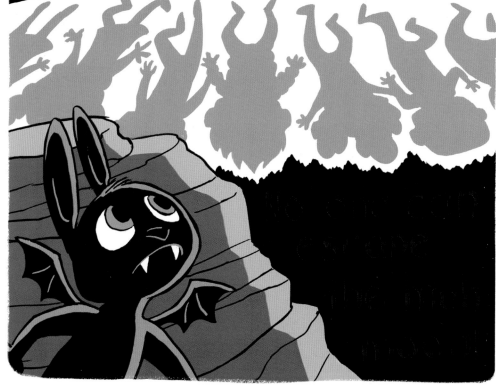

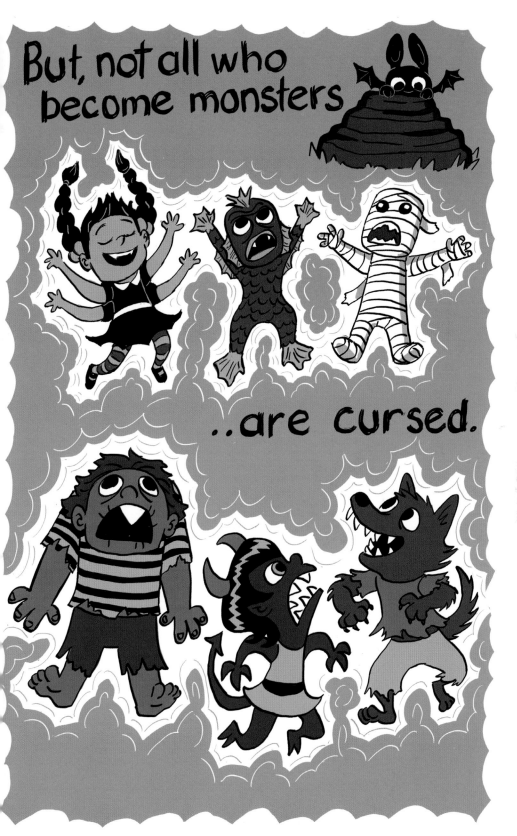

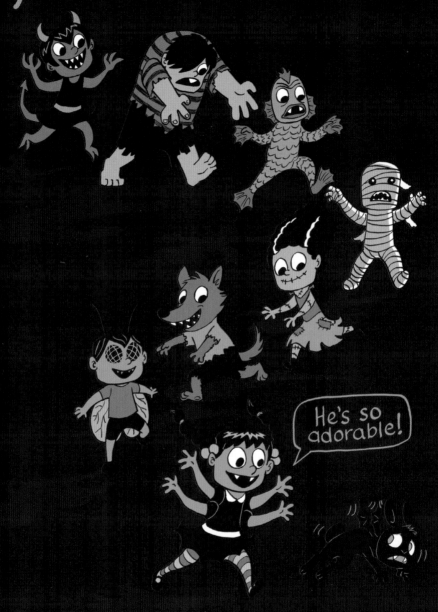

P-Wee 51

WWII FIGHTER ACE

No. 43

WORLD'S LARGEST SELLING WWII COMIC MAGAZINE!

EPISODE 3: P-Wee and the Lil Fighters

PICTURES AND STORY BY MIKE GABRIEL

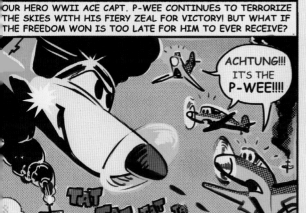

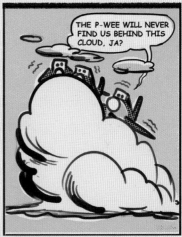

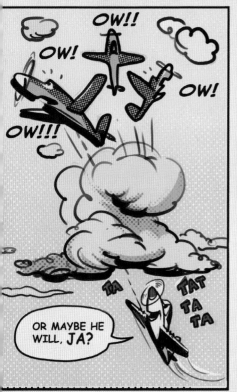

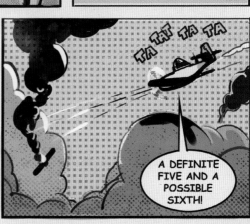

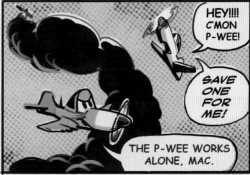

107

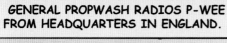
GENERAL PROPWASH RADIOS P-WEE FROM HEADQUARTERS IN ENGLAND.

COME IN, CAPT. P-WEE...GENERAL PROPWASH HERE...I WANT YOU TO REPORT DIRECTLY TO MY OFFICE IF---ER--I MEAN *WHEN* YOU MAKE IT BACK TO BASE!

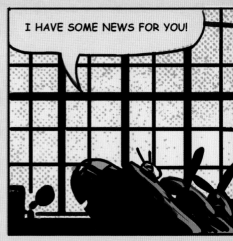
I HAVE SOME NEWS FOR YOU!

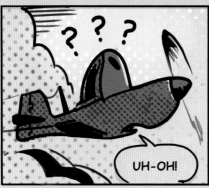
UH-OH!

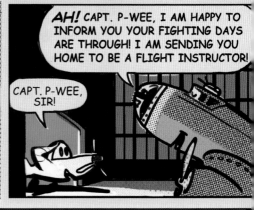
THIS CAN'T BE GOOD.

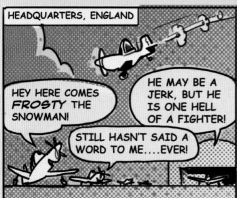
HEADQUARTERS, ENGLAND

HEY HERE COMES *FROSTY* THE SNOWMAN!

HE MAY BE A JERK, BUT HE IS ONE HELL OF A FIGHTER!

STILL HASN'T SAID A WORD TO ME....EVER!

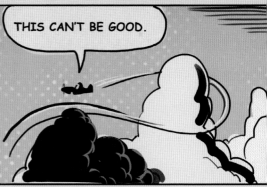
AH! CAPT. P-WEE, I AM HAPPY TO INFORM YOU YOUR FIGHTING DAYS ARE THROUGH! I AM SENDING YOU HOME TO BE A FLIGHT INSTRUCTOR!

CAPT. P-WEE, SIR!

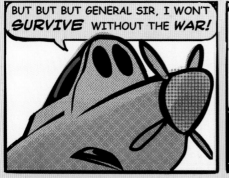
BUT BUT BUT GENERAL SIR, I WON'T *SURVIVE* WITHOUT THE *WAR!*

THAT'S THE PROBLEM! YOU HAVE GOT THINGS BACKWARDS! YOU'RE *LOSING TOUCH* WITH YOUR HUMANITY! NOBODY CAN STAND TO BE AROUND YOU! YOUR LIFE WILL BE LONELY AS HELL, WITH NOBODY BUT THE GHOSTS OF WAR TO KEEP YOU COMPANY. WHAT DO YOU SAY, CAPT. P-WEE? YOU HAVE DONE YOUR PART IN BATTLE, NOW WILL YOU GO DO YOUR PART ON THE HOME FRONT AND INSTRUCT *THE NEW RECRUITS?*

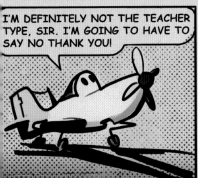

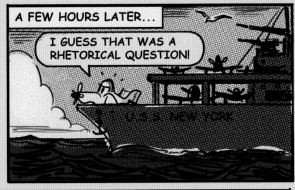

P-WEE REPORTS FOR DUTY BACK HOME IN THE GOOD OL USA BUT IS STILL UNHAPPY...

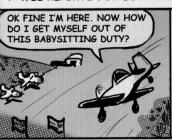

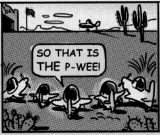

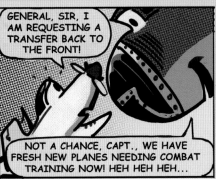

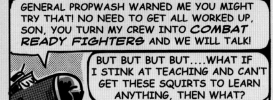

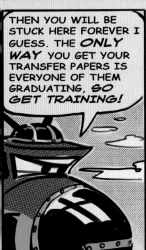

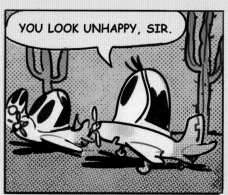

YOU LOOK UNHAPPY, SIR.

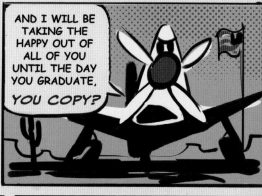

AND I WILL BE TAKING THE HAPPY OUT OF ALL OF YOU UNTIL THE DAY YOU GRADUATE, *YOU COPY?*

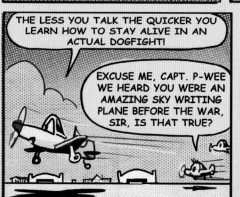

THE LESS YOU TALK THE QUICKER YOU LEARN HOW TO STAY ALIVE IN AN ACTUAL DOGFIGHT!

EXCUSE ME, CAPT. P-WEE WE HEARD YOU WERE AN AMAZING SKY WRITING PLANE BEFORE THE WAR, SIR, IS THAT TRUE?

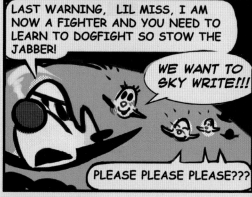

LAST WARNING, LIL MISS, I AM NOW A FIGHTER AND YOU NEED TO LEARN TO DOGFIGHT SO STOW THE JABBER!

WE WANT TO SKY WRITE!!!

PLEASE PLEASE PLEASE???

OK, THAT DOES IT...- TIME FOR LESSON ONE!

PLEASE PLEASE PLEASE PLEASE PLEASE PLEASE PLEASE PLEASE

RRRRD
R
R
R
R
RRRD

KAK KAK KAK

ZIP! ZIP! ZIP!

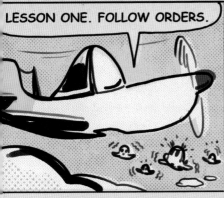

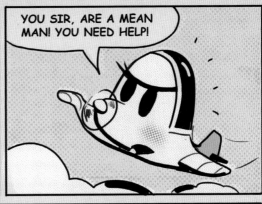

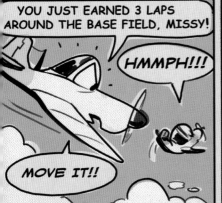

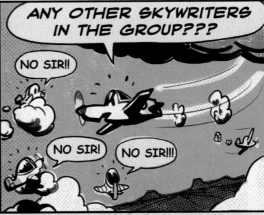

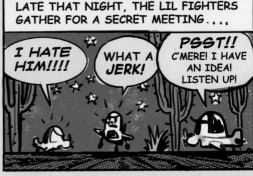

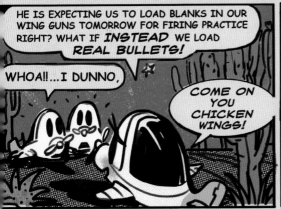

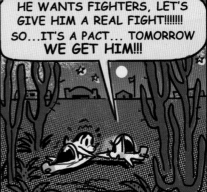

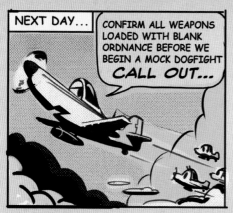

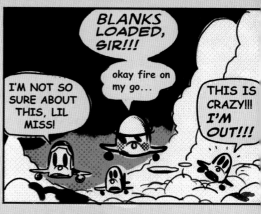

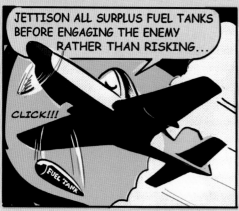

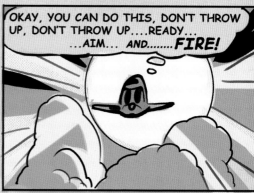

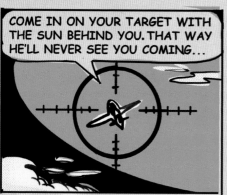

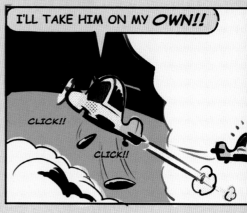

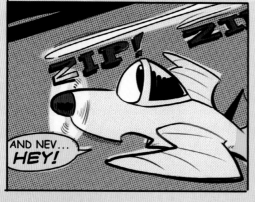

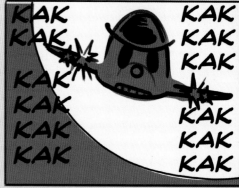

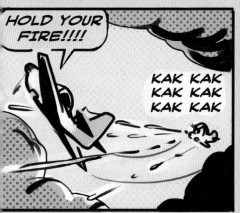

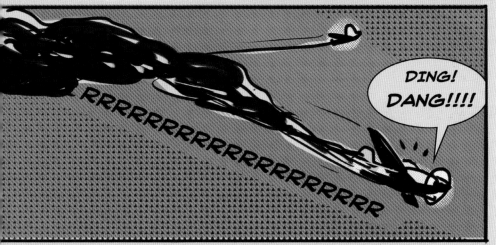

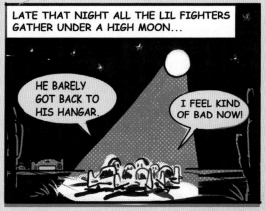

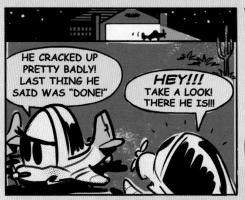

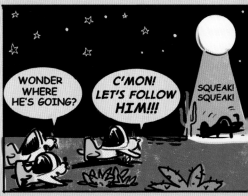

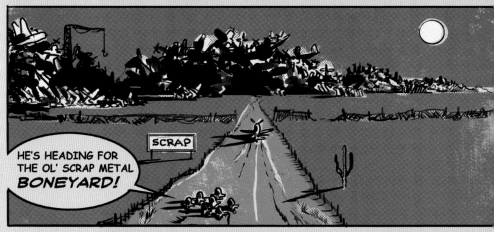

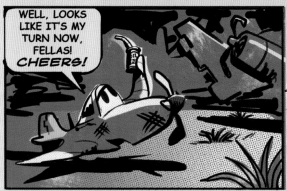

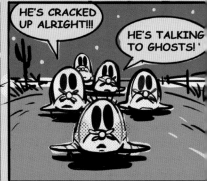

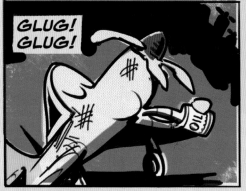

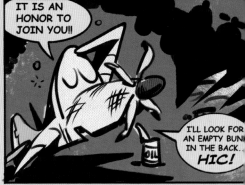

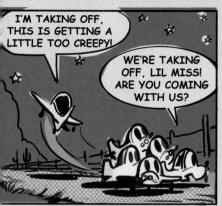
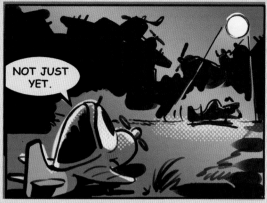
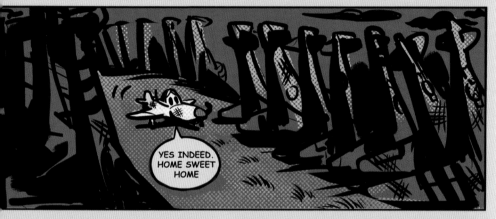
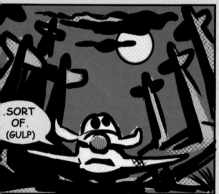
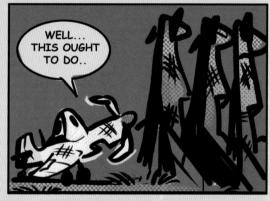
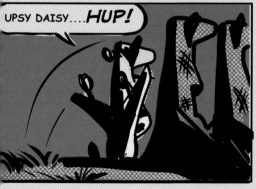
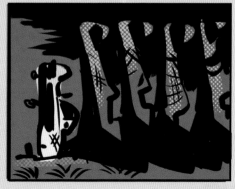

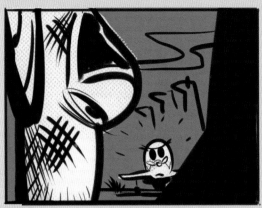

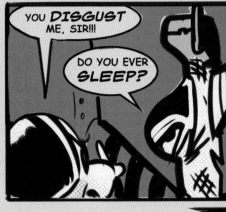

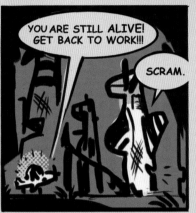

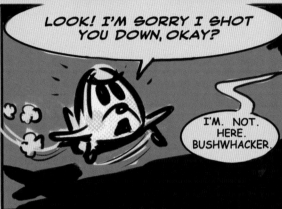

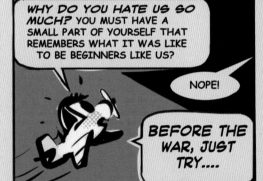

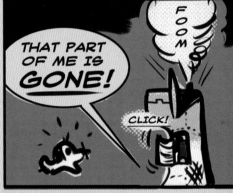

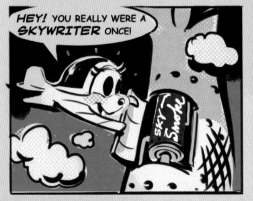

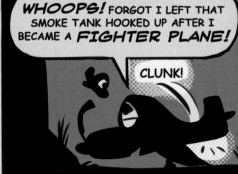

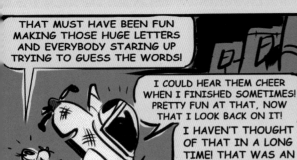

THAT MUST HAVE BEEN FUN MAKING THOSE HUGE LETTERS AND EVERYBODY STARING UP TRYING TO GUESS THE WORDS!

I COULD HEAR THEM CHEER WHEN I FINISHED SOMETIMES! PRETTY FUN AT THAT, NOW THAT I LOOK BACK ON IT!

I HAVEN'T THOUGHT OF THAT IN A LONG TIME! THAT WAS AN INNOCENT TIME FOR ME, JUST A KID.... LIKE YOU ALL.

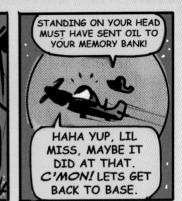

STANDING ON YOUR HEAD MUST HAVE SENT OIL TO YOUR MEMORY BANK!

HAHA YUP, LIL MISS, MAYBE IT DID AT THAT. *C'MON!* LETS GET BACK TO BASE.

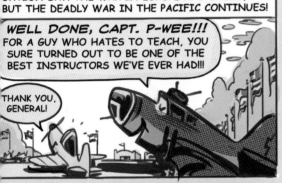

MONTHS LATER, IT'S OUR LIL FIGHTERS BIG GRAD-UATION DAY! THE WAR IN EUROPE HAS ENDED, BUT THE DEADLY WAR IN THE PACIFIC CONTINUES!

WELL DONE, CAPT. P-WEE!!! FOR A GUY WHO HATES TO TEACH, YOU SURE TURNED OUT TO BE ONE OF THE BEST INSTRUCTORS WE'VE EVER HAD!!!

THANK YOU, GENERAL!

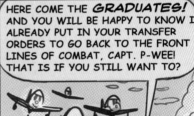

HERE COME THE *GRADUATES!* AND YOU WILL BE HAPPY TO KNOW I ALREADY PUT IN YOUR TRANSFER ORDERS TO GO BACK TO THE FRONT LINES OF COMBAT, CAPT. P-WEE! THAT IS IF YOU STILL WANT TO?

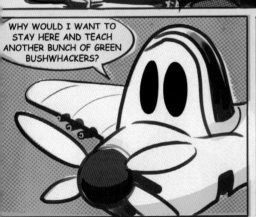

WHY WOULD I WANT TO STAY HERE AND TEACH ANOTHER BUNCH OF GREEN BUSHWHACKERS?

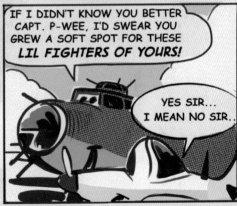

IF I DIDN'T KNOW YOU BETTER CAPT. P-WEE, I'D SWEAR YOU GREW A SOFT SPOT FOR THESE *LIL FIGHTERS OF YOURS!*

YES SIR... I MEAN NO SIR...

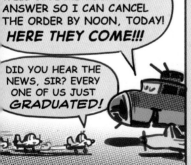

WELL GIVE ME YOUR FINAL ANSWER SO I CAN CANCEL THE ORDER BY NOON, TODAY! *HERE THEY COME!!!*

DID YOU HEAR THE NEWS, SIR? EVERY ONE OF US JUST *GRADUATED!*

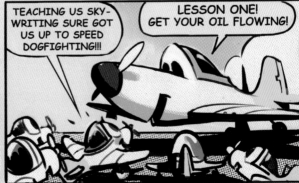

TEACHING US SKY-WRITING SURE GOT US UP TO SPEED DOGFIGHTING!!!

LESSON ONE! GET YOUR OIL FLOWING!

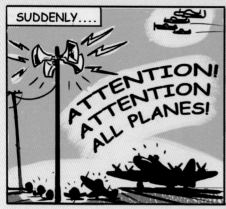

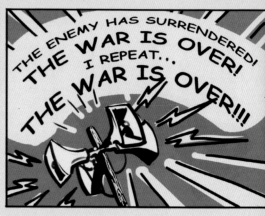

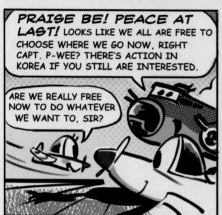

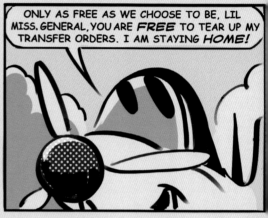

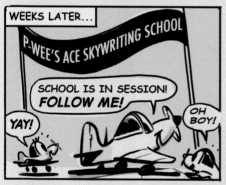

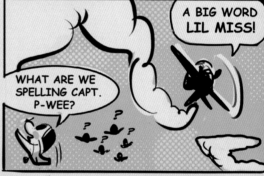

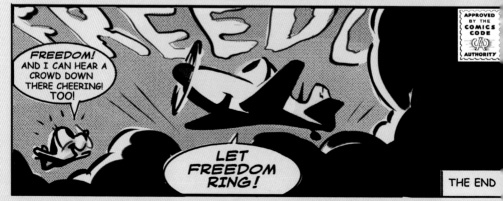

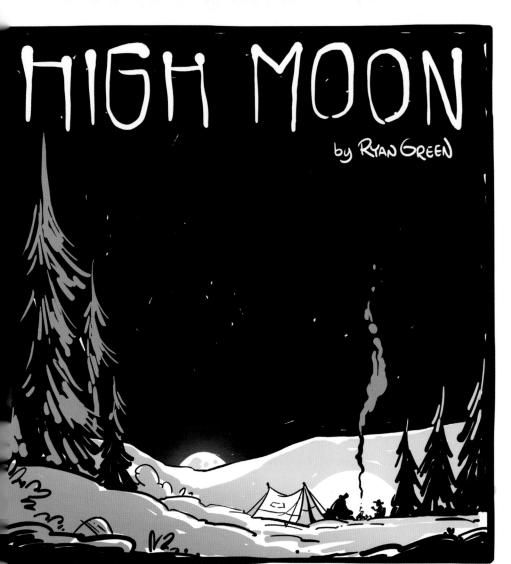

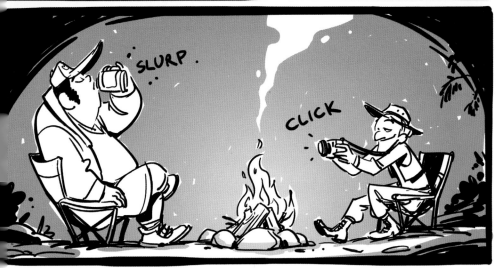

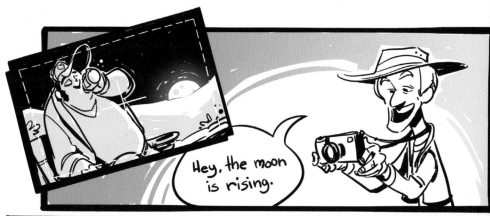

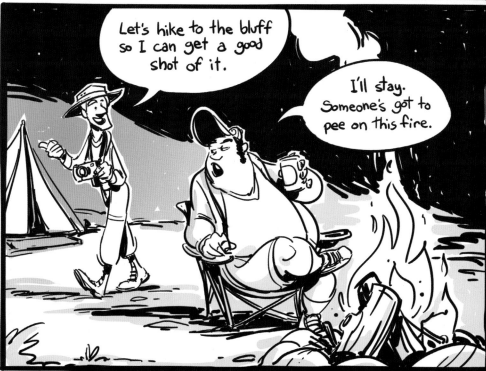

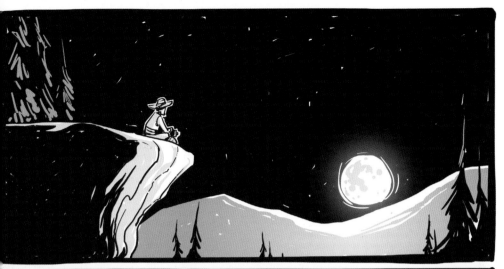

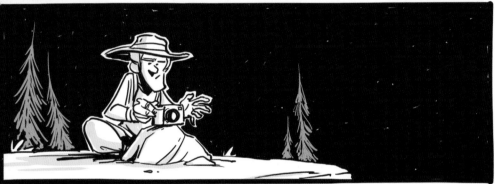

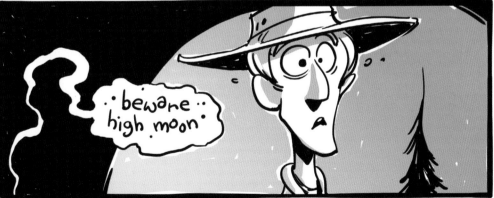

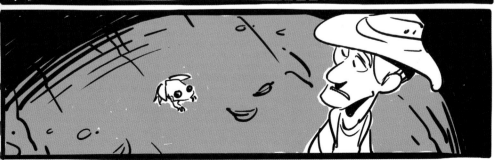

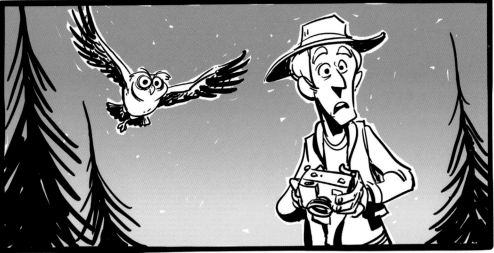
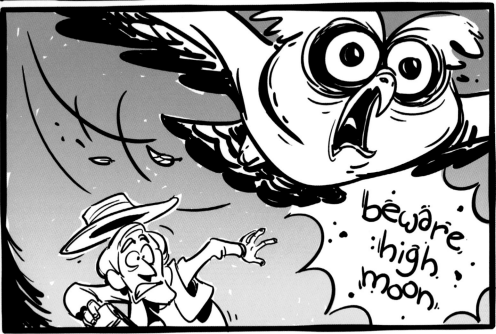

beware high moon

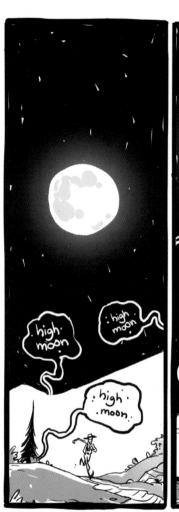
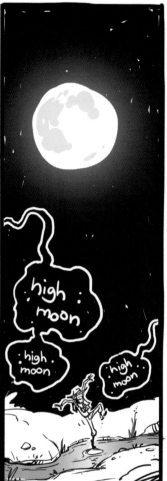
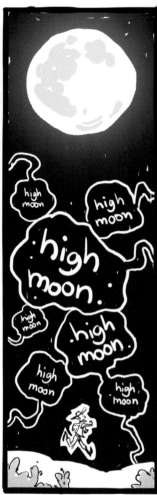
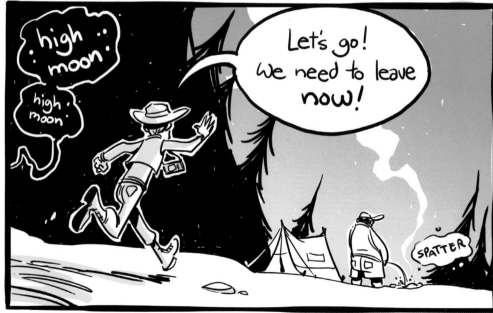

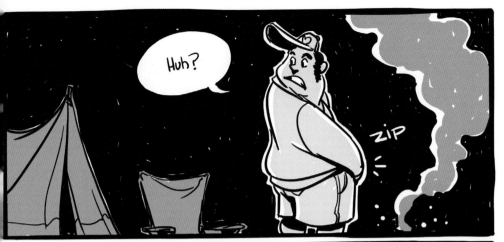

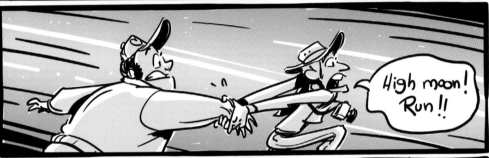

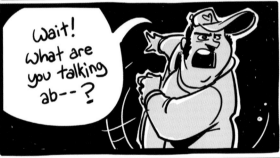

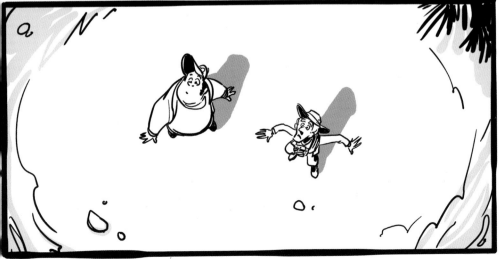

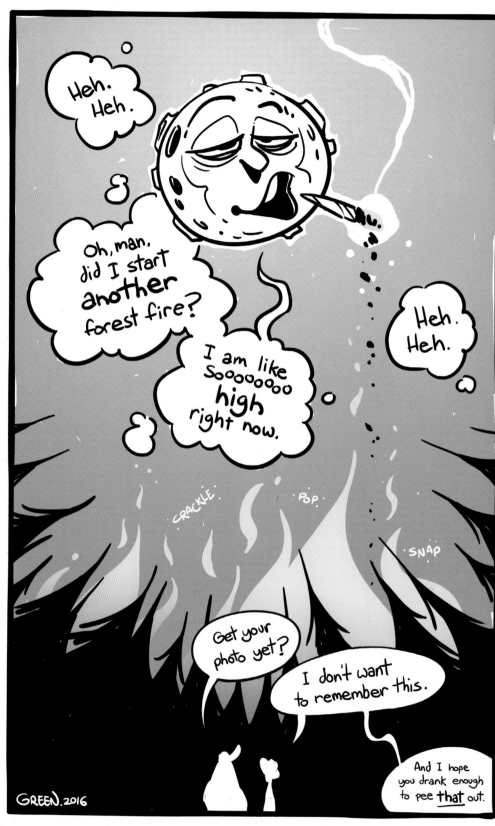

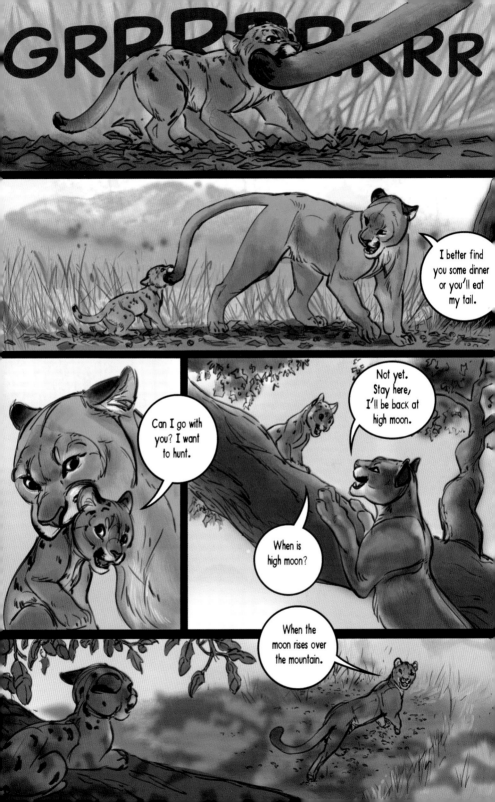

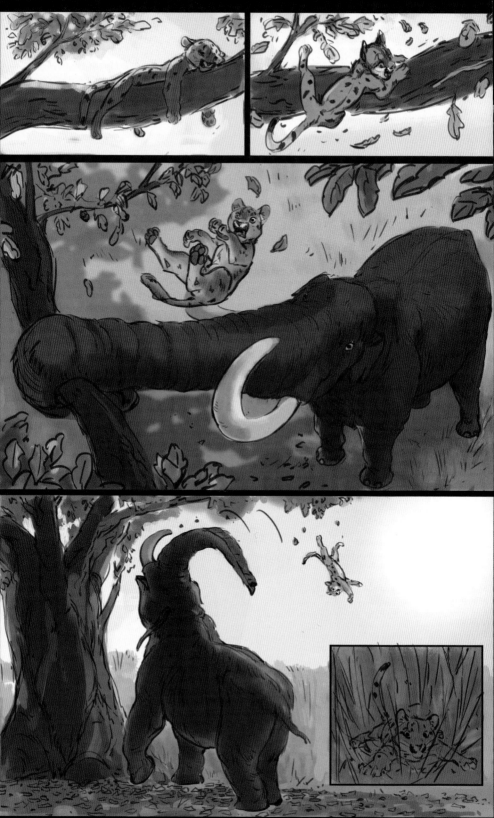

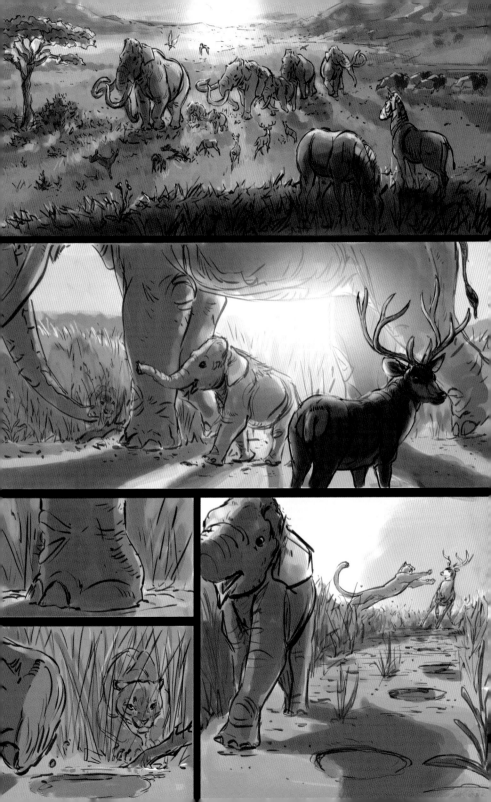

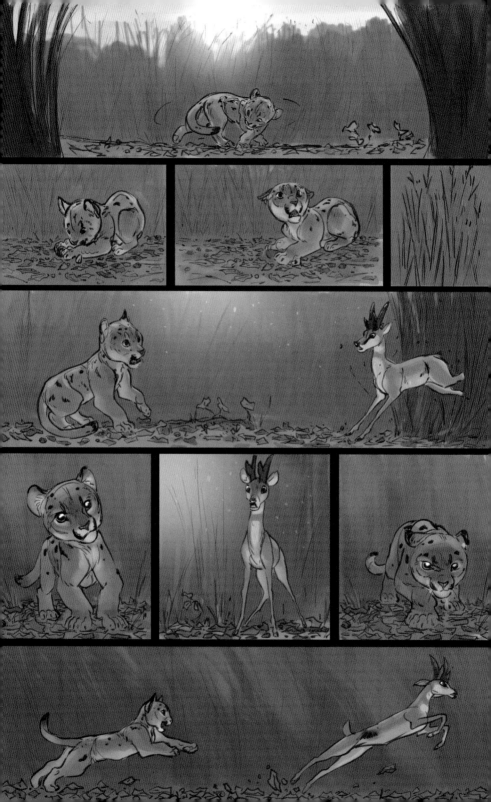

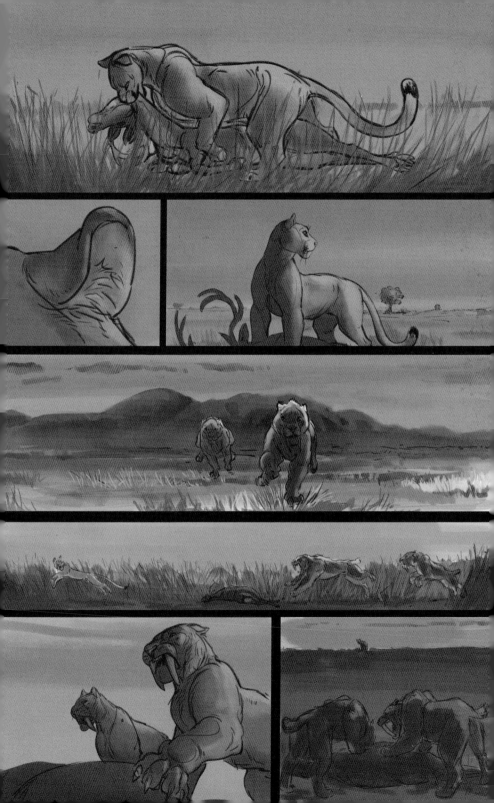

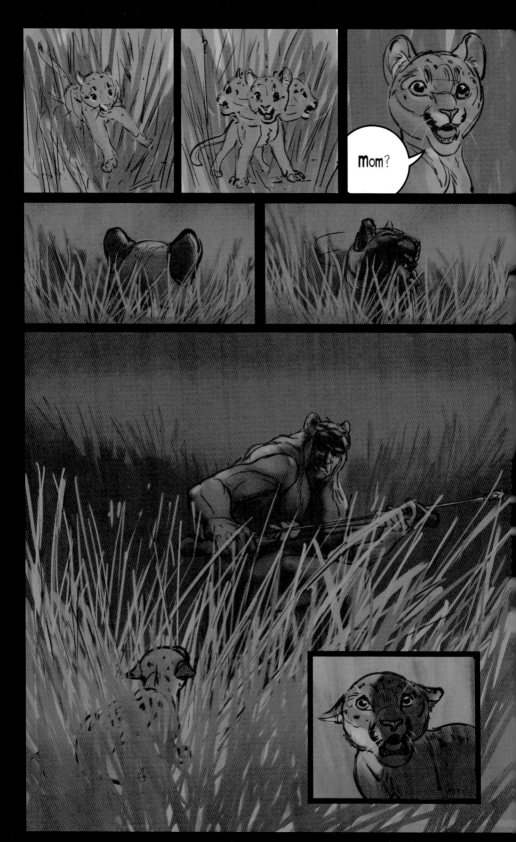

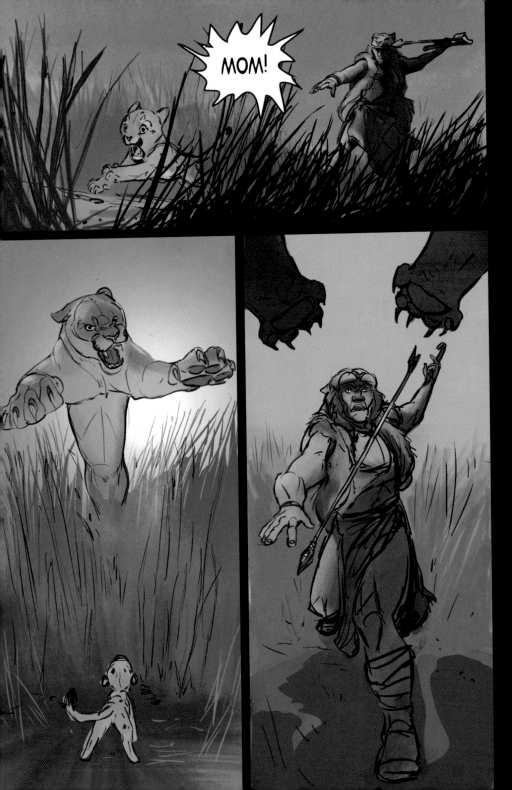

WHEN THE
MOON RISES OVER THE
MOUNTAIN

By David G. Derrick Jr.

WHEN is HIGH MOON?

drawings and verse by John Musker

Handmaid jounced with soup of split pea
In her gimcrack lilac jitney...

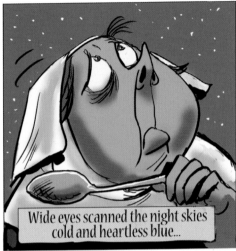

Wide eyes scanned the night skies
cold and heartless blue...

Wheeling 'round the barebleak gnarltrees
Carriage drawn by spellbound houndbees
Banshee barking mixed with buzzing
as they flew!

zZZOWRRR

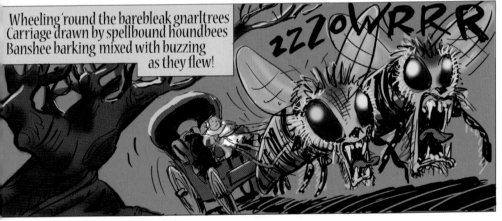

Lady Damson dozed in dyed fur
With her zither flung beside her
Which she brought across the storm-tossed
Zuider Zee...

Handmaid's face grew more distressed!
For deep within her burgeoning breast

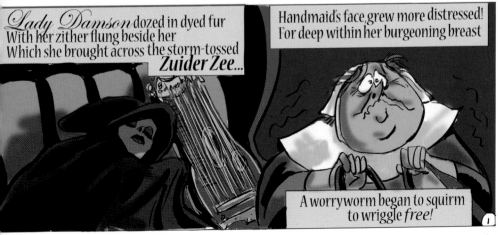

A worryworm began to squirm
to wriggle *free!*

1

135

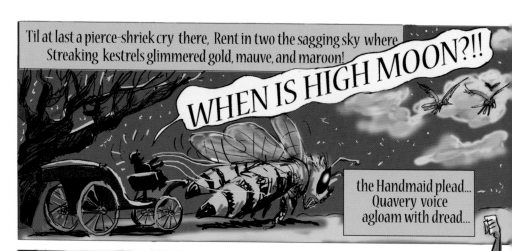

Til at last a pierce-shriek cry there, Rent in two the sagging sky where
Streaking kestrels glimmered gold, mauve, and maroon!

WHEN IS HIGH MOON?!!

the Handmaid plead...
Quavery voice
agloam with dread...

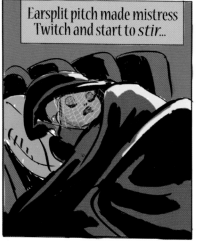

Earsplit pitch made mistress
Twitch and start to *stir*...

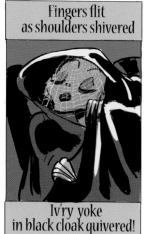

Fingers flit
as shoulders shivered

Iv'ry yoke
in black cloak quivered!

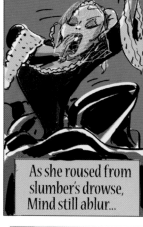

As she roused from
slumber's drowse,
Mind still ablur...

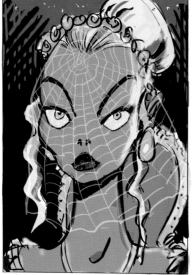

Spider=spun, the lace veil hung
About fair face, unlined and young

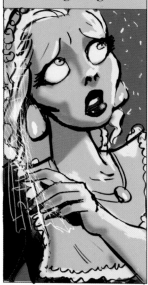

Full it flushed with floods
of roiling rising fear!

Spying moon's e'er swift
ascent
As it climbed stairclouds,
never spent

Striding high
to lonely throne
that hung quite near

2

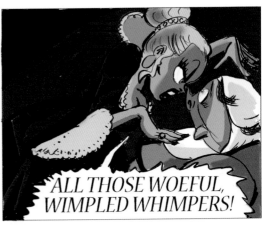

So too rose this slim grim lady
Discarding veil, yet face still shady
Turned her gaze at gap-toothed
jitt'ry, dumbstruck maid:

ALL YOUR SICK'NING DIMPLED SIMPERS!

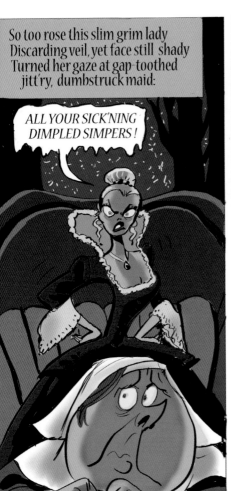

ALL THOSE WOEFUL, WIMPLED WHIMPERS!

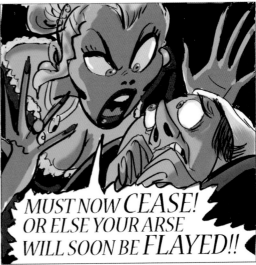

MUST NOW *CEASE!* OR ELSE YOUR ARSE WILL SOON BE *FLAYED!!*

Handmaid cowered, Mistress towered!!
Veins a'thobbing while she glowered!
Keening Queen gangrened
Spewed regal, wretched wrath!

YOU KNOW MY FATE, YOU PEWLING PRATE! I"LL HAVE YOUR HEAD. WE GET THERE LATE!

BEFORE HIGH MOON, "TIS TRUE THAT I MUST HAVE MY BATH!

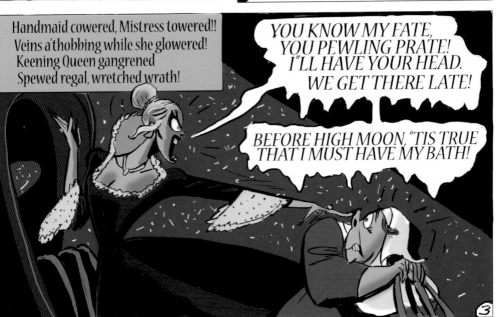

③

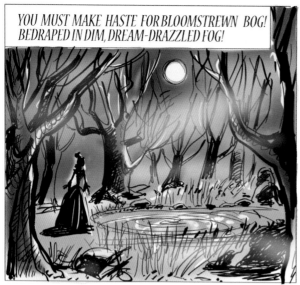

YOU MUST MAKE HASTE FOR BLOOMSTREWN BOG!
BEDRAPED IN DIM, DREAM-DRAZZLED FOG!

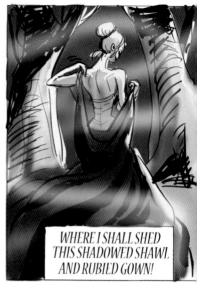

WHERE I SHALL SHED
THIS SHADOWED SHAWL
AND RUBIED GOWN!

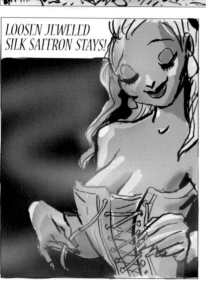

LOOSEN JEWELED
SILK SAFFRON STAYS!

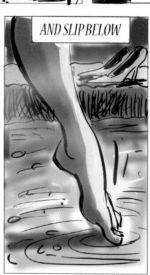

AND SLIP BELOW

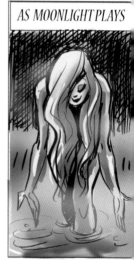

AS MOONLIGHT PLAYS

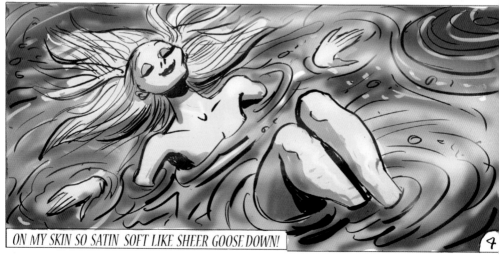

ON MY SKIN SO SATIN SOFT LIKE SHEER GOOSE DOWN!

4

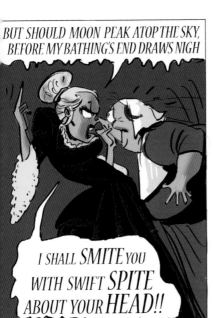

BUT SHOULD MOON PEAK ATOP THE SKY, BEFORE MY BATHING'S END DRAWS NIGH

I SHALL *SMITE* YOU WITH SWIFT *SPITE* ABOUT YOUR *HEAD!!*

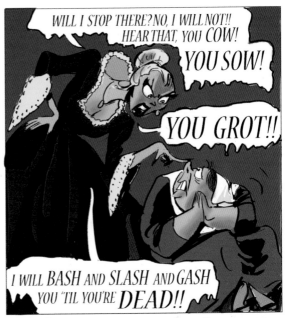

WILL I STOP THERE? NO, I WILL NOT!! HEAR THAT, YOU *COW!*

YOU SOW!

YOU GROT!!

I WILL *BASH* AND *SLASH* AND *GASH* YOU 'TIL YOU'RE *DEAD!!*

Shaken Maid shook restless steeds! Milady yelled:

HOUNDBEES NEED SPEED!!

Cracked her whip, and made them LEAP and fly like fire!!

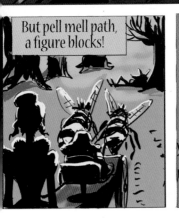

But pell mell path, a figure blocks!

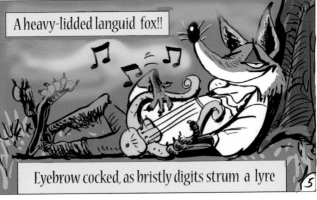

A heavy-lidded languid fox!!

Eyebrow cocked, as bristly digits strum a lyre

5

139

Such beauty strewn before me...

Demands a sketch,

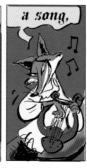

a song,

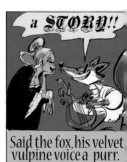

a STORY!!

Said the fox, his velvet vulpine voice a purr.

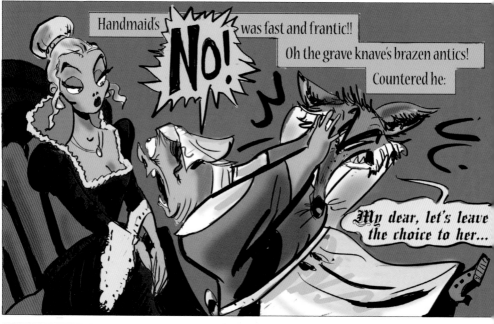

Handmaid's was fast and frantic!!

NO!

Oh the grave knave's brazen antics!

Countered he:

My dear, let's leave the choice to her...

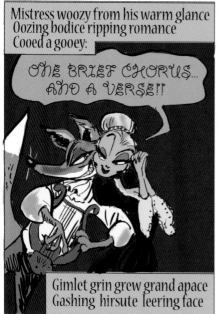

Mistress woozy from his warm glance
Oozing bodice ripping romance
Cooed a gooey:

ONE BRIEF CHORUS...
AND A VERSE!!

Gimlet grin grew grand apace
Gashing hirsute leering face

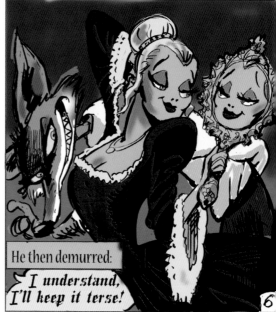

He then demurred:

I understand,
I'll keep it terse!

6

But his tempo was andante
And the song was penny ante

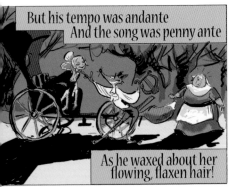

As he waxed about her
flowing, flaxen hair!

He twirled it 'round his finger
While her maid implored the singer

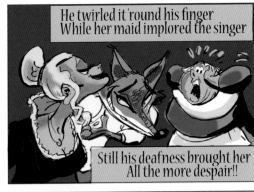

Still his deafness brought her
All the more despair!!

'Til she finally cracked her whip

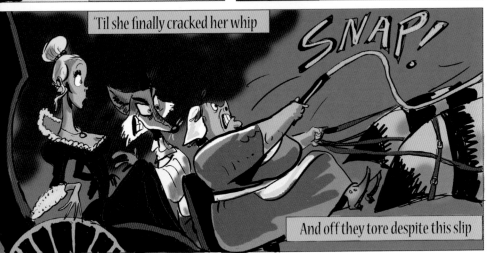

SNAP!

And off they tore despite this slip

As pale moon swiftly sought
the apex of its trek...

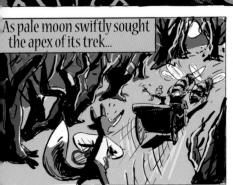

Lady stewed: WOMAN! YOU ARE RUDE!!
YOU ARE A PROLE, AND YOU'RE A PRUDE!!

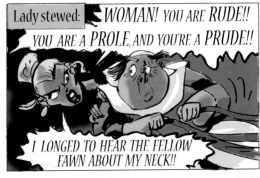

I LONGED TO HEAR THE FELLOW
FAWN ABOUT MY NECK!!

But as the carriage neared feared fen
Mad'ning distraction reared again!

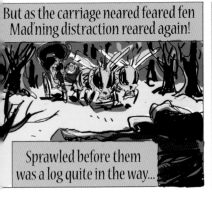

Sprawled before them
was a log quite in the way...

And on that log there lounged a lizard...
(Tealish tongue was sharply scissored)

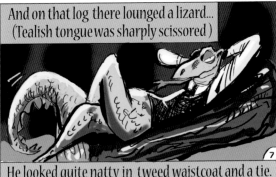

He looked quite natty in tweed waistcoat and a tie.

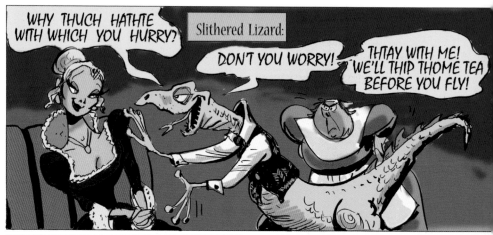

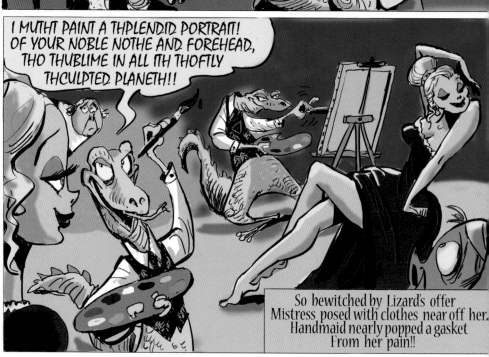

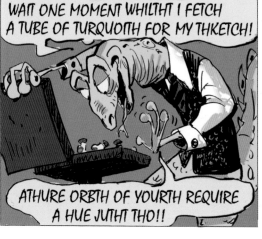

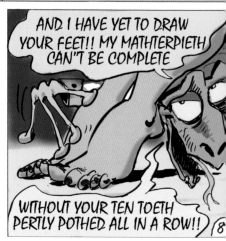

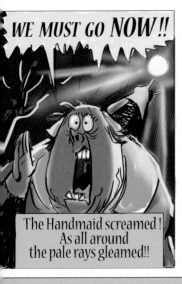

WE MUST GO NOW!!

The Handmaid screamed!
As all around
the pale rays gleamed!!

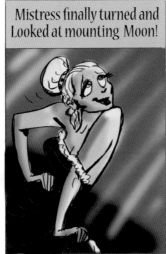

Mistress finally turned and
Looked at mounting Moon!

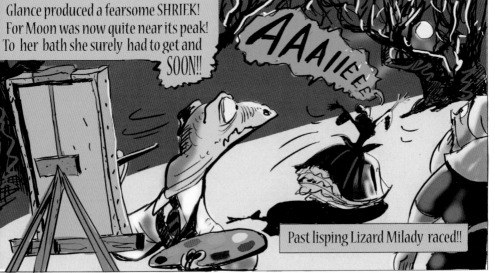

Glance produced a fearsome SHRIEK!
For Moon was now quite near its peak!
To her bath she surely had to get and
SOON!!

AAAIIEEE!

Past lisping Lizard Milady raced!!

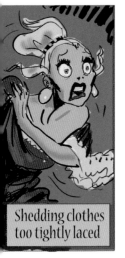

Shedding clothes
too tightly laced

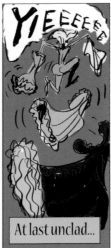

YIEEEEE!

At last unclad...

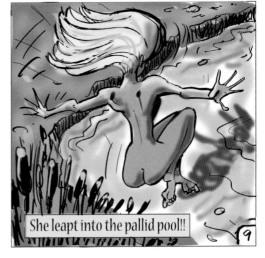

She leapt into the pallid pool!!

143

But alas, alack and fie!
The Moon already was sky-high...

When milady sank beneath those ripples
oh so cruel...

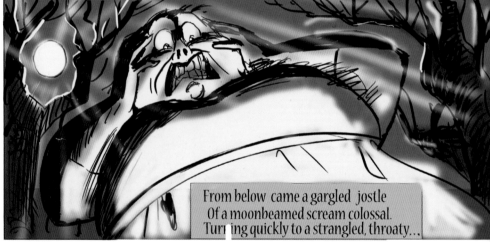

From below came a gargled jostle
Of a moonbeamed scream colossal.
Turning quickly to a strangled, throaty...

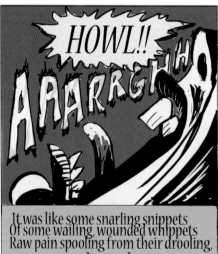

HOWL!!
AAARRGH!!O

It was like some snarling snippets
Of some wailing, wounded whippets
Raw pain spooling from their drooling,
spewling jowls.

Lady grasped, at crumbling bank's edge
fumbling fingers sought the dank ledge

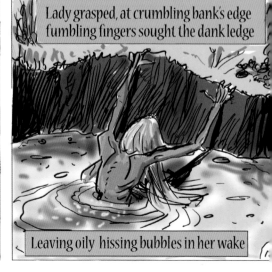

Leaving oily hissing bubbles in her wake

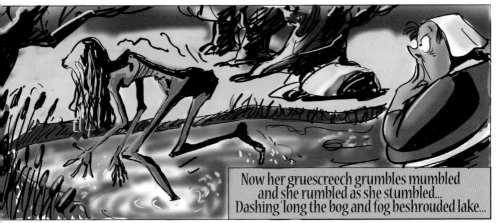

Now her gruescreech grumbles mumbled
and she rumbled as she stumbled...
Dashing 'long the bog and fog beshrouded lake...

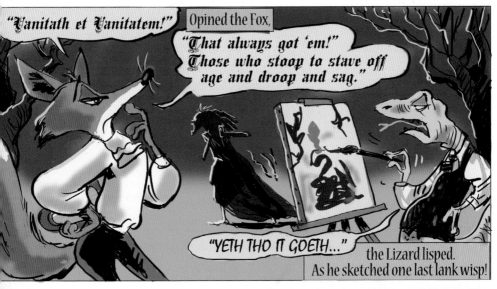

"Vanitath et Vanitatem!" Opined the Fox,

"That always got 'em!"
Those who stoop to stave off
age and droop and sag."

"YETH THO IT GOETH..." the Lizard lisped.
As he sketched one last lank wisp!

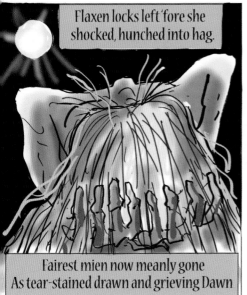

Flaxen locks left 'fore she
shocked, hunched into hag.

Fairest mien now meanly gone
As tear-stained drawn and grieving Dawn

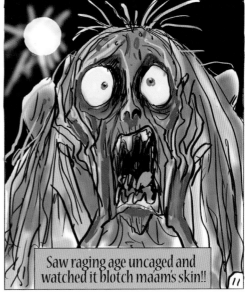

Saw raging age uncaged and
watched it blotch maam's skin!!

The beauty Fox and Lizard *flattered*...
Turned back to bones so thin,

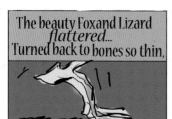

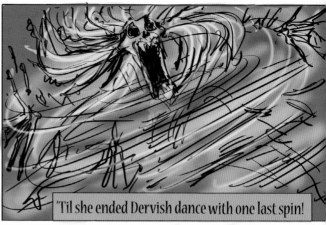

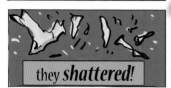

they **shattered!**

'Til she ended Dervish dance with one last spin!

Today they say only one knows
The night's events, so legend goes,

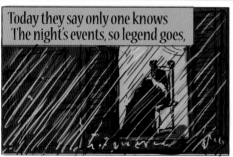

Red hair turned by those dark deeds
to wintry white.

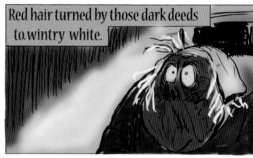

Now when folks pass
that brackened fen

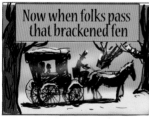

As **High Moon** rises and pale rays glow brittle bright!!

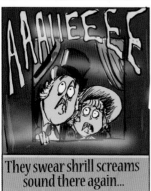

They swear shrill screams
sound there again...

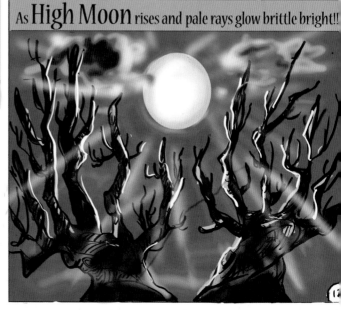

The Cycle

by DONNA LEE

Tell me, do you know the tale of the Red Moon? No? Well, listen closely and and remember well. This will help you go about the night, but will also bring you great fear...

This has been a story told through many generations. So when you survive the night when the moon is at its highest you must continue to share this tale.

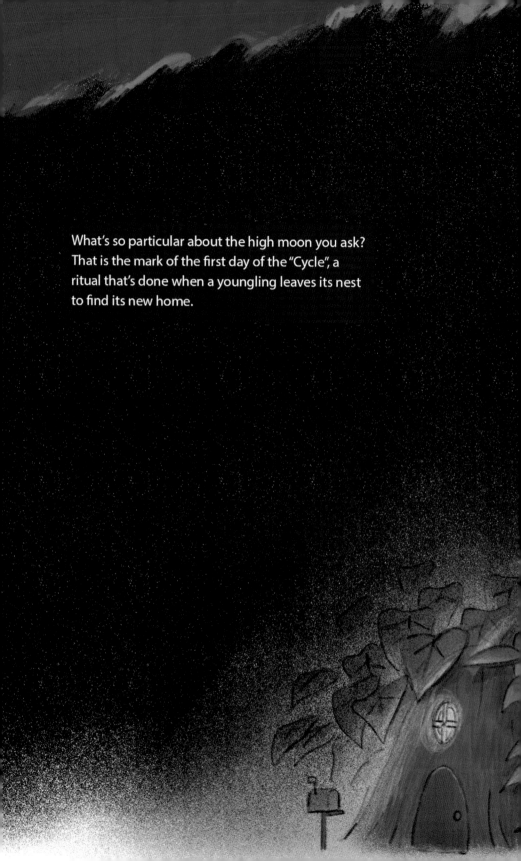

What's so particular about the high moon you ask?
That is the mark of the first day of the "Cycle", a
ritual that's done when a youngling leaves its nest
to find its new home.

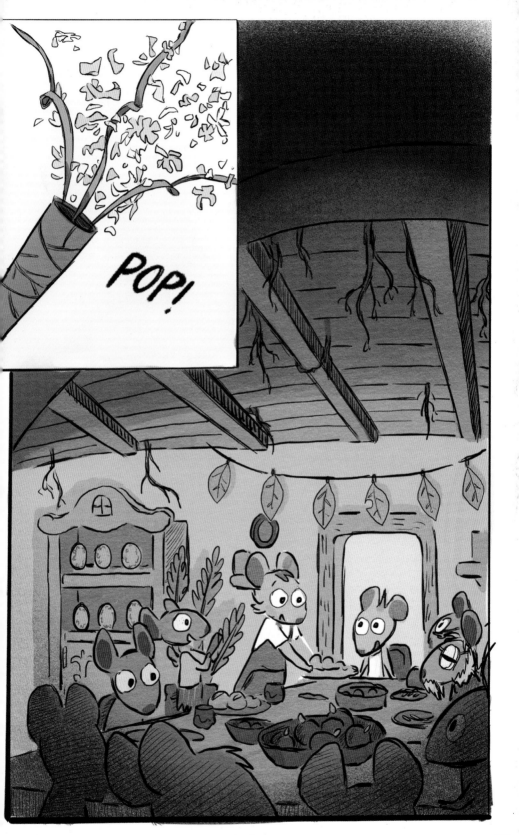

POP!

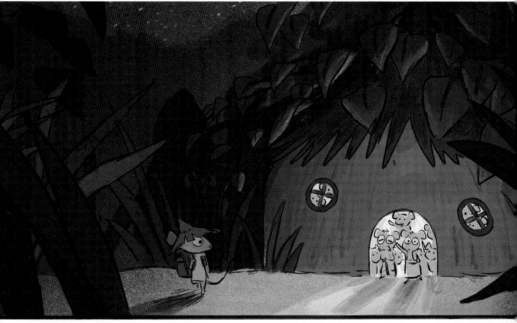

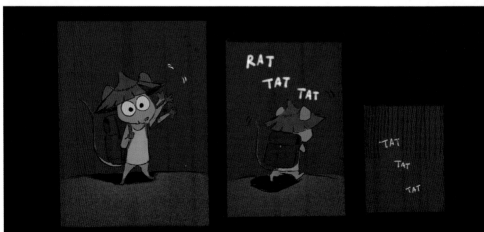

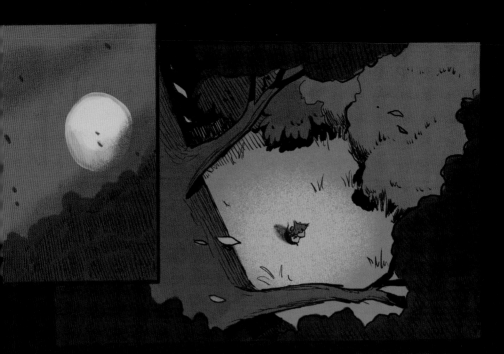

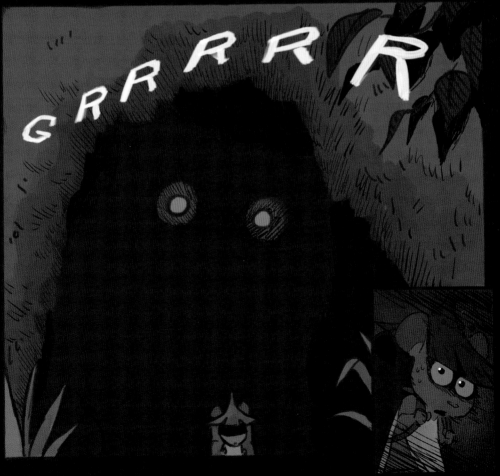

GRRRRR

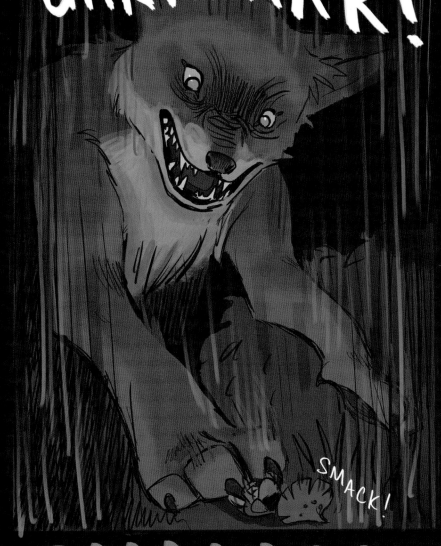

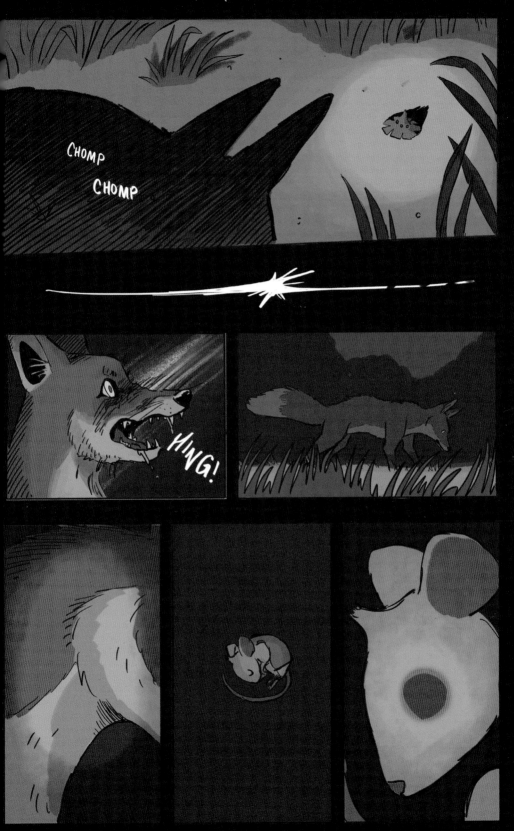

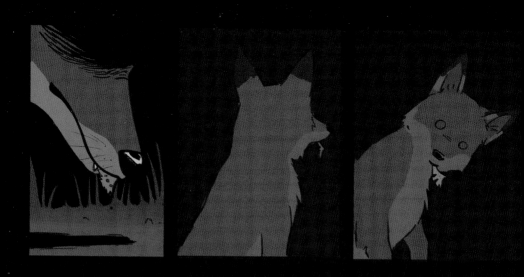

If you're not careful, it'll consume your soul until there's nothing left of it and make you its new home...

SHELLEY LONG REINS

A TRUE STORY

I WAS 15 YEARS OLD WHEN I DECIDED TO MAIL SHELLEY LONG A PUMPKIN.

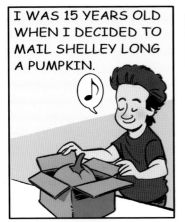

LET ME BACK UP—

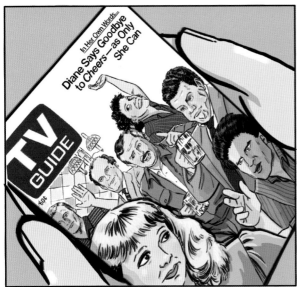

rough draft

Dearest Shelley Long,

I can't belive you are finally reading this letter for which I had wanted to write since early March.

When I first heard the rumor of you leaving Cheers, I couldn't belive it. After all, I heard it from a kid who rides my bus. Any way, I didn't belive it was true. Then my dad brought home a newspaper article that said you were going to quit Cheers to be with your family and to make more movies. I was totally crushed and was desperatly waiting for the season finally of Cheers to see if Diane and Sam would "tie the knot". I guess I was a little disappointed when Diane left without a big send off. After all it is very hard to see someone leave who you have admirred & loved for a very long time, and when she didn't get a big farewell party, I was kind of upset.

I really can't see Cheers without you next fall Shelley. I mean, the whole show was Diane and Sam and all the troubles they had with their relation-ship. Now I read in the paper that Sam is going to sell Cheers to women. I'm sorry but that idea stinks! Cheers is Sam's, and if he get involved with the new lady (who could never in a million years take your place), I'll just die.
DIANE CHAMBERS IS #1!

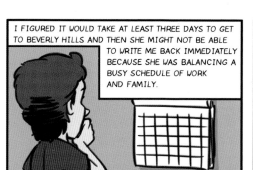

I FIGURED IT WOULD TAKE AT LEAST THREE DAYS TO GET TO BEVERLY HILLS AND THEN SHE MIGHT NOT BE ABLE TO WRITE ME BACK IMMEDIATELY BECAUSE SHE WAS BALANCING A BUSY SCHEDULE OF WORK AND FAMILY.

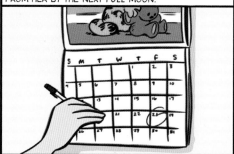

BUT TWO WEEKS WOULD SURELY BE ENOUGH TIME TO GET A RESPONSE. I WOULD CERTAINLY HEAR BACK FROM HER BY THE NEXT FULL MOON.

...*"HIGH MOON."*

In the meantime ...

I WOULD TAPE CHEERS AND HANG ON DIANE CHAMBERS' EVERY WORD.

"THIS IS ONE OF THE MOST AMATEURISH, HACKNEYED, ODIOUS PIECES OF EFFLUVIUM EVER TO WASH DOWN A PIKE."

THEN I WOULD LOOK UP THE DEFINITION OF THE THINGS SHE SAID IN THE DICTIONARY.

"effluvium"
noun
a slight exhalation or vapor, especially one that is disagreeable or noxious.

I WOULD GO TO SCHOOL...

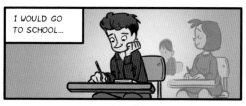

WHERE MY ENDLESS QUOTING WAS BELOVED BY ALL.

YOU'RE TOTALLY GOING TO BOMB THAT TEST!

I KNOW!

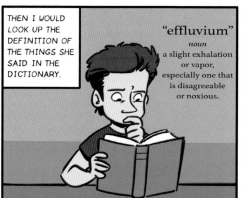

DON'T LISTEN TO HER NORMAN. DON'T EVER BE DETERED BY THE MINDLESS JIBES OF THE IGNORANT MASSES.

I WOULD HAVE A CUSTOM T-SHIRT MADE!

SO YEAH, ON THE FRONT IT SHOULD SAY, "DIANE CHAMBERS IS #1" AND ON THE BACK...

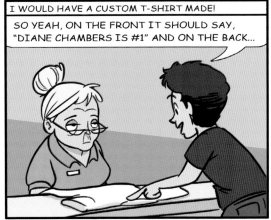

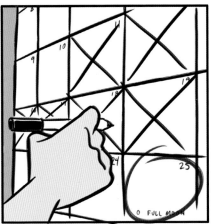

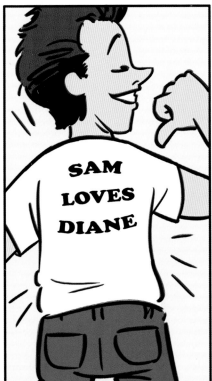

SAM LOVES DIANE

I WOULD DO HOMEWORK.

I FLY THROUGH A PUCKISH ARENA. WHERE ECHOS DANCE, WHERE ECHOS DANCE, WHERE ECHOS DANCE.

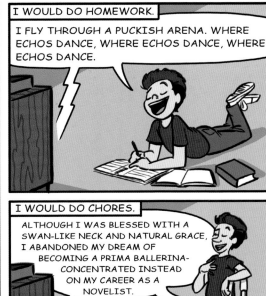

I WOULD DO CHORES.

ALTHOUGH I WAS BLESSED WITH A SWAN-LIKE NECK AND NATURAL GRACE, I ABANDONED MY DREAM OF BECOMING A PRIMA BALLERINA- CONCENTRATED INSTEAD ON MY CAREER AS A NOVELIST.

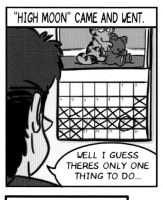

"HIGH MOON" CAME AND WENT.

WELL I GUESS THERES ONLY ONE THING TO DO...

I WOULD WRITE ANOTHER LETTER.

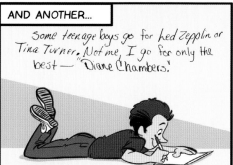

"Hello Again" this is your #1 fan Dan Abraham.

AND ANOTHER...

I am a normal person. I am not some weird·o who goes around writing letters to celebrities.

AND ANOTHER...

Some teenage boys go for Led Zepplin or Tina Turner. Not me, I go for only the best — "Diane Chambers."

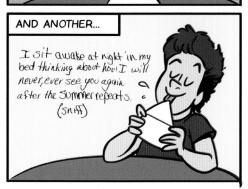

AND ANOTHER...

I sit awake at night in my bed thinking about how I will never, ever see you again after the summer repeats. (sniff)

159

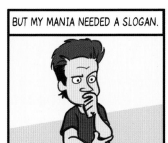
BUT MY MANIA NEEDED A SLOGAN.

AND ONCE CONCEIVED, I IMMEDIATELY CREATED A DOZEN SIGNS ON THE PRINTING PRESS WE HAD IN GRAPHIC ARTS CLASS.

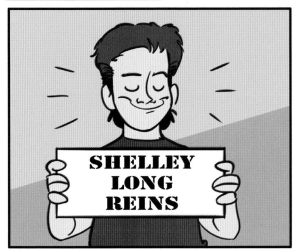

SHELLEY LONG REINS

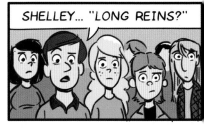

SHELLEY... "LONG REINS?"

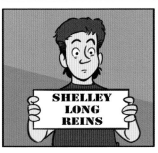

SHELLEY LONG REINS

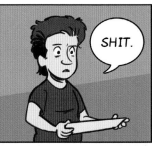

SHIT.

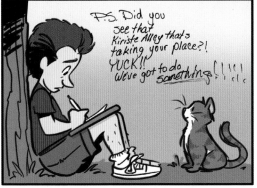

P.S. Did you see that Kiriste Alley that's taking your place?! YUCK!! We've got to do something!!!!

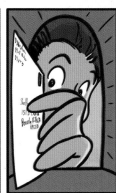

I WOULD RELENTLESSLY WATCH DIANE CHAMBERS' LAST EPISODE OF CHEERS.

BUT FROM THE PAIN, CREATED ART.

I WOULD WATCH OUR BARN CAT GIVE BIRTH TO KITTENS AND BLESS THE CUTEST ONE WITH THE NAME~

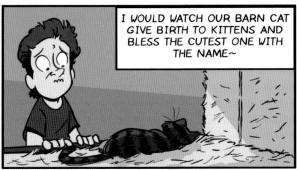

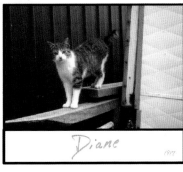

TIME PASSED AND I STILL HADN'T HEARD A PEEP FROM SHELLEY LONG. WAS SHE EVEN GETTING MY LETTERS? WITH THE ENDLESS AMOUNT OF FAN MAIL SHE MUST HAVE BEEN GETTING EVERY DAY. I NEEDED TO STAND OUT!

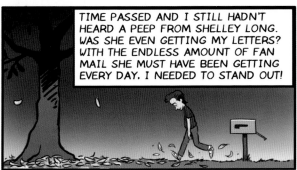

ANYONE CAN WRITE LETTERS!

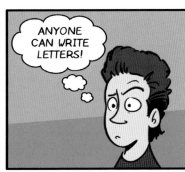

I WOULD MAKE HER A CASSETTE TAPE.

DEAREST SHELLEY LONG. DID YOU GET MY PUMPKIN?

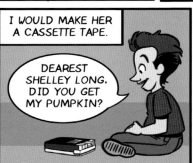

AND CONTINUE TO WRITE.

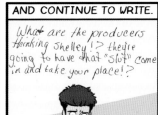

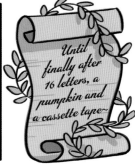

SHELLEY LONG

April 14, 1988

Dear Dan—

I am writing to you on behalf of Shelley Long. We have received all your fan mail, including the cassette tape sent at Christmastime. Shelley is very touched and grateful by your support and admiration. However, as you can imagine, she is also very busy. Maintaining a successful movie career as well as a family life can be very time consuming. Unfortunately, she is unable to personally reply to all her fan mail. Please trust me Dan that Shelley is aware of you and appreciates your respect for her as a person and actress. She extends much gratitude and warm wishes.

Sincerely,
Deborah Godert
Assistant to Ms. Shelley Long

 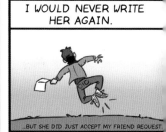

I WOULD NEVER WRITE HER AGAIN.

...BUT SHE DID JUST ACCEPT MY FRIEND REQUEST.

162

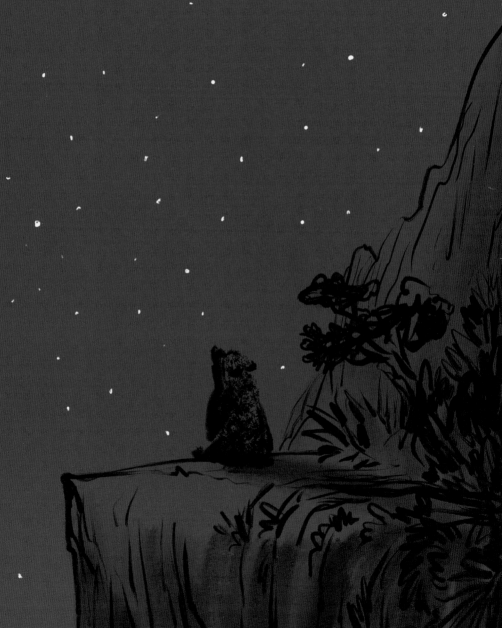

LONELY NIGHT

BY DAVID PIMENTEL

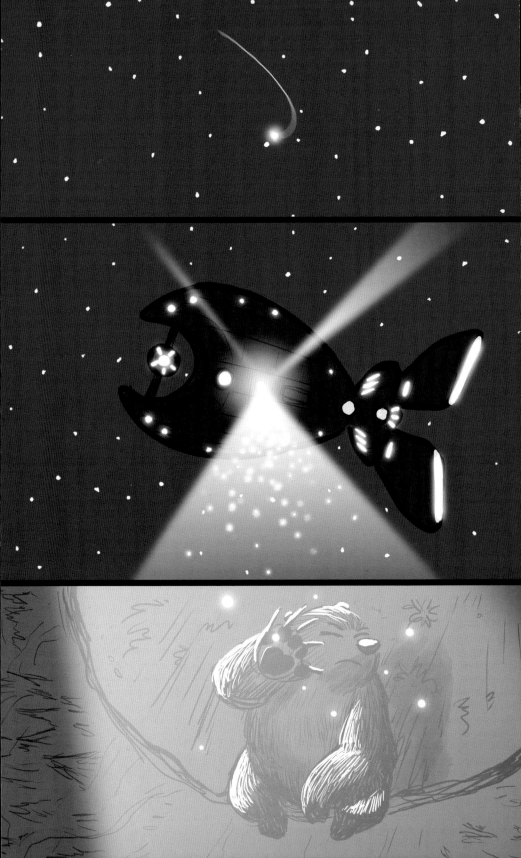

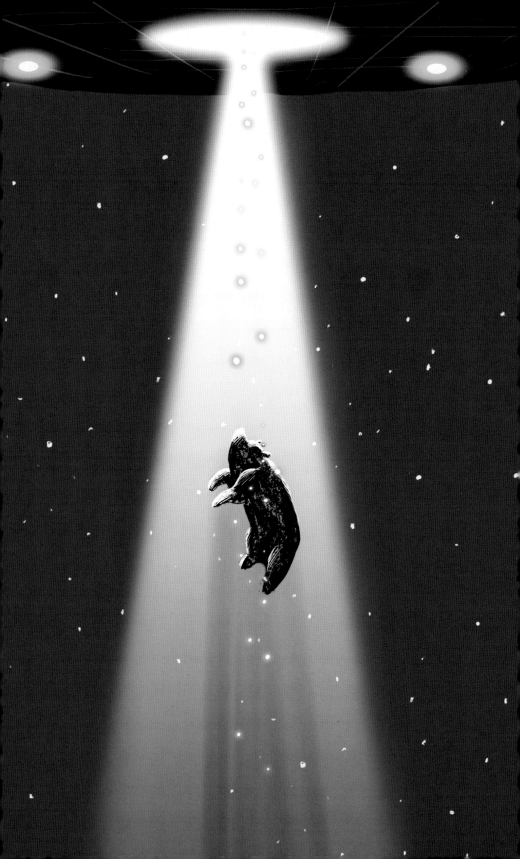

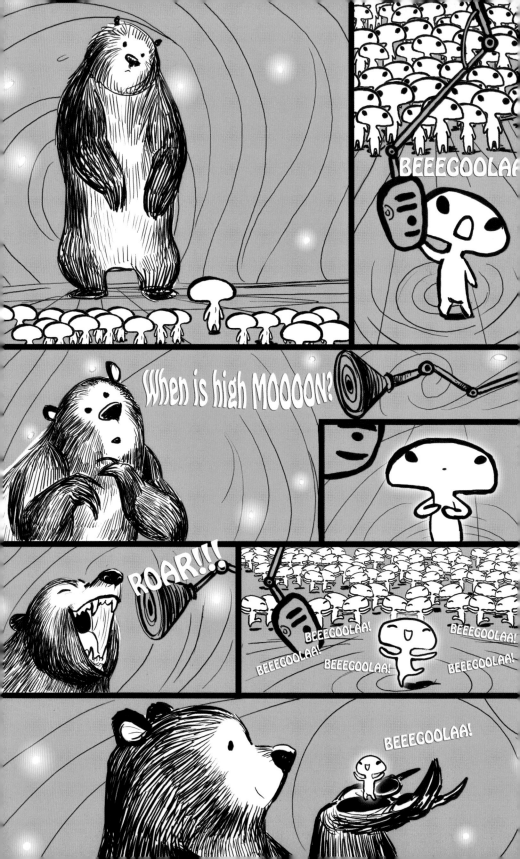

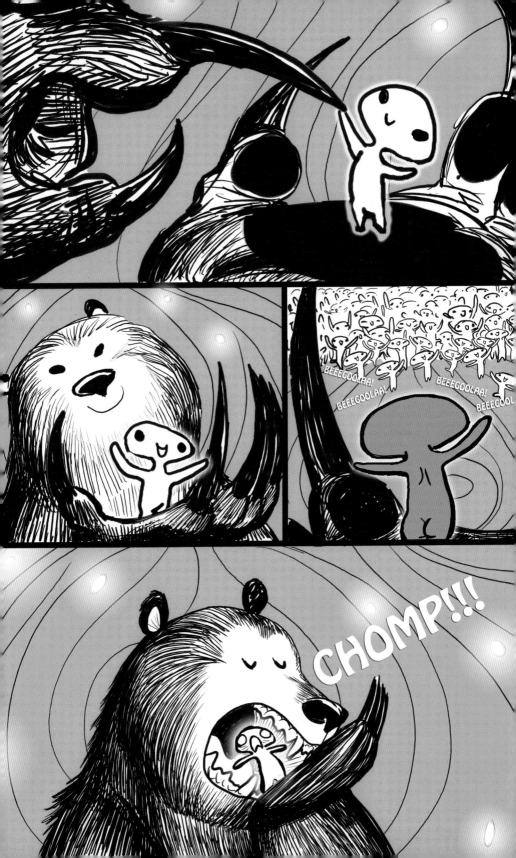

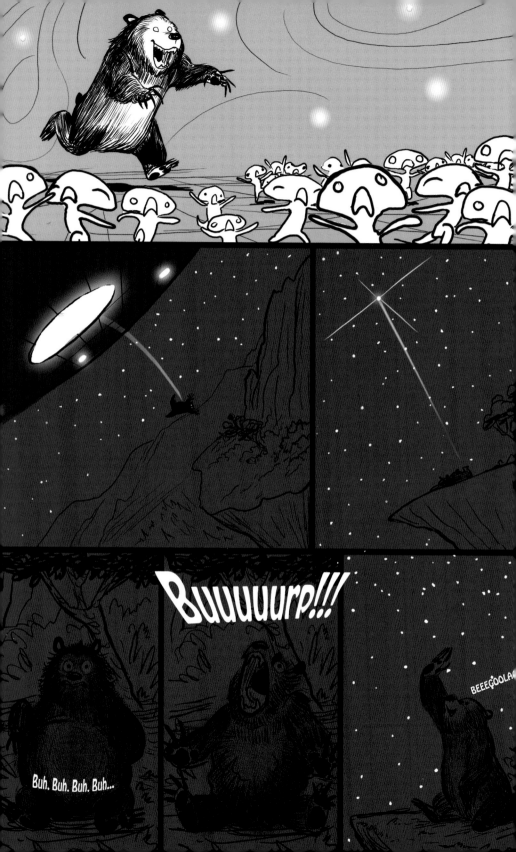

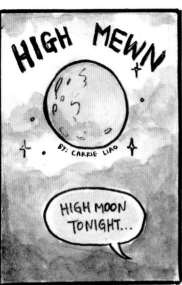

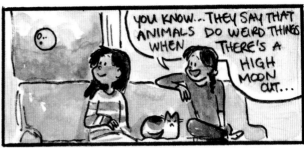

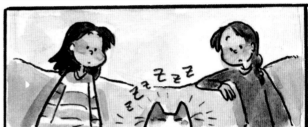

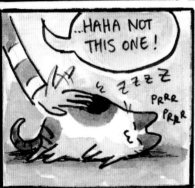

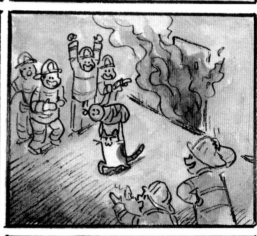

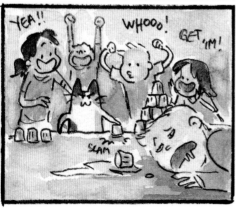

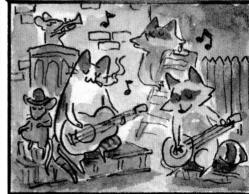

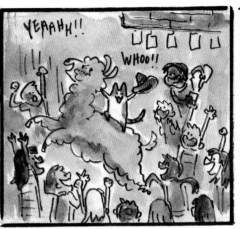

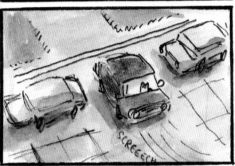

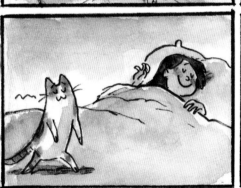

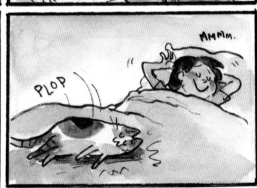

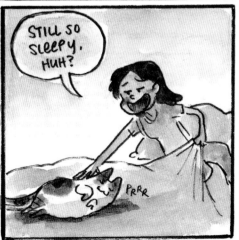

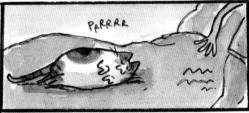

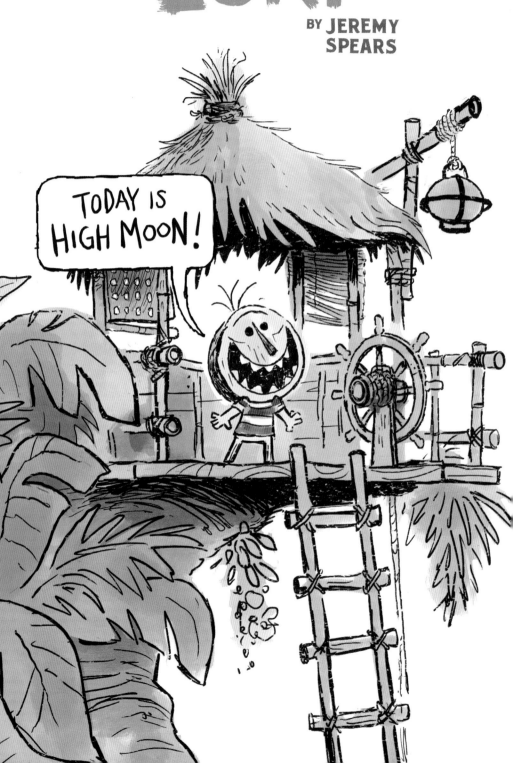

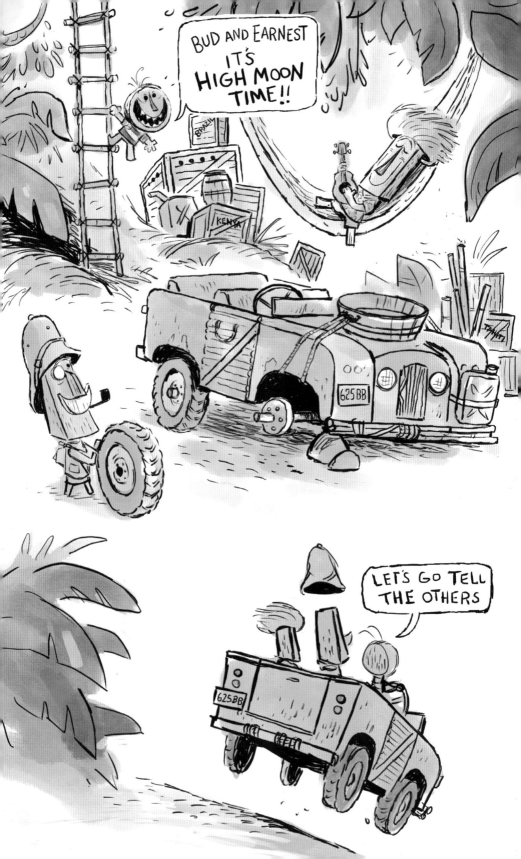

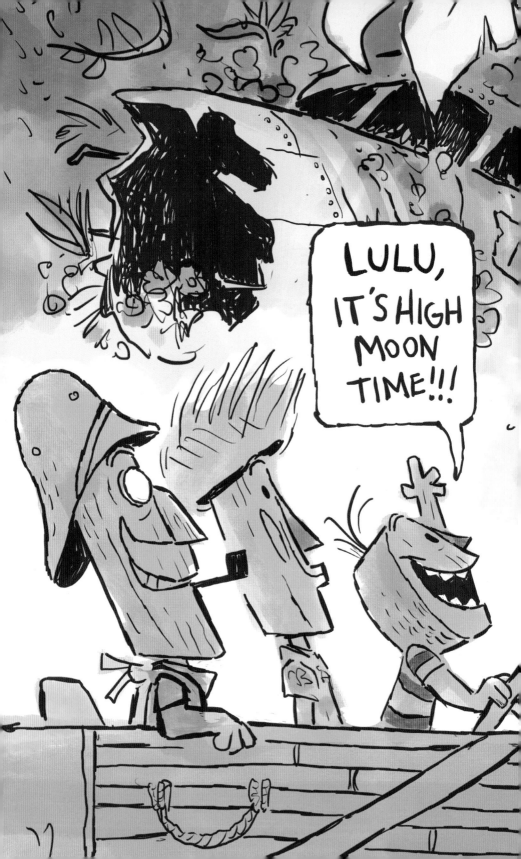

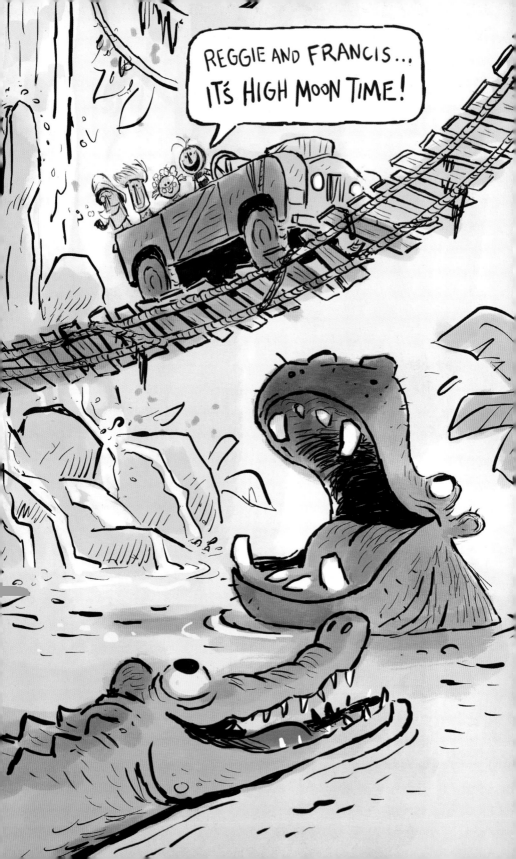

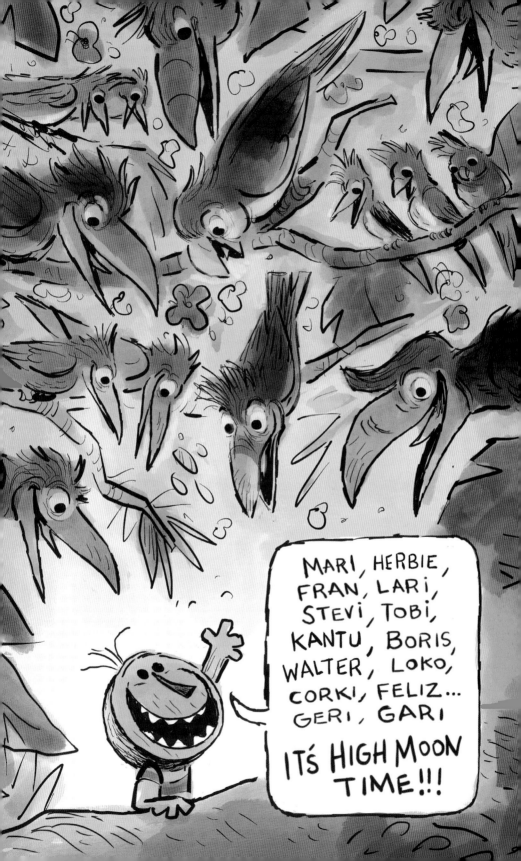

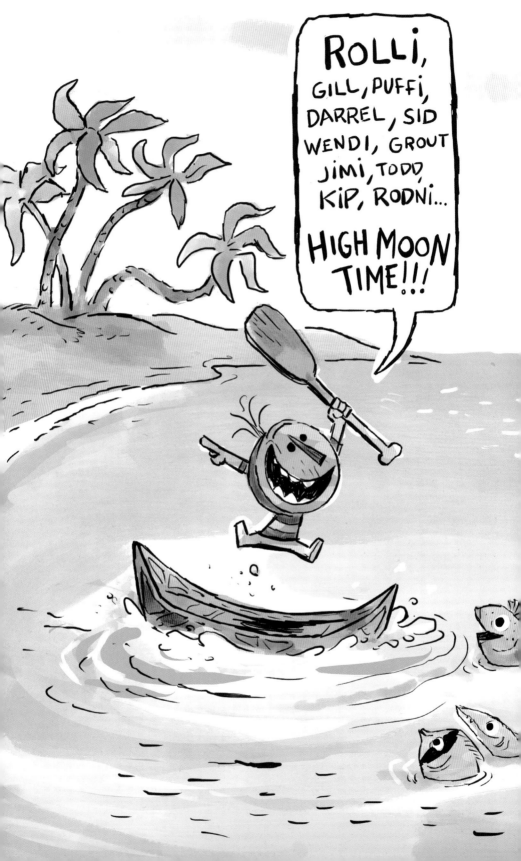

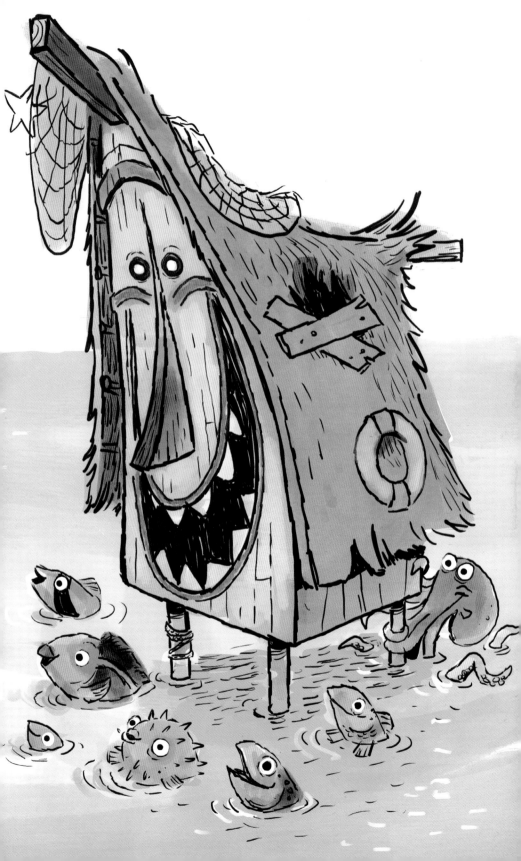

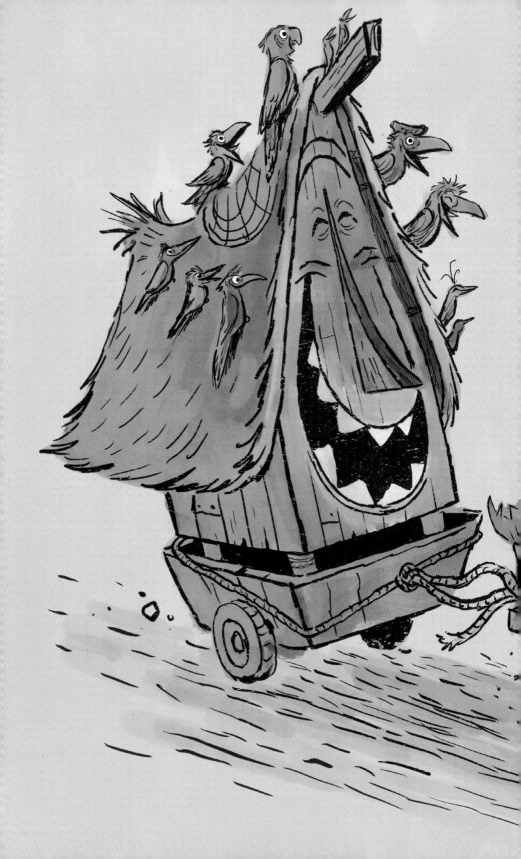

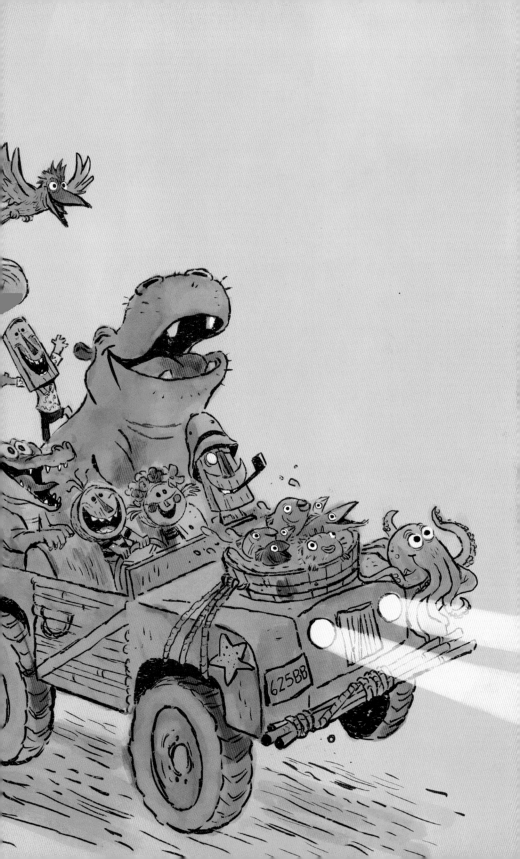

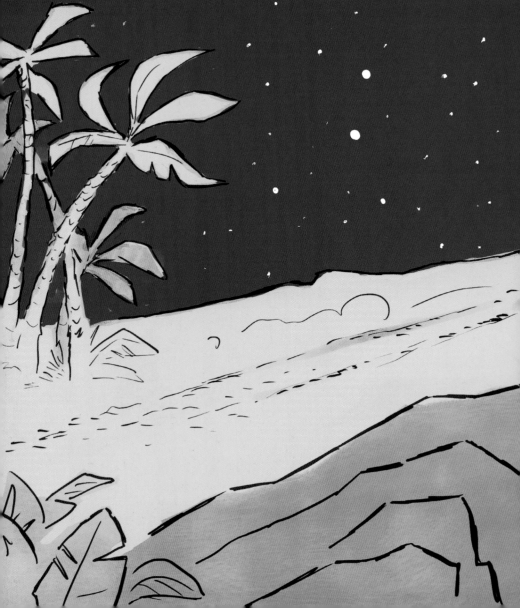

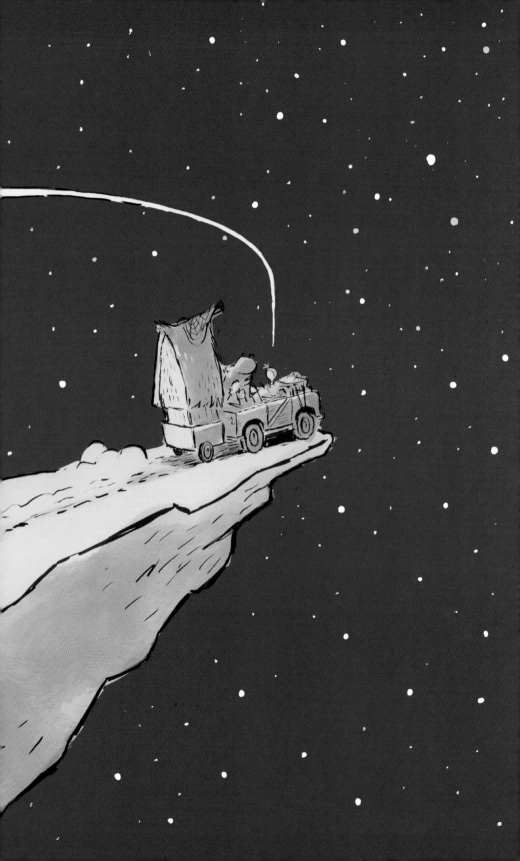

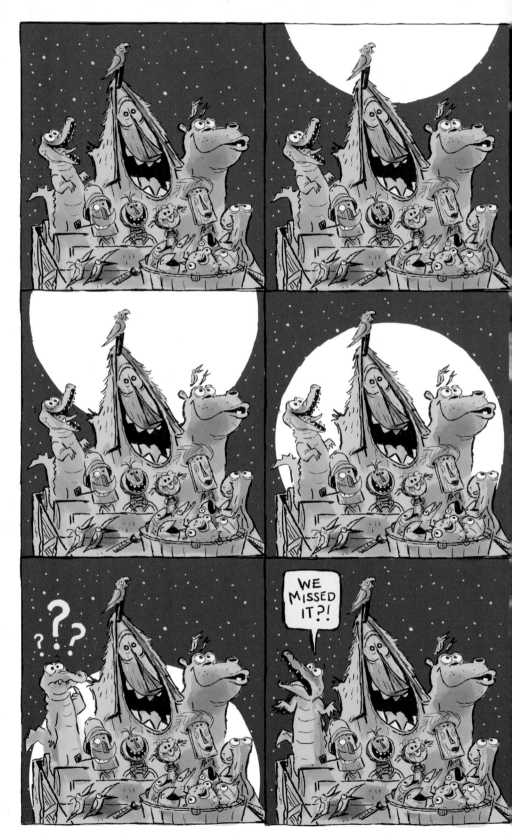

FAWN
VEERASUNTHORN

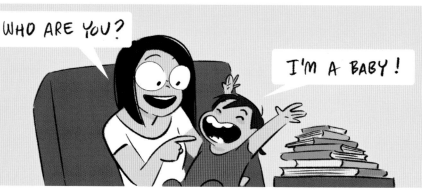

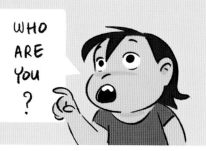

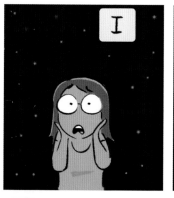

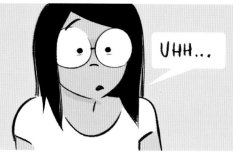

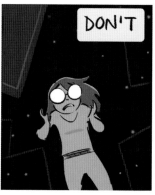

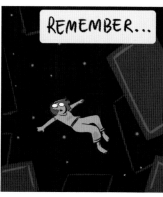

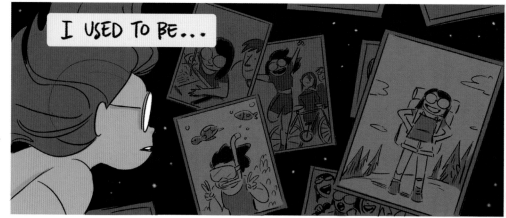

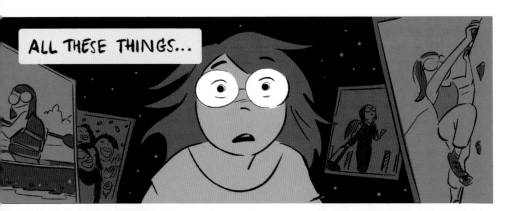

ALL THESE THINGS...

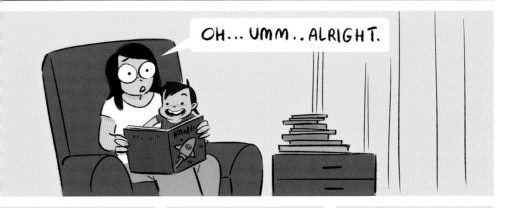

READ! MOMMY READ!

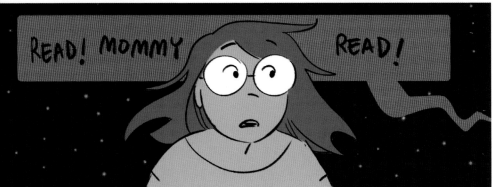

OH... UMM.. ALRIGHT.

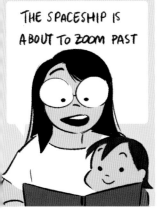

THE SPACESHIP IS ABOUT TO ZOOM PAST

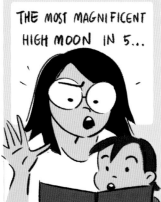

THE MOST MAGNIFICENT HIGH MOON IN 5...

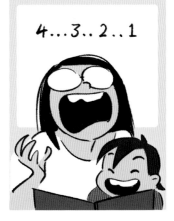

4...3.. 2.. 1

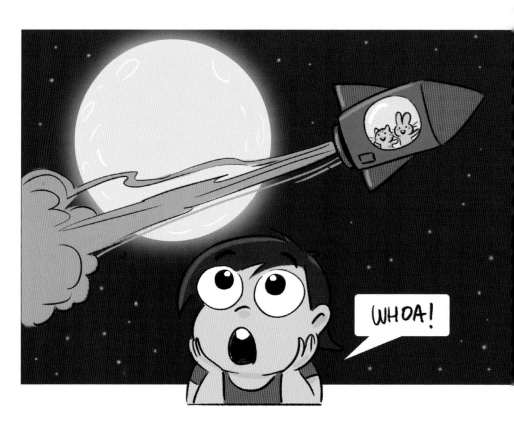

WHOA!

THAT'S AMAZING!

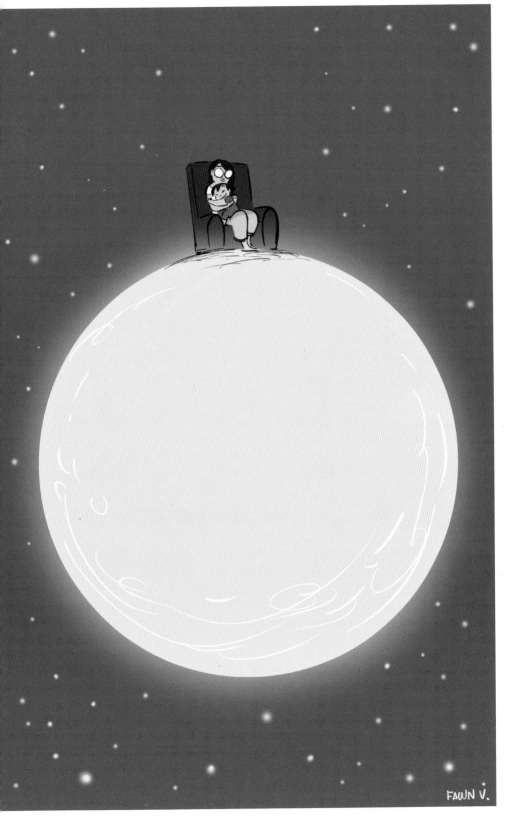

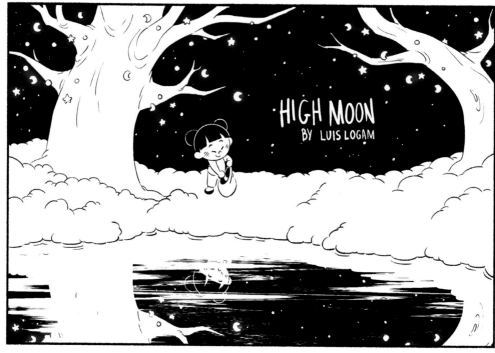

HIGH MOON
BY LUIS LOGAM

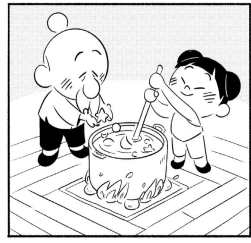

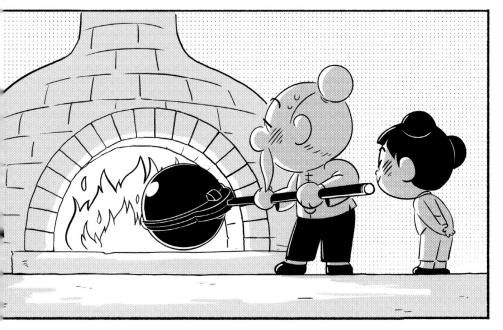

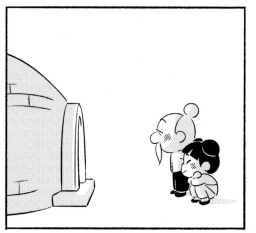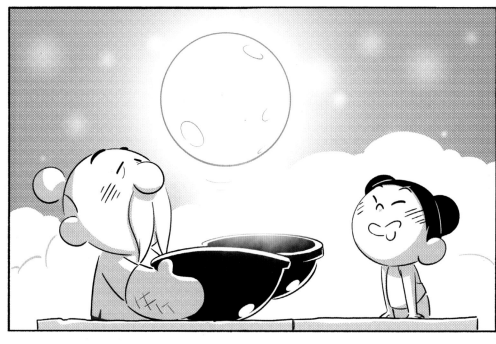

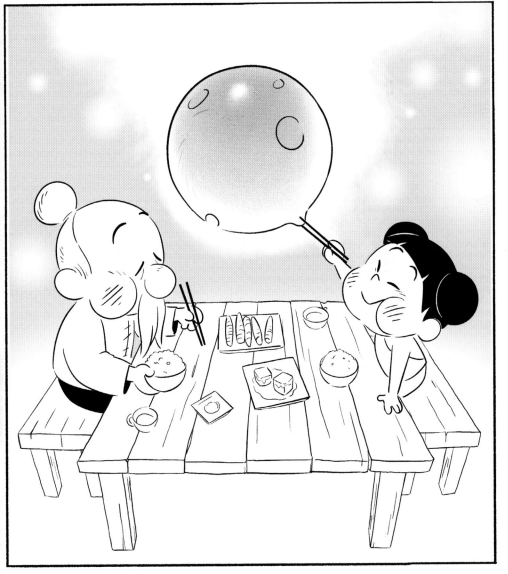

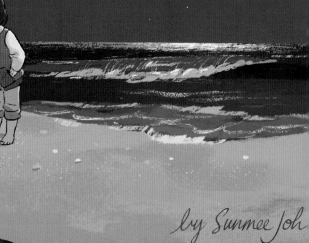

Moon Tides

by Sunmee Joh

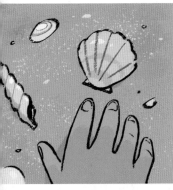
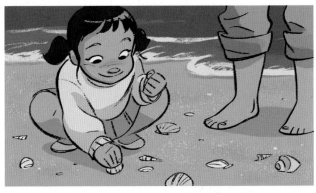

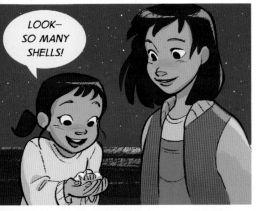

LOOK— SO MANY SHELLS!

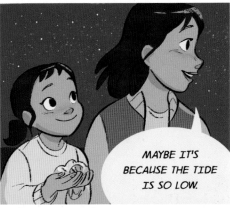

MAYBE IT'S BECAUSE THE TIDE IS SO LOW.

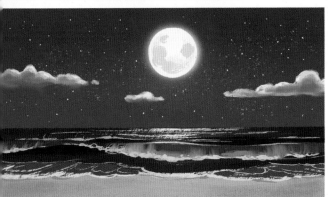

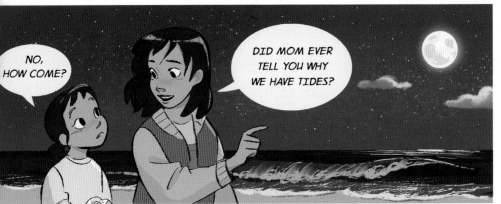

NO, HOW COME?

DID MOM EVER TELL YOU WHY WE HAVE TIDES?

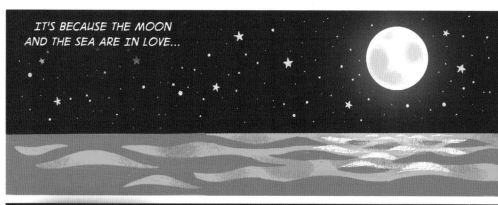

IT'S BECAUSE THE MOON AND THE SEA ARE IN LOVE...

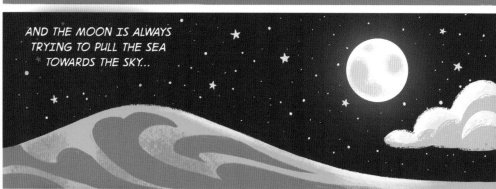

AND THE MOON IS ALWAYS TRYING TO PULL THE SEA TOWARDS THE SKY...

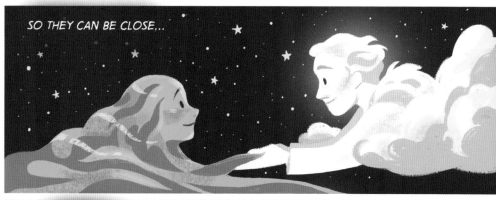

SO THEY CAN BE CLOSE...

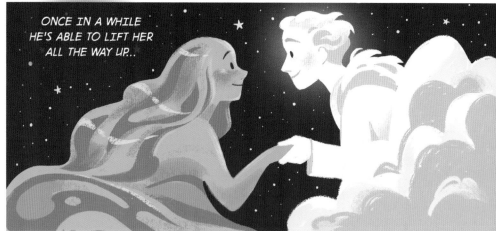

ONCE IN A WHILE HE'S ABLE TO LIFT HER ALL THE WAY UP...

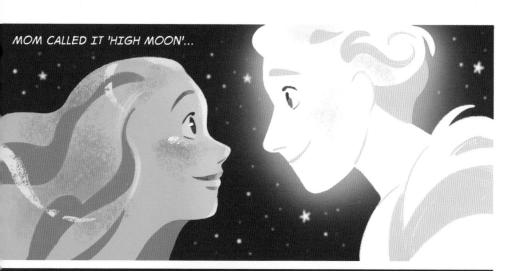

MOM CALLED IT 'HIGH MOON'...

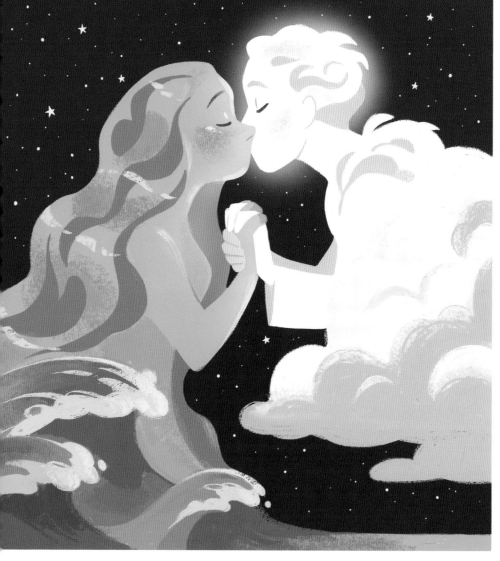

197

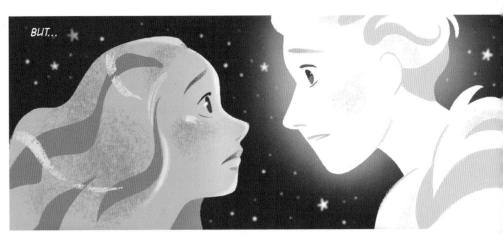

BUT...

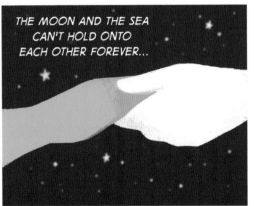

THE MOON AND THE SEA CAN'T HOLD ONTO EACH OTHER FOREVER...

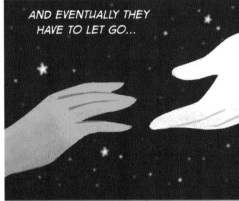

AND EVENTUALLY THEY HAVE TO LET GO...

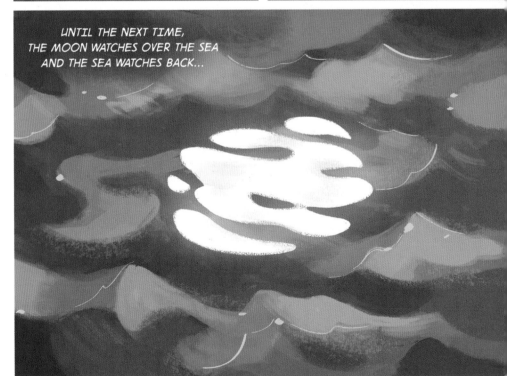

UNTIL THE NEXT TIME, THE MOON WATCHES OVER THE SEA AND THE SEA WATCHES BACK...

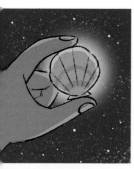
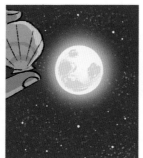
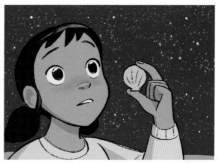

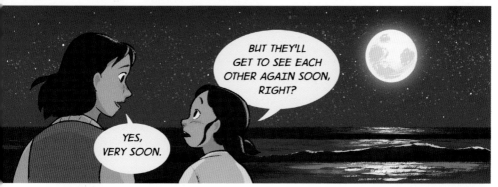

BUT THEY'LL GET TO SEE EACH OTHER AGAIN SOON, RIGHT?

YES, VERY SOON.

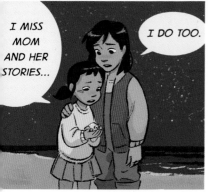
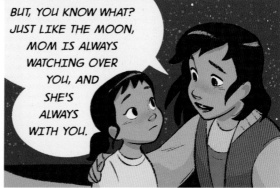

I MISS MOM AND HER STORIES...

I DO TOO.

BUT, YOU KNOW WHAT? JUST LIKE THE MOON, MOM IS ALWAYS WATCHING OVER YOU, AND SHE'S ALWAYS WITH YOU.

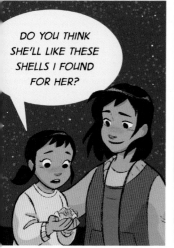
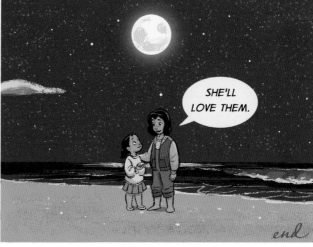

DO YOU THINK SHE'LL LIKE THESE SHELLS I FOUND FOR HER?

SHE'LL LOVE THEM.

end

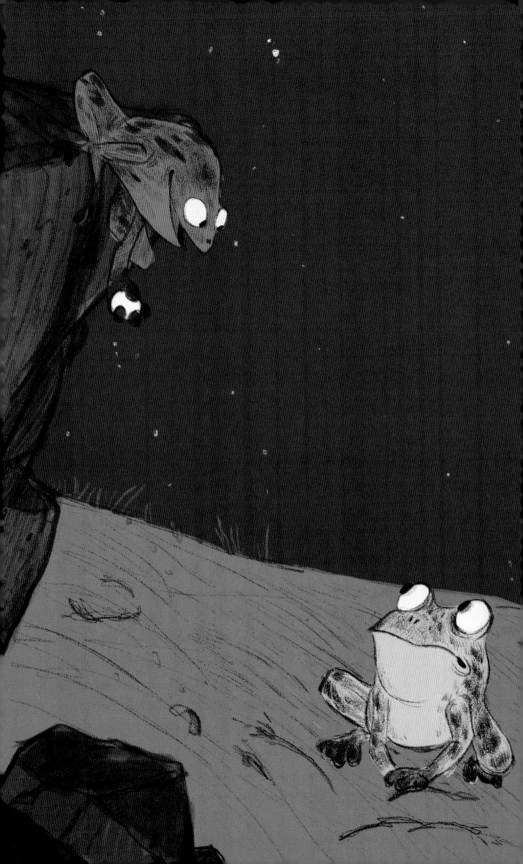

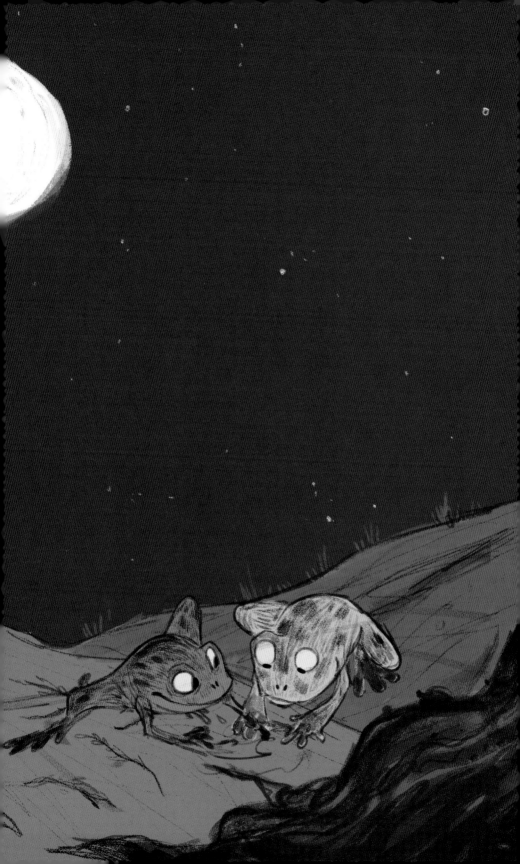

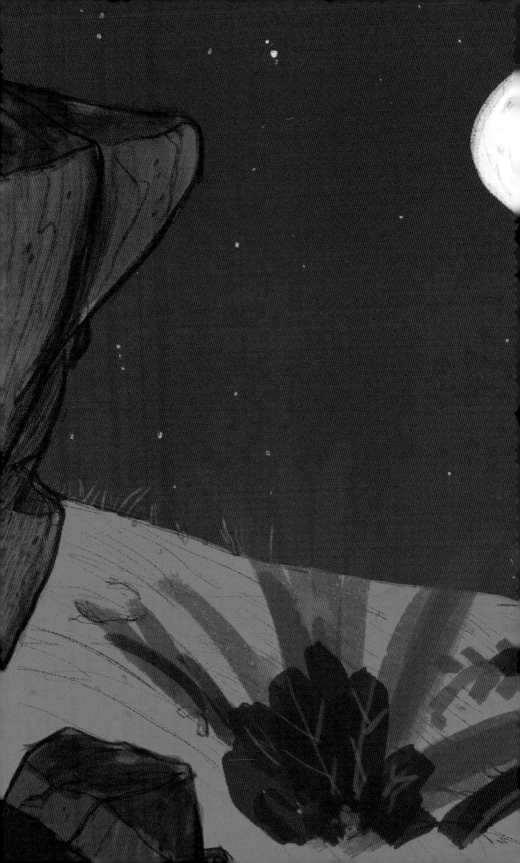

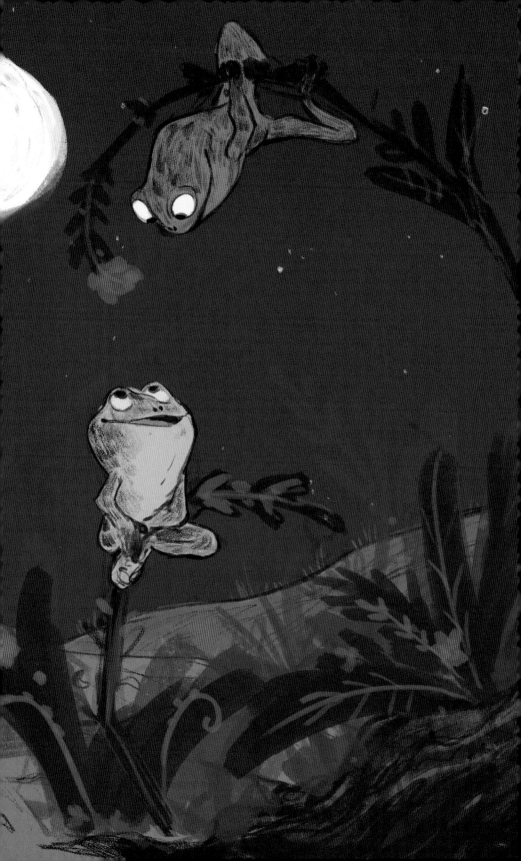

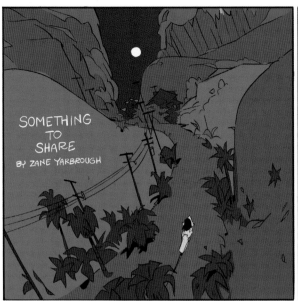

SOMETHING
TO
SHARE
BY ZANE YARBROUGH

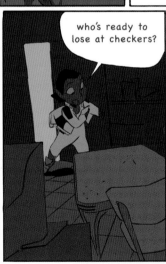

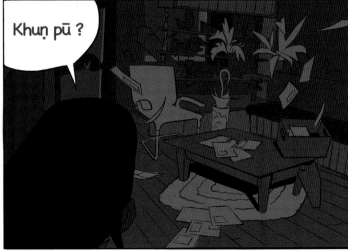

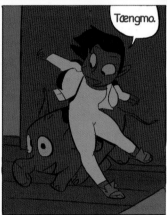

Tœngmo.

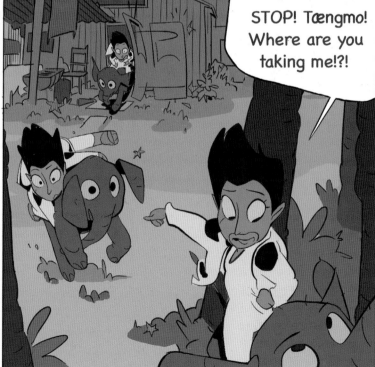

STOP! Tœngmo! Where are you taking me!?!

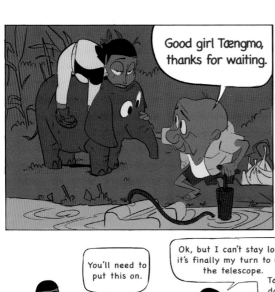

Good girl Tængmo, thanks for waiting.

What's going on?

I've got something wonderful to show you.

You'll need to put this on.

Ok, but I can't stay long, it's finally my turn to use the telescope.

Take mine, I don't need it.

Is this a vest full of water?

I call it a MOON FLOATIE!

So are we going on some sort of hike?

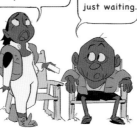

Khuṇ pū! what about your knees?

No Hiking. No Knees, just waiting.

What are we waiting for?

The culmination of my life's work.

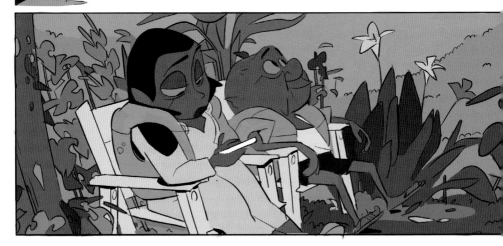

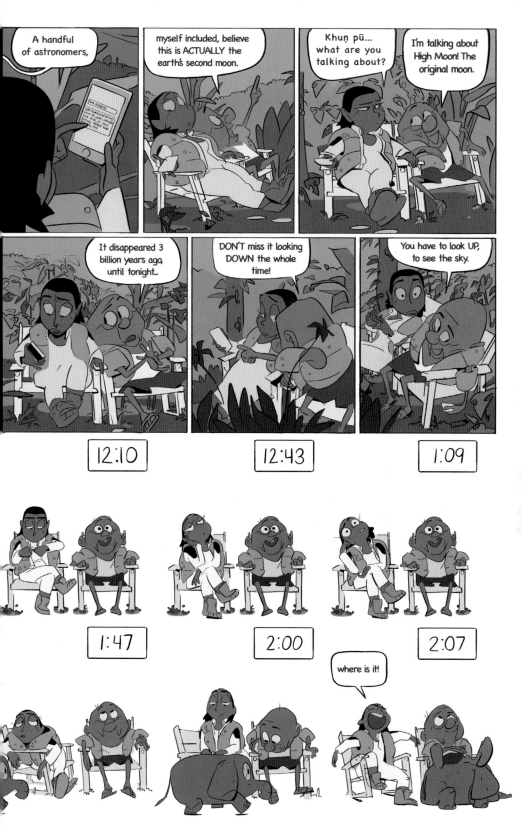

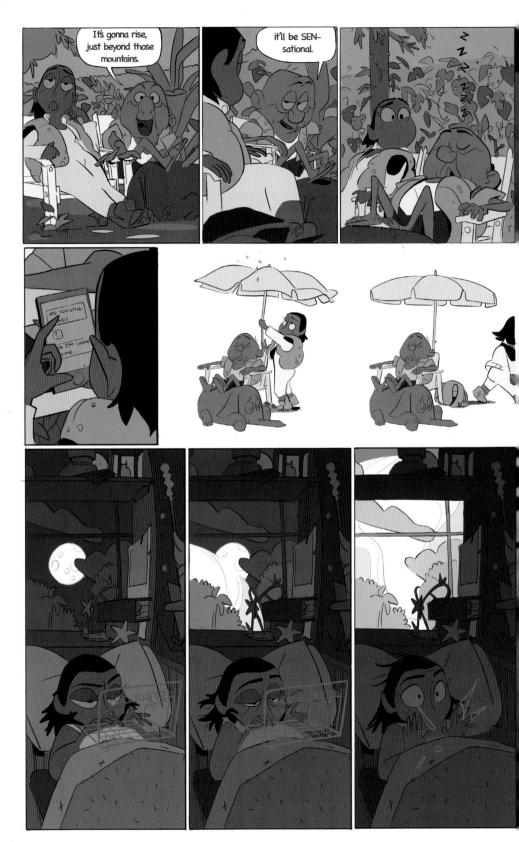

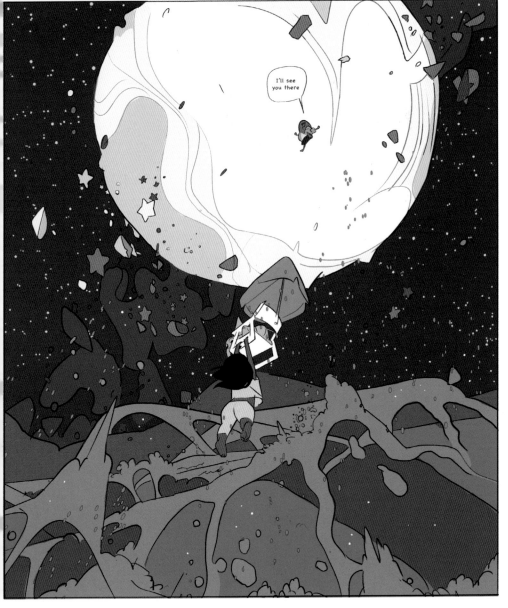

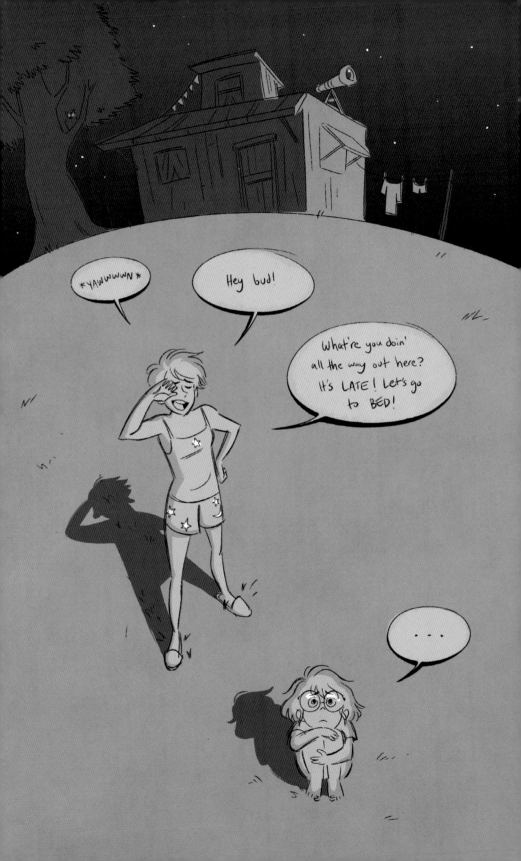

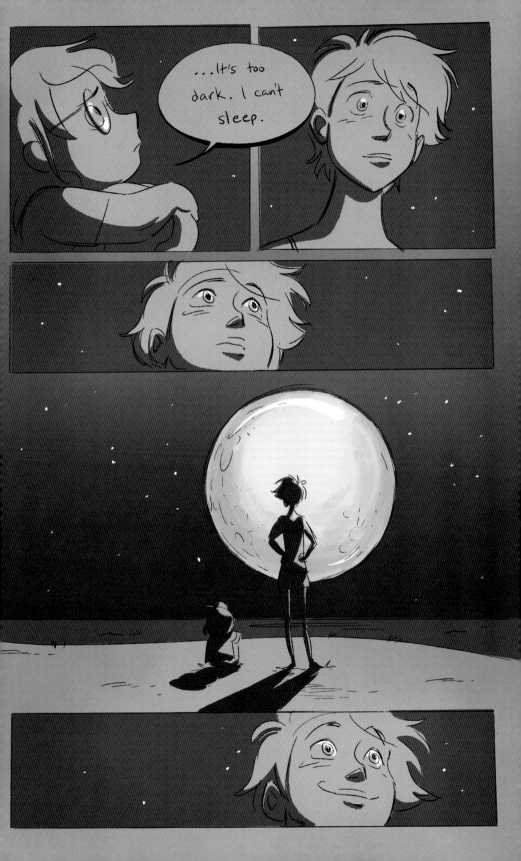

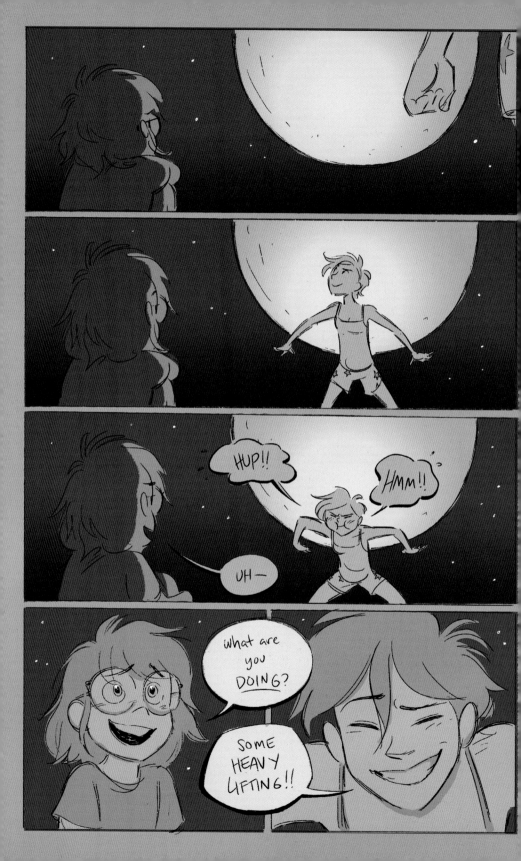

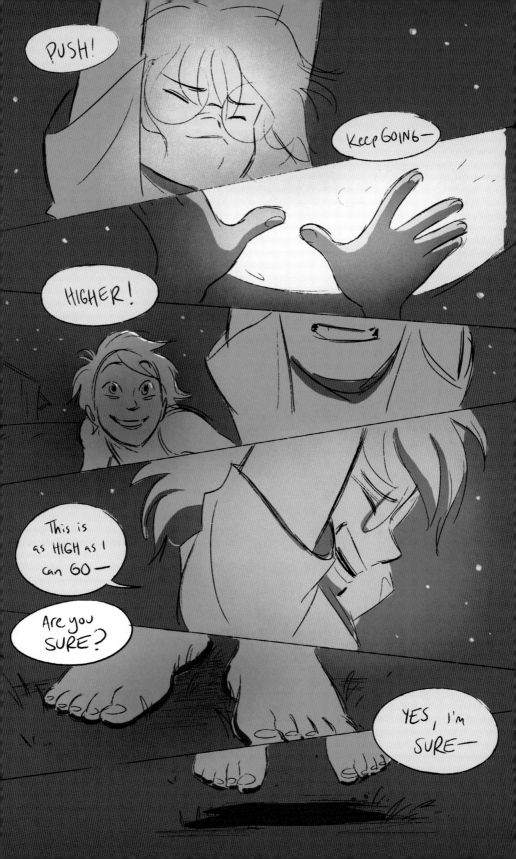

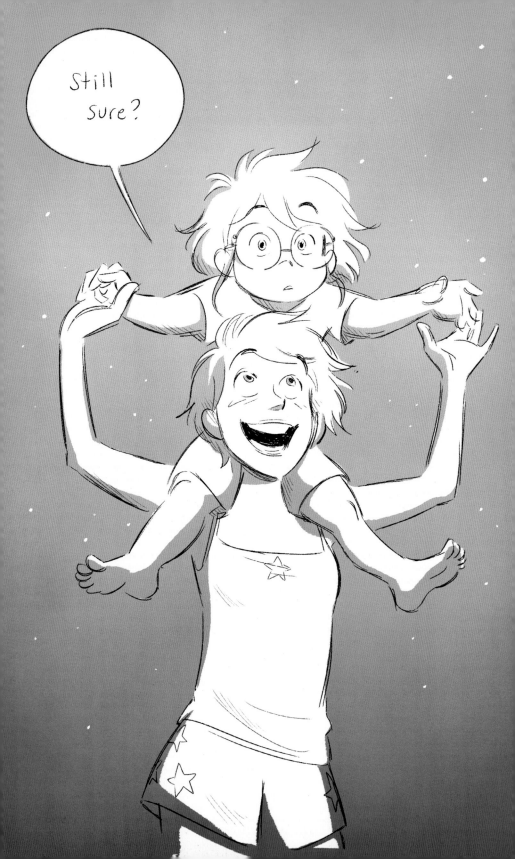

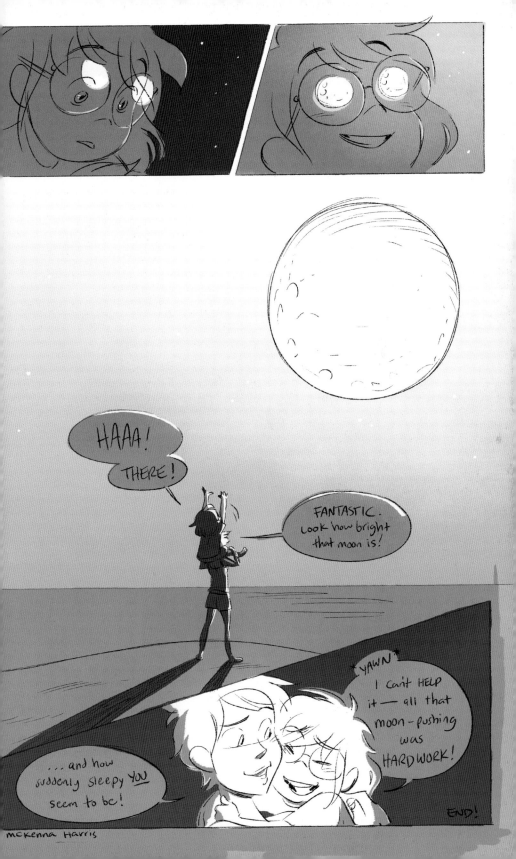

McKenna Harris

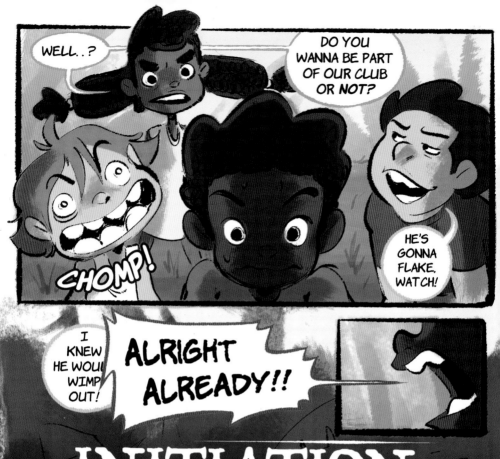

INITIATION

CARLOS ROMERO

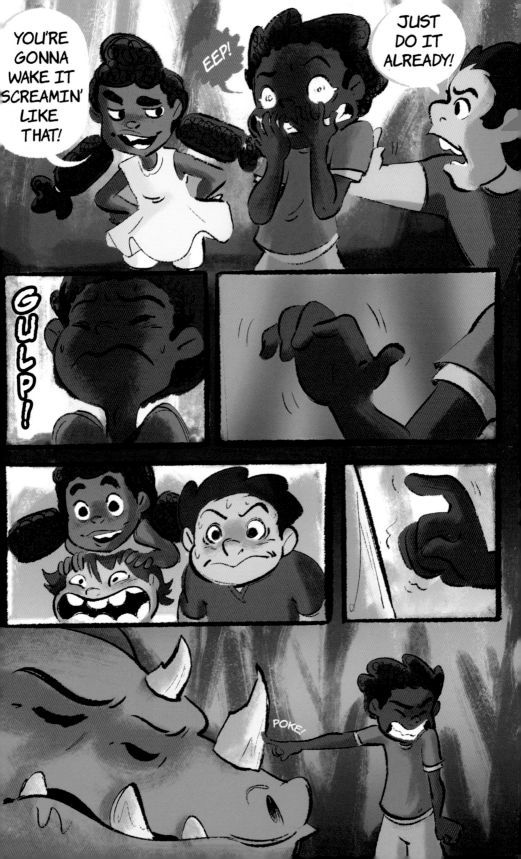

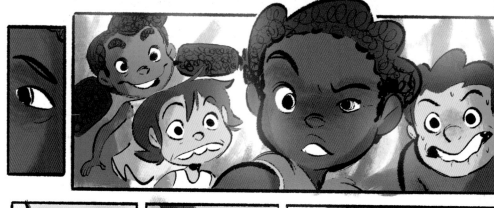

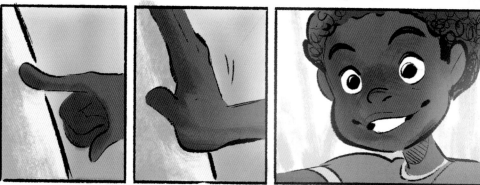

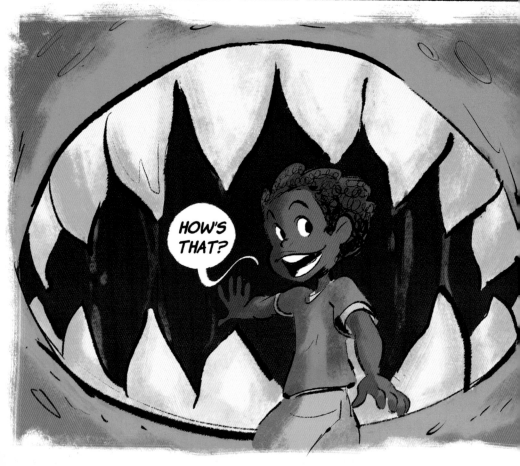

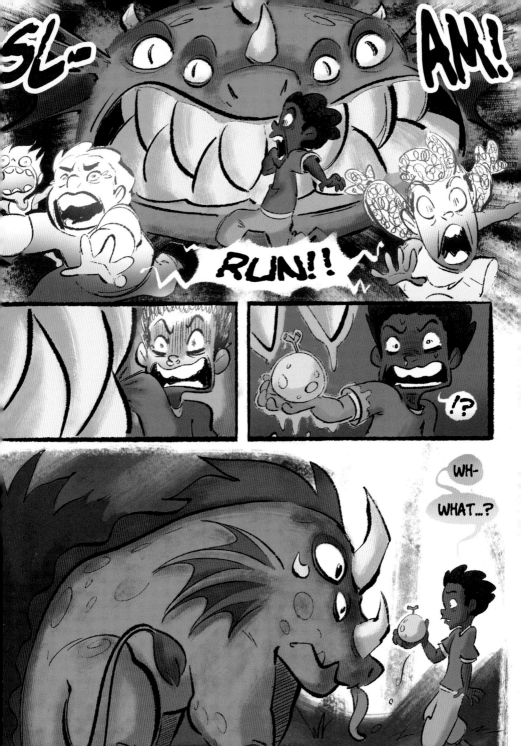

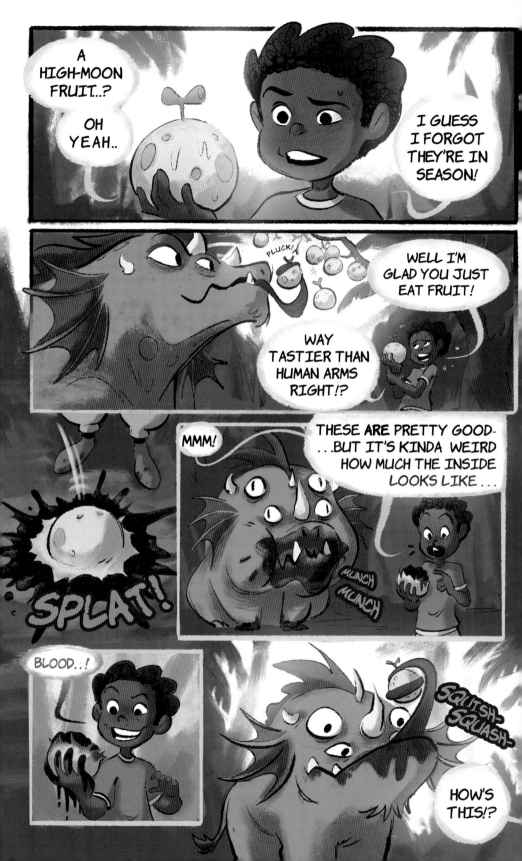

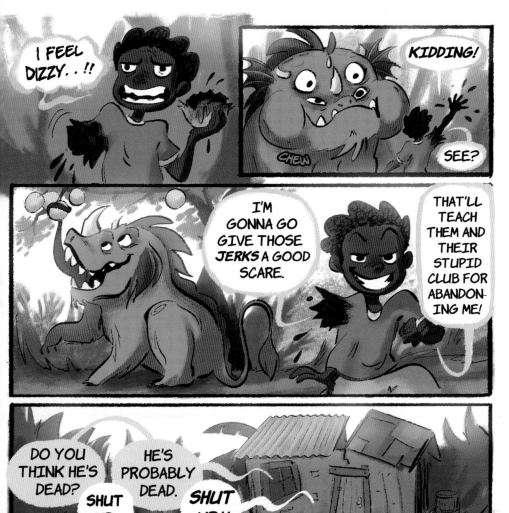

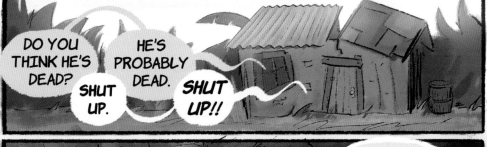

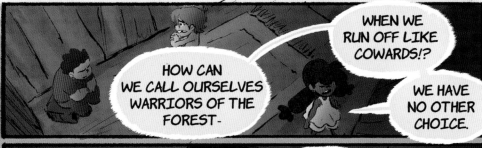

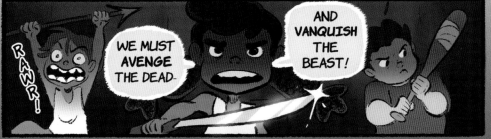

CHIRP
CHIRP

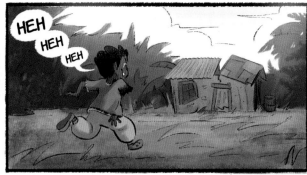

HEH
HEH
HEH

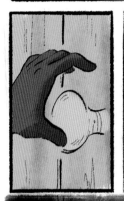

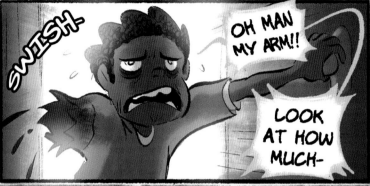

SWISH-

OH MAN MY ARM!!

LOOK AT HOW MUCH—

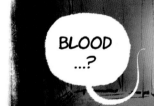

BLOOD ...?

HUH.

IT WAS WEIRD. I COULDN'T FIND THEM ANYWHERE!

...OH WELL

WHO'D FALL FOR SUCH A DUMB PRANK ANYWAY?

BUT HEY, I PICKED YOU SOME MORE—

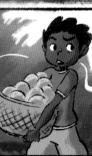

!?

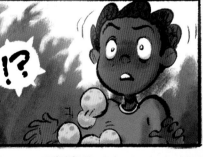

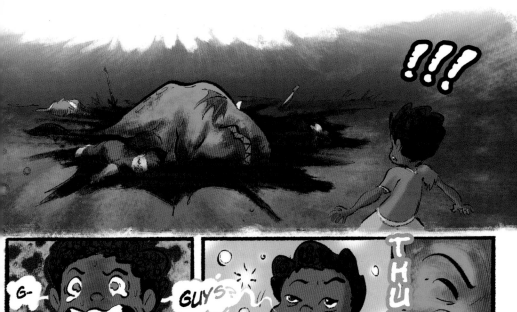

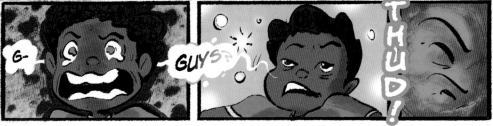

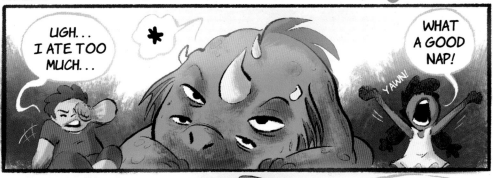

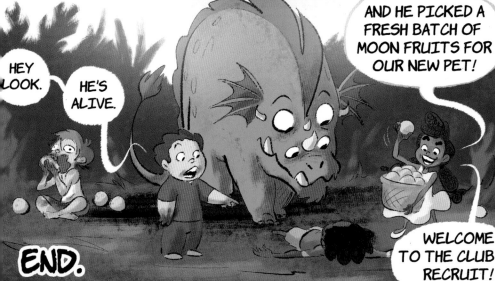

END.

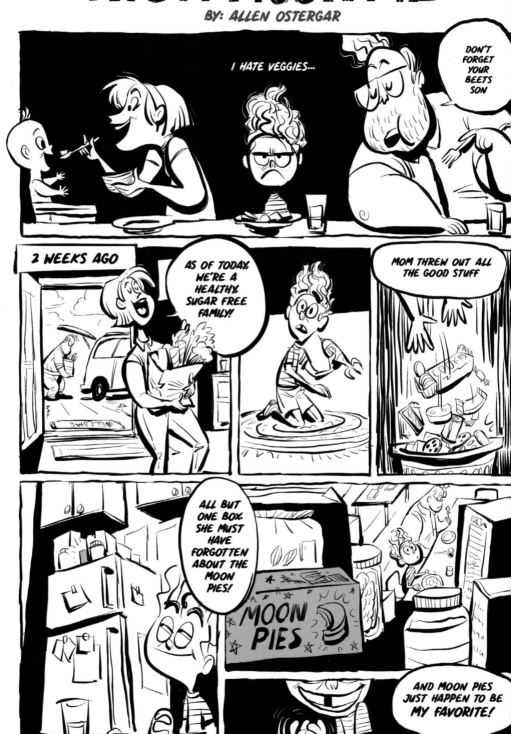

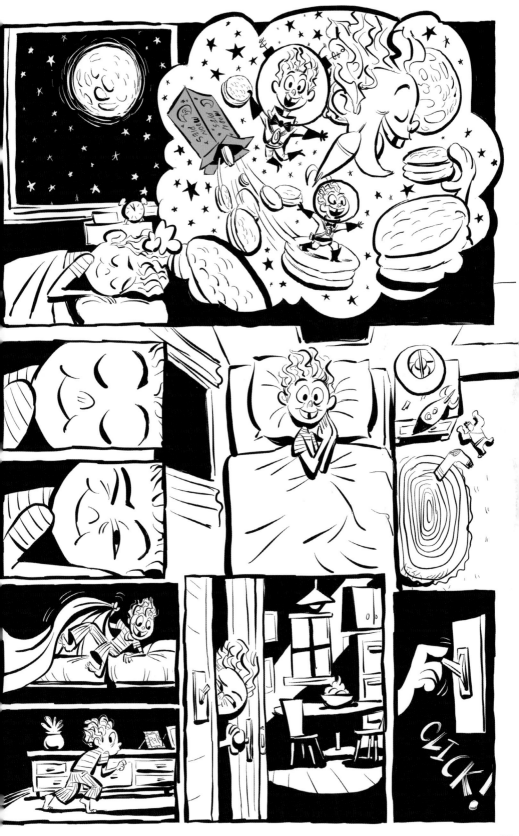

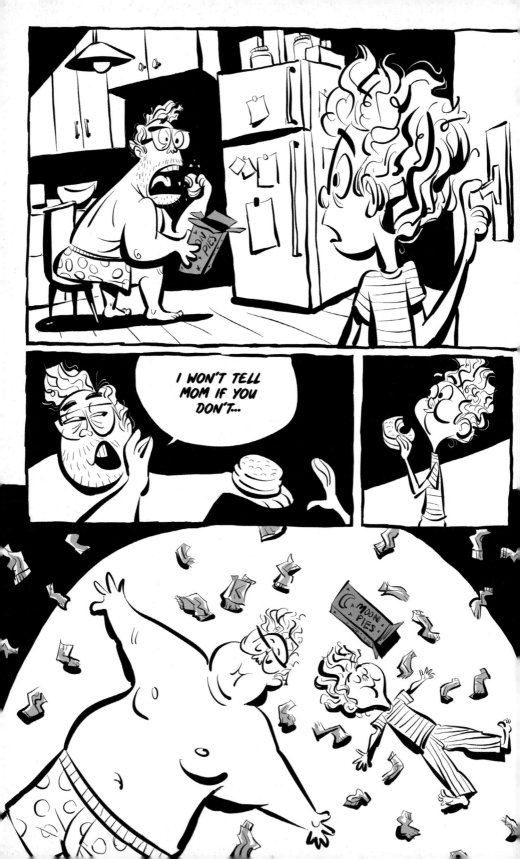

cailín

by Samantha Vilfort

co-written by Hailey Koart

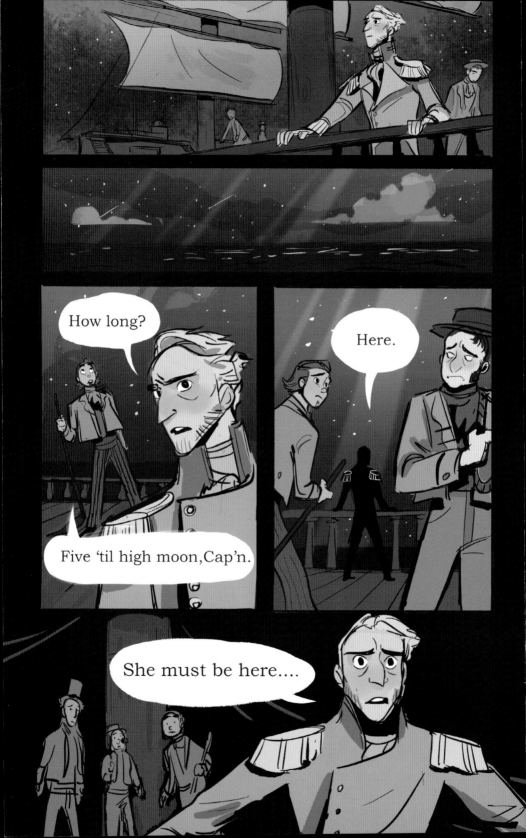

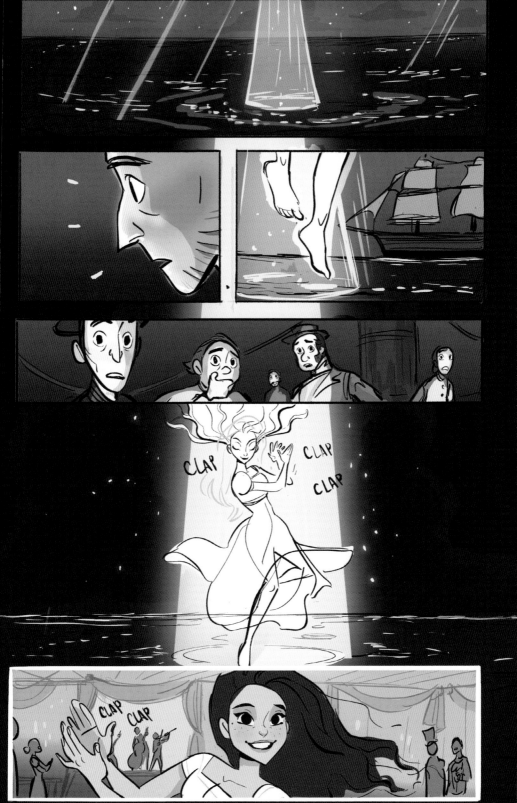

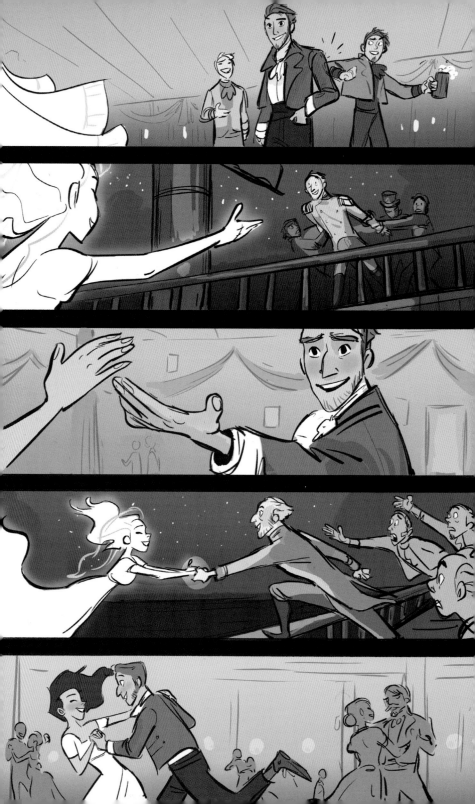

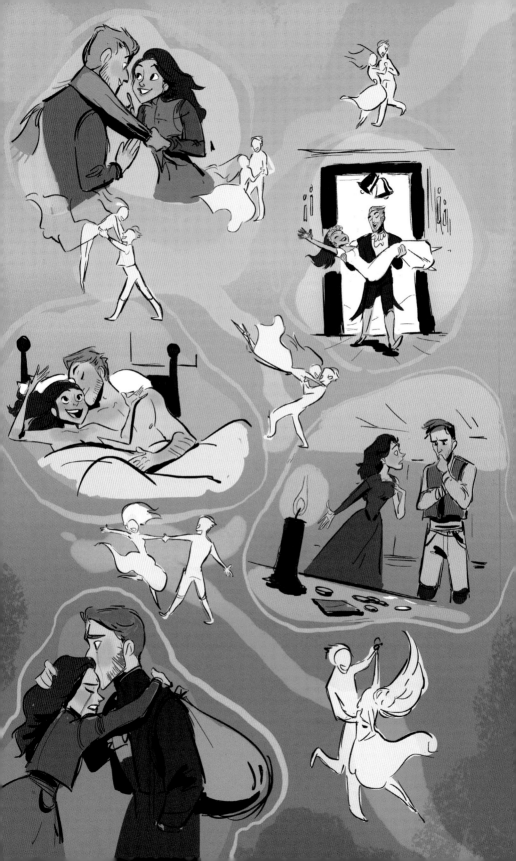

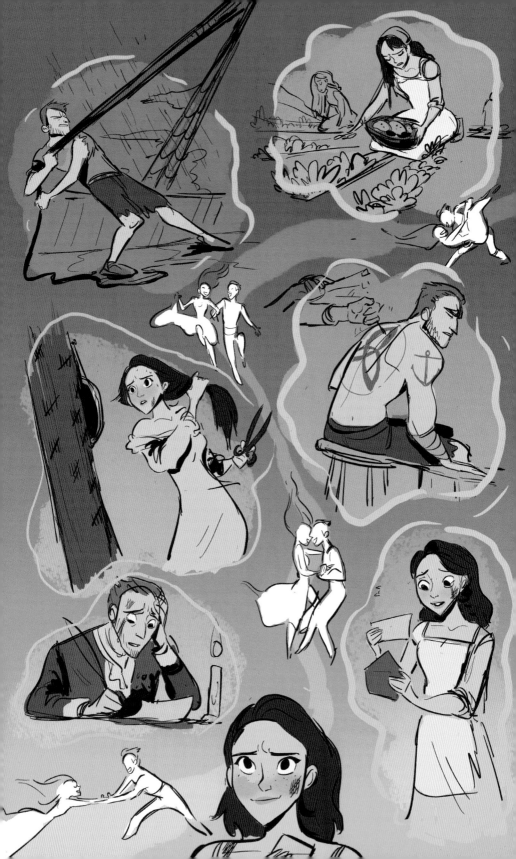

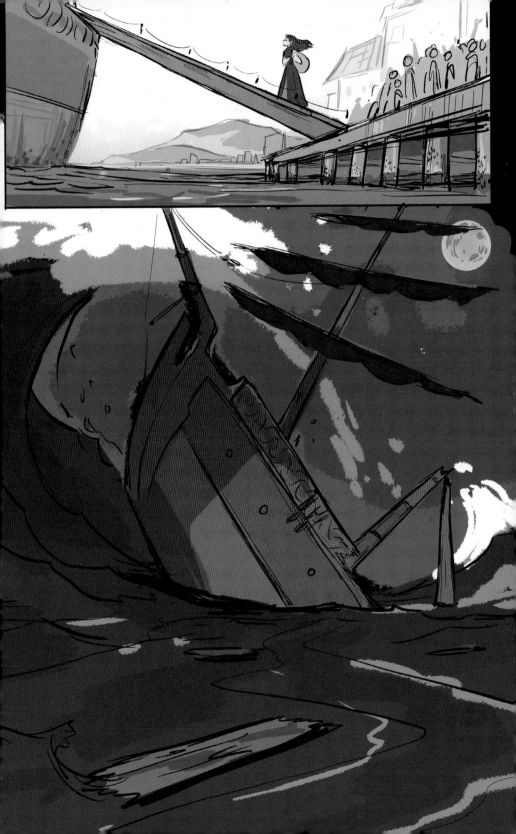

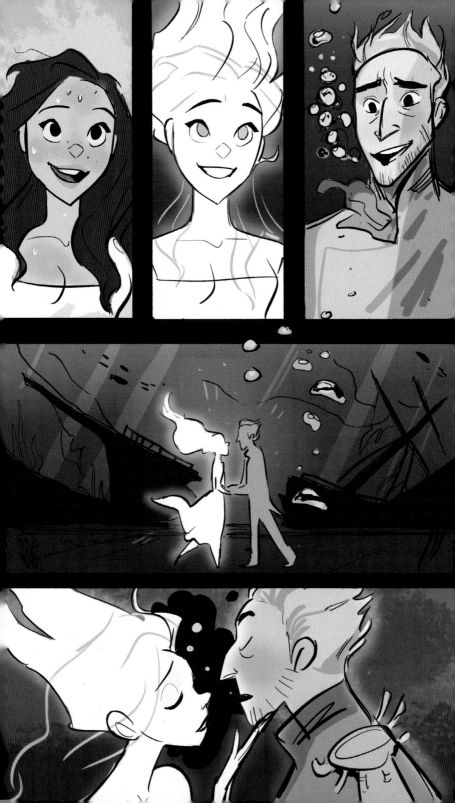

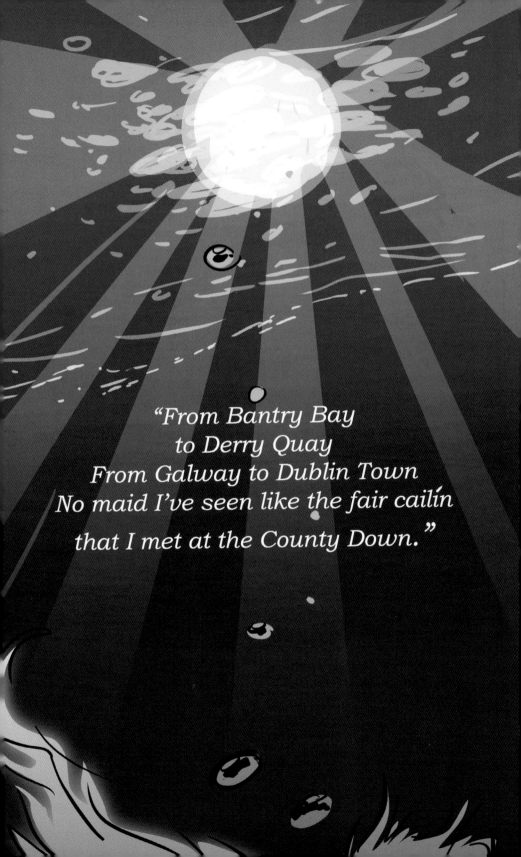

"From Bantry Bay
to Derry Quay
From Galway to Dublin Town
No maid I've seen like the fair cailín
that I met at the County Down."

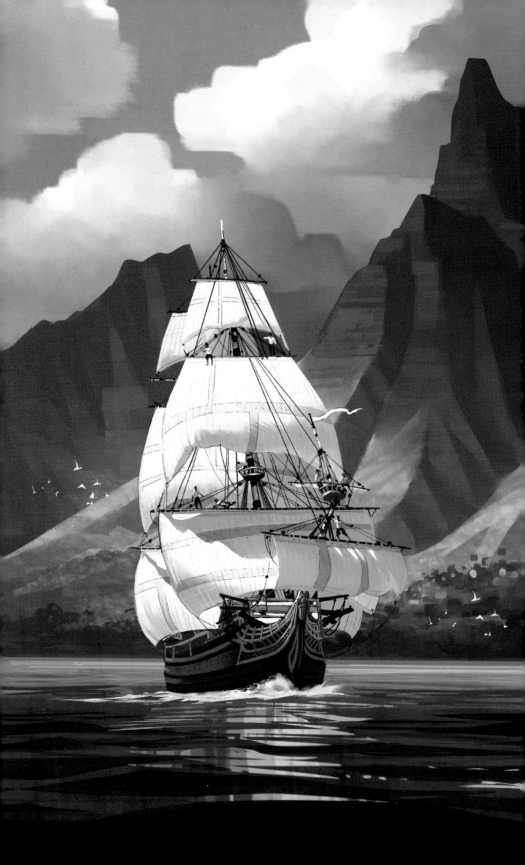

Moon

and the

Bounty

by

James Finch

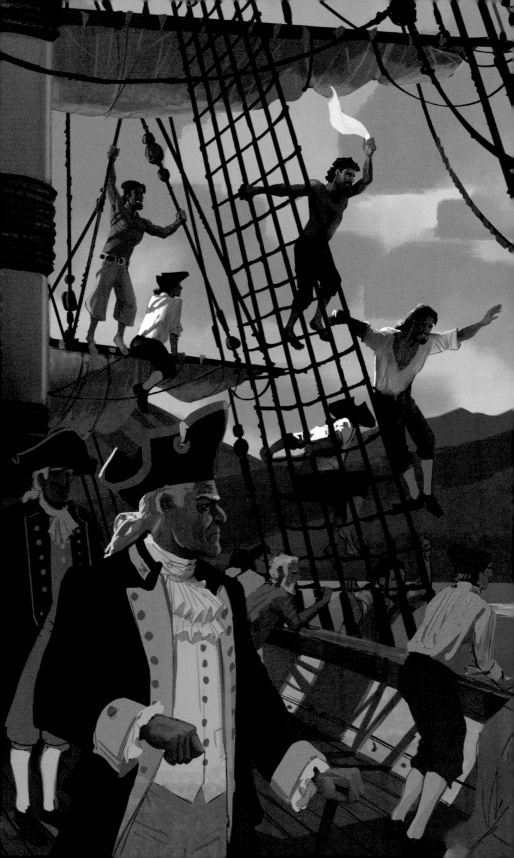

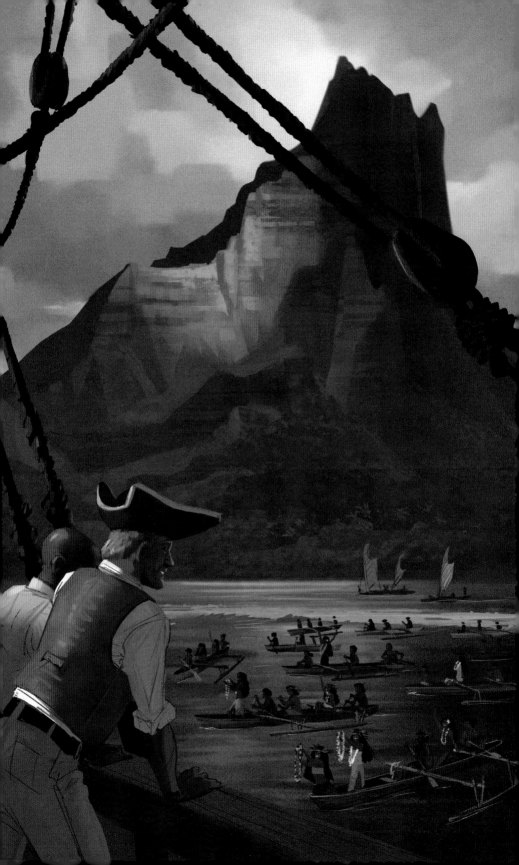

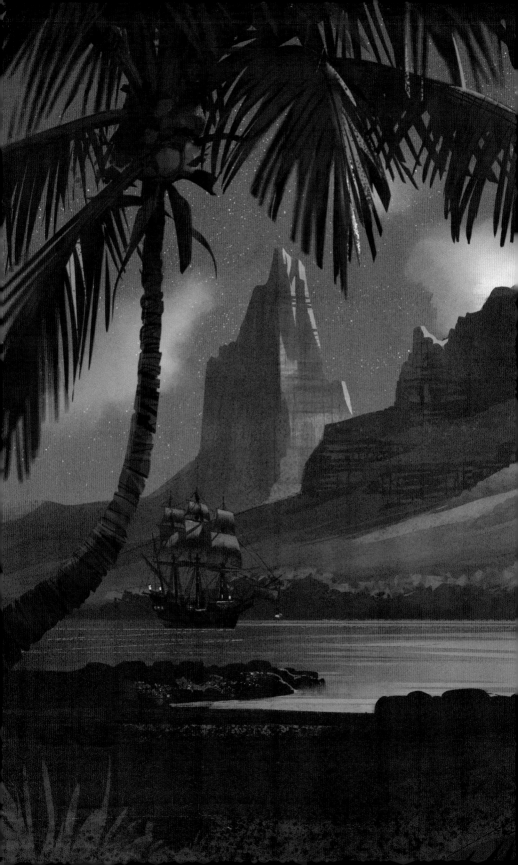

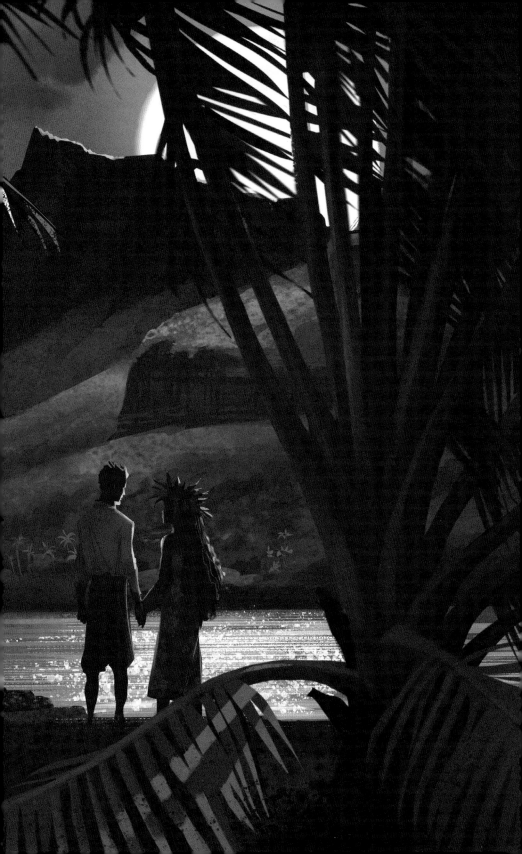

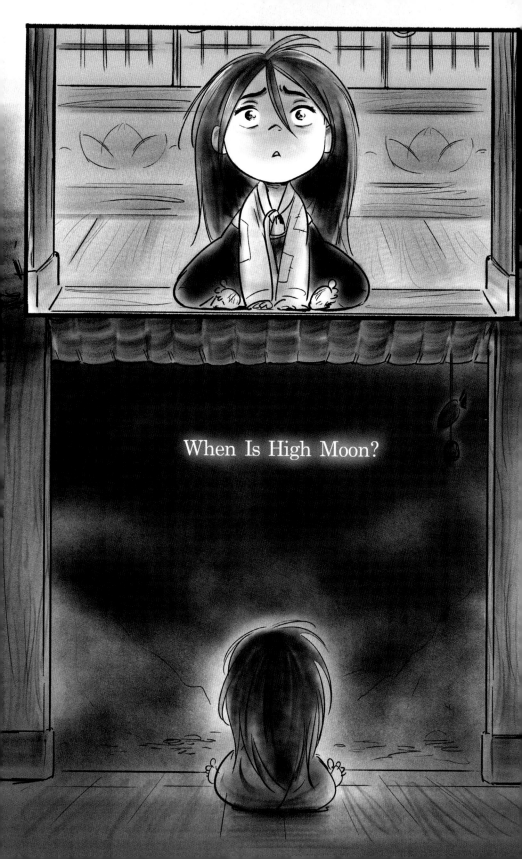

When Is High Moon?

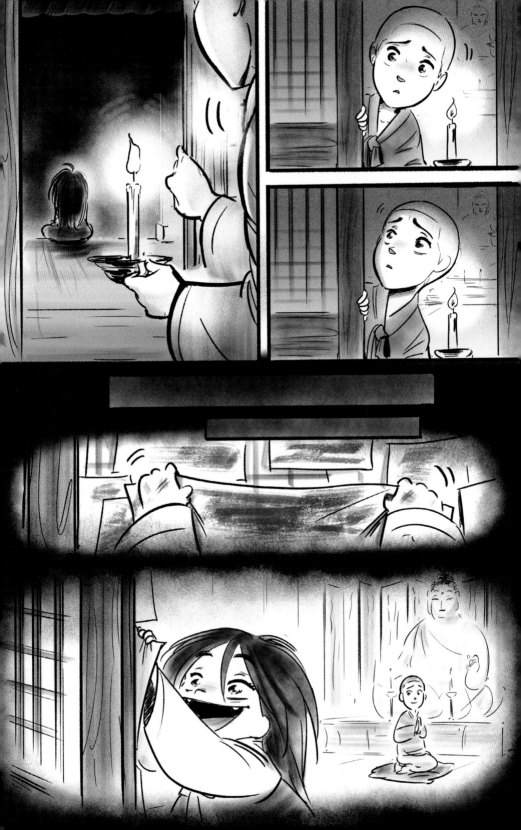

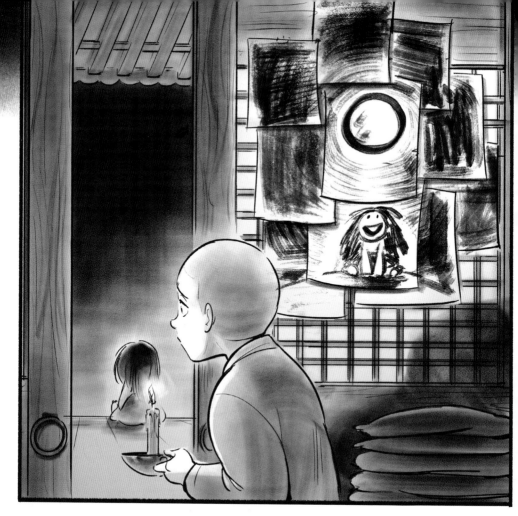

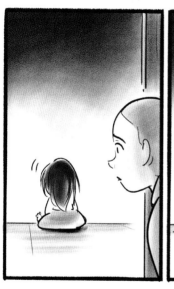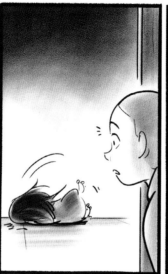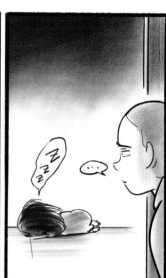

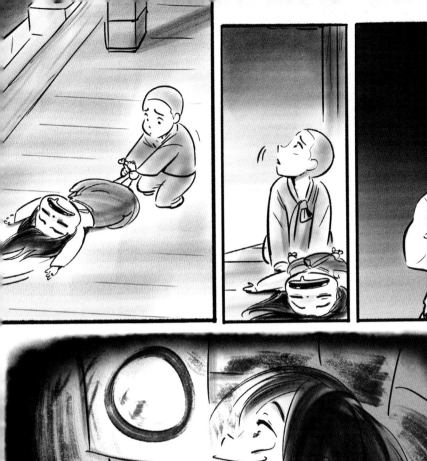

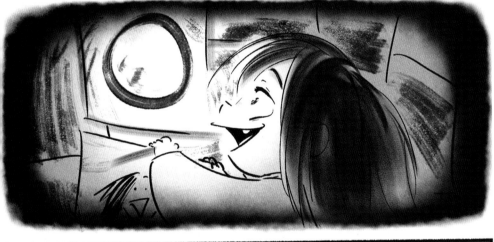

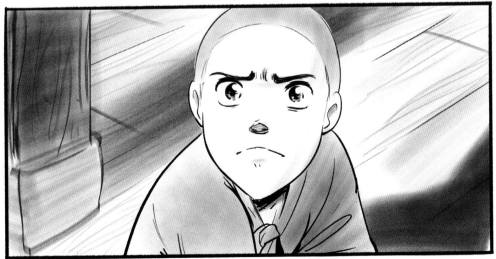

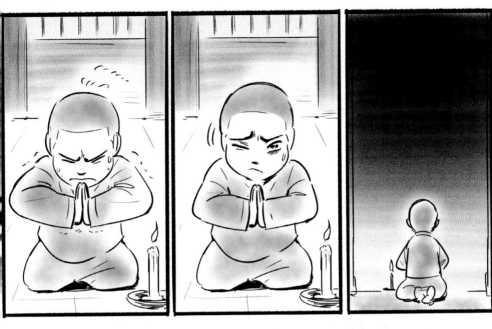

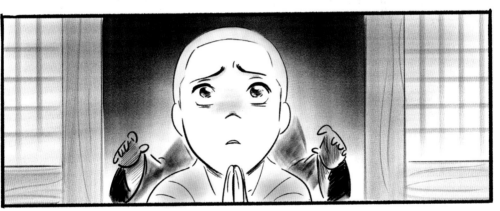

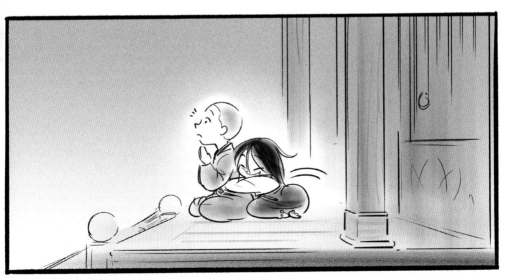

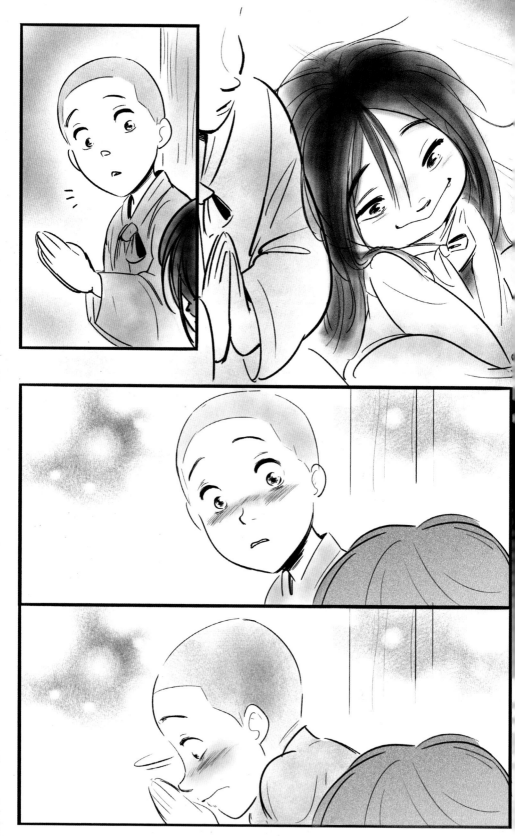

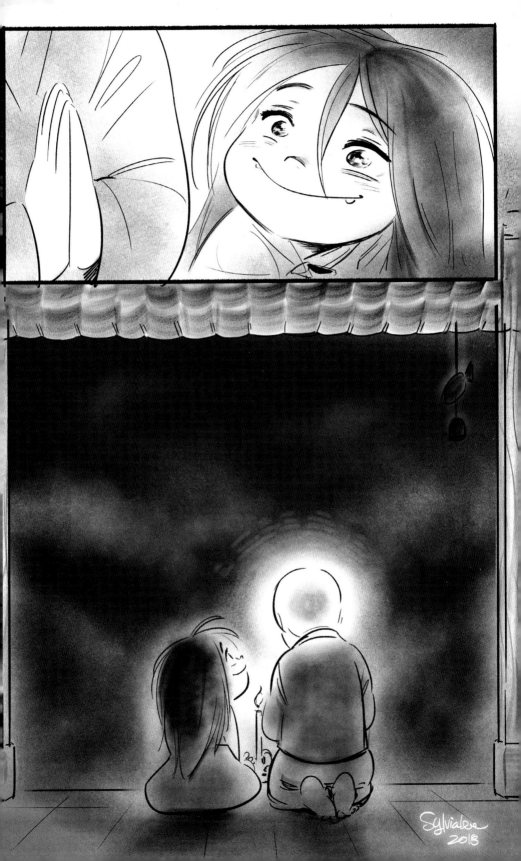

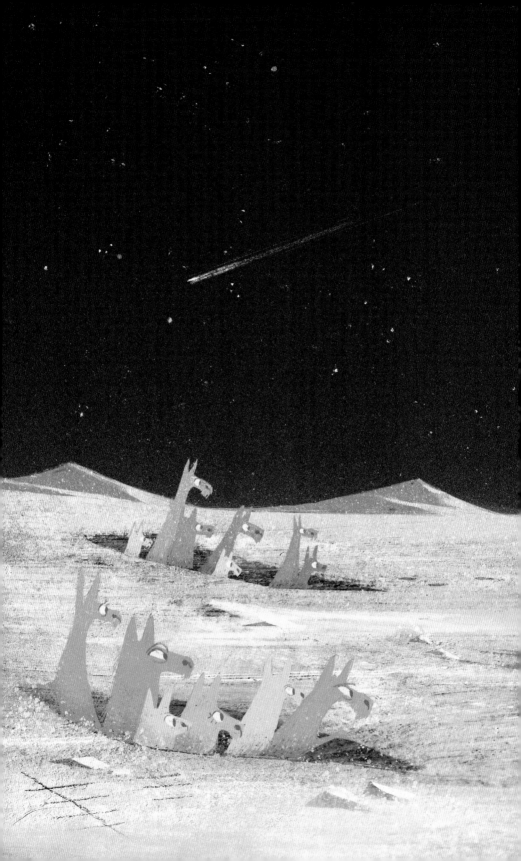

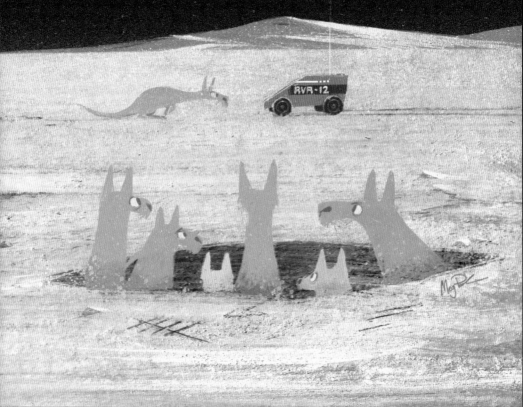

ARTIST BIOGRAPHIES

ALLEN OSTERGAR started animating at Walt Disney Animation Studios in 2014, where he fell in love with bringing characters to life. He also loves to storyboard! Outside the studio you may find him riding his bike up twisty mountain roads.
@alleno4

ALISHEA GIBSON is a coffee-drinking and cartoon-loving story artist.
alishea.blogspot.com

ANDY HARKNESS started with Disney in 1994 as an animation clean-up artist on *Pocahontas*. After *The Hunchack of Notre Dame*, he moved into the layout department and worked on *Mulan*, *John Henry*, *Lilo and Stitch* and *Brother Bear*. Andy's first job as an Art Director was on *Open Season* at Sony Animation, then back to Disney for *Glago's Guest*, *Prep and Landing*, *The Ballad of Nessie* and *Moana*. He's been nominated three times for an Annie award, winning once with *Prep and Landing*, for which he also received an Emmy. Andy's dream, when he grows up, is to write and illustrate children's books full-time.
andyharknessart.com

BILL SCHWAB started his career on MTV's *Beavis and Butthead,* while studying at Pratt Institute in Brooklyn, NY – and was forever hooked on animation! Bill has spent the majority of his career working as a visual development artist and character designer at Walt Disney Animation Studios. He most recently worked on *Moana* and is now collaborating on *Frozen 2*. Bill lives in Los Angeles with his wife, two kids, and labrador retriever.
billschwabdesign.blogspot.com

BRIAN KESINGER is an Annie award-winning story artist, illustrator and author. A career at Disney for over twenty years has spanned both hand-drawn and CG animated films from *Tarzan* to *Moana*. In addition to Brian's film work, he is also a celebrated writer and illustrator of several books that showcase his unique personal style, wit and ability to tell engaging stories. Brian's artistic journey has led him to an additional home at Marvel Comics, where he blends his animation background with the sequential artform to create dazzling and expressive art.
bkartonline.com

BRITTNEY LEE is a visual-development artist at Walt Disney Animation Studios. A graduate of the Rochester Institute of Technology, she knew that she would pursue a career in animation from the moment she saw *The Little Mermaid* at age six. Brittney currently lives in Los Angeles with her husband and their two cats. She has contributed work to several of Disney Animation's titles, including *Moana*, *Zootopia*, *Wreck-it Ralph* and *Frozen*, as well as the Disney short films *Paperman*, *Get A Horse*, *Frozen Fever*, and *Feast*. She is currently working on the upcoming sequel to *Frozen*.

CAMILLE ANDRE is a French artist who studied at Gobelins l'Ecole de l'Image in Paris. She worked for several American studios (Sony Pictures Animation, Blue Sky, Illumination Mac Guff, etc) before working at Disney. Her art is a mix between North European, East European and Asian styles, combined to create magical atmosphere and light with fantastical creatures and worlds. She loves mixing techniques (digital and traditional) and working with watercolor.

camille-andre-book.tumblr.com

CARLOS ROMERO is a huge fan of pizza. And warm weather. And loves drawing cartoons! He's been drawing them since he could hold a pencil. His reign of terror as a story artist started at Illumination on *Minions*, continued at Disney with *Moana*, *Zootopia* and *Ralph Breaks the Internet*, and goes on at Sony on the in-production movie *Vivo*. Won't anyone stop him?!

@cromer0s

CARRIE LIAO is a story artist living in Los Angeles with one increasingly fat cat. She currently draws at Disney Animation (previously Nickelodeon and Warner Bros), enjoys traveling and eating ALL THE FOOD in her spare time. She loves cilantro and really doesn't like fluorescent lighting >:(

@cisforfrenchfry

CHRIS HUBBARD hails from the eastern US, and has been stomping around feature animation for eons. He first started destroying cities as a traditional animator on movies like *Tarzan* and *Treasure Planet*. He's been a story artist for Walt Disney Feature Animation, Warner Brothers, and Illumination, creating havoc on films such as *Zootopia*, *The Secret Life of Pets 2*, and *Inner Workings*. He can currently be seen chewing cars at Skydance Animation on the movie *Luck*. Chris lives in Los Angeles with his wife Kirin, a cat, and two dogs – one of which is part-Kaiju.

hubbardchrisw.wixsite.com/chrishubbardstory

CHRIS URE originally hails from the Windy City. He went to art school in California way back when, in a time before there was a World Wide Web or DVDs. After graduating from CalArts, he freelanced here-and-there before ending up at Walt Disney Animation Studios, where he's worked as a story (and occasional visual development) artist for the last tenty-three years. His credits include films such as *The Nightmare Before Christmas*, *Monsters, Inc.*, *Tarzan*, *Atlantis: The Lost Empire*, *Tangled*, *Frozen*, and *Big Hero 6*.

DAN ABRAHAM hails from Frankenmuth, Michigan. All he did growing up was watch *Cheers* and draw cartoons. Dan's little story was a labor of love and embarrassment – which he hopes you enjoy!

DAVID G. DERRICK JR has been a story artist for way too long. Right now he works at Disney Feature Animation, but he wants you to read his web comic *Ghost of the Gulag* at:

ghostofthegulag.com

DAVID PIMENTEL was Head of Story on the ever-popular *Bee Movie* – pretty fancy!
@davepimentel

DON HALL has worked at Disney Animation for twenty-three years. He lives in Pasadena, CA. with his wife, two sons, and the most spoiled Labradoodle on the planet.

DONNA LEE is a story artist, illustrator and bird lover who was born and raised in the suburbs of Chicago. Ever since she was little, she has always dreamed of working on an animated film, and her passion led her to the land of Hollywood. She started her first job as a story artist at Disneytoons Studio, which progressed to working at DreamWorks, Paramount Pictures, and Titmouse Studios, where she received the 'Daytime Creative Arts' Emmy Award, and recently has worked at the Disney Feature Animation on *Frozen* 2. When she's not at home playing with her pet bird, she goes out searching for inspiration in new places, people and Korean barbecue.
@dlee08

FAWN VEERASUNTHORN is a story supervisor at Walt Disney Animation Studios. She joined as a story artist in 2011, and has worked on films such as *Frozen*, *Zootopia*, as well as *Moana*. In her free time, she loves drawing comics about cats and babies.
@fawnv

GRIZ AND NORM are Normand Lemay & Griselda Sastrawinata.

Norm joined Walt Disney Animation Studios in 2009 as a story artist. In recent years, he contributed to *Frozen*, *Big Hero 6*, *Zootopia*, and *Moana*. Norm was nominated for an Annie Award for his work on Disney's *Moana*, more specifically for a very "shiny" sequence featuring the giant crab Tamatoa. At the moment, he is hard at work on *Frozen* 2. He is one half of the art duo Griz and Norm. The real-life couple share tidbits of their art knowledge with the world through their 'Tuesday Tips,' an online series of tips and tutorials for beginners and professionals alike.

Griz was born in Indonesia and fell in love with animation as a little girl watching Disney's *Cinderella* and *Sleeping Beauty*. Her wonderful design sensibilities and a keen eye for color have contributed to the look, character design and costumes of countless animated projects as well as illustrated children's books. Recently lending her artistic hands on *Frozen 2*, she also contributed to *Moana*, *Olaf's Frozen Adventure*, and *Inner Workings*, as well as Dreamworks' *How To Train Your Dragon 2*, *The Croods*, *Shrek Forever After*, *Kung Fu Panda: Legend of the Masters*, *Home*, *Penguins of Madagascar*, *Puss In Boots* and *Rise of the Guardians*.

HILLARY BRADFIELD has worked in television as a story artist and director, and Disney features as a story apprentice. When she isn't drawing she's watching bad movies, drinking coffee, and snuggling her pet cat named Professor Science.
hillarybradfield.blogspot.com

JAMES FINCH is a graduate from Ringling College of Art and Design. He has had the great fortune to work at Disney Animation since graduation as a layout and background designer on films like *Tarzan, Atlantis: The Lost Empire, Princess and the Frog, Frozen, Big Hero 6* and *Moana*. His personal work is landscape painting and waves.
jamesfinchart.com

JAMES WOODS joined the visual development department at the Walt Disney Animation Studios in 2017 and specializes in the art of character design. Originally from Hampshire in England, he aspired from age four to become an artist at Disney due to an early obsession with *The Little Mermaid*. He has also contributed to features at Paramount Animation, and was the Lead Character Designer on *Mary Poppins Returns*. In his own time, James is inspired by fashion, popular culture, nostalgia and whimsy, which he enjoys implementing into his work.
jamwoods.tumblr.com

JEFF MERGHART is a character designer who started his career as an animator on *An American Tail* with Don Bluth at the Sullivan Bluth Studios. He's been professionally animating, character designing, concepting, boarding, layouting, learning and loving the craft ever since. He commutes everyday from San Diego where he lives with his wife and two daughters, teaching and performing Polynesian dance and music through their group Halau 'O Na Ali'i.
artstation.com/jmerghart

JEFF RANJO is an eighteen-year veteran of Disney Animation Studios, where he has summoned mighty Titans, tortured a llama in the jungle, designed a time machine, and made both a snowman and a demigod sing. He also helped a penguin get tubed and food fall from the sky at Sony Pictures Animation, and is, at this very moment, playing with monsters at a secret location. You can find him on Instagram taking pictures of toys and drawing aliens.
jeffranjo.tumblr.com

JEREMY SPEARS is an Annie-Award winning story artist. He spends much of his free time with his wife and three kids, as well as dreaming up new creations in his Whittle Woodshop. For the past eleven years Jeremy has worked at the Walt Disney Animation Studios on such films as *Frozen, Moana, Zootopia*, and *Ralph Breaks the Internet*. He's lucky to be surrounded by amazingly talented artists everyday – all of them in this book!
whittlewoodshop.com

JOE MATEO is an animator and story artist, originally from the Philippines. He began drawing for the Walt Disney Animation Studios in 1995 as an in-betweener for the character of John Smith in *Pocahontas*, followed by work on *The Hunchback of Notre Dame*, *Mulan*, *Tarzan*, *The Emperor's New Groove*, and *Fantasia 2000*. Joe progressed to the role of animator on *Home on the Range*, while his first job as story artist was for *Bolt*, proceeded by *Meet the Robinsons* (also supplying the voice of Tiny the T-Rex), *Tangled*, *Big Hero 6* (where he headed the department), and *Zootopia*. Joe has been nominated for four Annie Awards, winning in 2010 for his storyboarding on *Prep & Landing*, for which he also received an Emmy.

JOHN MUSKER is a forty-year animation veteran where at various times he animated, storyboarded, wrote, directed, and produced a number of feature films. More crucially, he is more or less a fifty-five-year reader of comics – which he loves. He grew up on Jack Kirby, Steve Ditko, Berni Wrightson, Joe Kubert, and later found the brilliant Jean Giraud and Will Eisner. He has the unique honor of being rejected by both Disney and Marvel Comics when he was starting out.

LISSA TREIMAN was born in Los Angeles and has never managed to leave. After graduating from CalArts she began working as a story artist at Walt Disney Feature Animation in 2007, where she has contributed to films such as *Tangled*, *Wreck-it Ralph*, *Big Hero 6*, *Zootopia*, *Gigantic* and *Ralph Breaks the Internet*. Lissa has always had a deeply held love of comics, and in 2015 she drew the first six issues of the ongoing published comic *Giant Days*, from Boom! Studios. Lissa loves dogs. All dogs. At the time of writing this she still does not know how to ride a bicycle. Shameful.
lissabt.tumblr.com

LORELAY BOVÉ is a Visual Development Artist at Walt Disney Animation Studios. She grew up in Spain, inspired by her father's art, Disney animation, and classic Hollywood films. Lorelay has been at Disney since 2007, and is honored to have worked on various films, such as *Princess and the Frog*, *Tangled*, *Wreck-it Ralph*, and *Big Hero 6*.
lorelaybove.com

LUIS LOGAM grew up in Australia – and now resides in the mean streets of Burbank. He joined the Disney story team in 2016, and feels lucky to have the opportunity to work with so many artists he admires and loves. Luis like to read manga, mains Diddy Kong, and has a healthy fear of the outside.
@luislogam

MCKENNA HARRIS is a story artist based in California. She loves iced lattes, the Spongebob Squarepants musical, and drinking iced lattes, while reminiscing about the Spongebob Squarepants musical.

MEG PARK is originally from Scotland, and moved to Los Angeles to work as a Visual Development Artist at Walt Disney Animation Studios in 2017. She was previously a freelance artist and has worked with clients including Illumination, Google ATAP, Disney Publishing, Sony Pictures Animation and Paramount Pictures.

megpark.tumblr.com

MICHAEL HERRARA is a Southern Californian and a professional story artist. He studied Character Animation at CalArts and has since worked for studios like Reel FX, Rovio Animation Company, and Walt Disney Animation Studios. He is also a designer, actor, pirate, and musician, who strives to tell stories with everything he does. He has no idea what comes next and he likes it that way.

papertiki.myportfolio.com/projects

MIKE GABRIEL was born wanting to work at Walt Disney Animation Studios. Growing up in Salina, Kansas, as well as watching Disney movies, he also loved reading Archie and Harvey comics, Mad magazine (Mort Drucker, Jack Davis, Paul Coker Jr.), drawing Peanuts characters, and building many of Big Daddy Roth's Weirdo and Rat Fink models on his way to knocking on Walt's door. Mike is lucky enough to now look back on a thirty-eight-year career at Walt Disney Animation. At the studio, he has been given many different assignments including animating, character design, and story – co-directing the features *Rescuers Down Under* and *Pocahontas*, as well as co-art directing *Wreck-it Ralph*, and making the Oscar-nominated short *Lorenzo* in 2004. Mike also created the Walt Disney corporate castle logo that plays at the head of every Disney film production. Currently doing concept, visual development and Walt Disney Imagineering theme park ride design, he is grateful to all these talented *When Is High Moon?* artists who have contributed to this book and inspired his work daily. Mike created his *P-Wee 51* series based on his father's real experiences as a WWII fighter pilot.

mikegabrielart.com

NANCY KRUSE has been a story artist at Disney for eight years so far. Before that, she worked on a long-running show about yellow people with overbites.

@skeptiva

NEYSA BOVÉ is a visual development artist and costume designer, born and raised in Andorra, Spain. Bové lives and breathes fashion, and is a lover of all things girly. She studied Fashion Design at FIDM (The Fashion Institute of Design and Merchandising) and later took courses at CalArts' acclaimed animation department. After a Costume Design internship at Walt Disney World, Neysa began her career working at Disney Consumer Products. She has since designed Barbie dolls for Mattel, and now puts her costume talents to work at Disney Feature Animation – Neysa's very first contribution to film in visual development and costume design was for *Moana*. Her inspirations are beautiful photography, fashion, traveling, and food.

RYAN GREEN was born in Williamsport, Pennsylvania – the birthplace of Little League baseball. Ryan did not play baseball. So he left his home town, swung by the Pennsylvania State University to grab a degree in biology, and took his first art class as an elective. Suddenly addicted to putting pencil to paper, Ryan ran to the Columbus College of Art and Design and learned to animate. After fifteen years of animating and storyboarding in Columbus, New York and Los Angeles, he is now a story artist at Walt Disney Animation Studios in Burbank, CA. He has worked on *Moana*, *Zootopia*, and *Ralph Breaks the Internet*. Currently, his life toggles between storyboarding on *Frozen 2* and wrangling his two-year-old daughter. His personal work has been displayed at Q Pop Gallery and Gallery Nucleus in Los Angeles, CA and at Bynd Artisan in Holland Village, Singapore.
@ryangreenart

SAMANTHA VILFORT is a Bay Area native who booked it south to Los Angeles to pursue animation in 2013! While attending college she was lucky enough to work as a freelance story artist, and spend a summer up at LAIKA as a story intern. Since graduating in 2017 it's been a whirlwind of drawings, Venmo transactions, and finishing her first year as a story artist at Disney Animation Studios.
samanthavilfort.com

STEPHANIE RIZO is from Orange County, CA and has been working at Disney for almost a year as a Story Trainee.
stephanierizo.com

SUNMEE JOH is a Southern California native and CalArts alum. She is currently a story artist at Walt Disney Animation Studios and has worked on such films as *Feast* and *Moana*. Outside of animation, she loves cats, flowers and the ocean. A mermaid at heart, she looks forward to one day swimming off into the sunset.
@sunmeejoh

SYLVIA LEE is currently a story artist at Walt Disney Animation Studios. She spent most of her life reading manga and watching anime in South Korea. After joining the Story department in 2015, she has contributed to films such as *Moana* and *Wreck-it Ralph 2*. Her favorite hobby is taking naps.
@sylvialee_e

ZANE YARBROUGH is originally from Texas. His early passion for filmmaking and monster makeup led to a degree in drawing comics and, eventually, a career in the animation industry. During the week, Zane works as a story artist racking his brain for story ideas and sketching them out. In his spare time, he enjoys plotting little adventures with his dog, catching up with family, spending time with friends and traveling the world with his girlfriend.
zaneyarbrough.tumblr.com

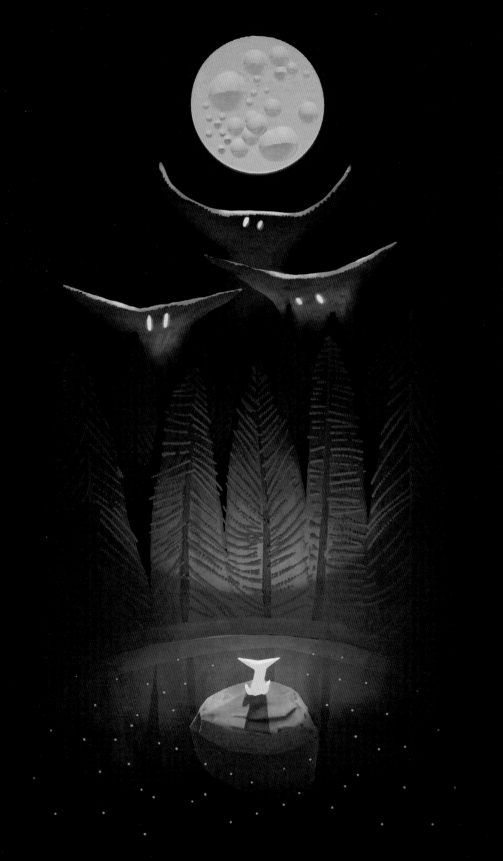

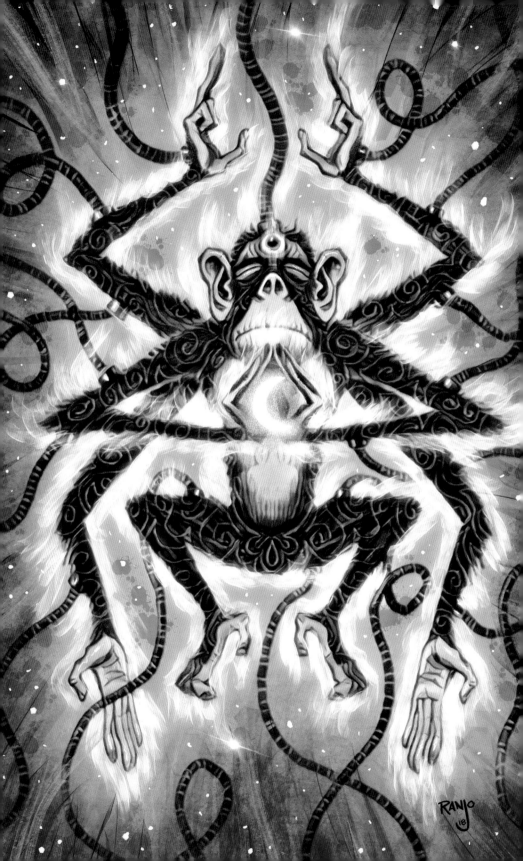

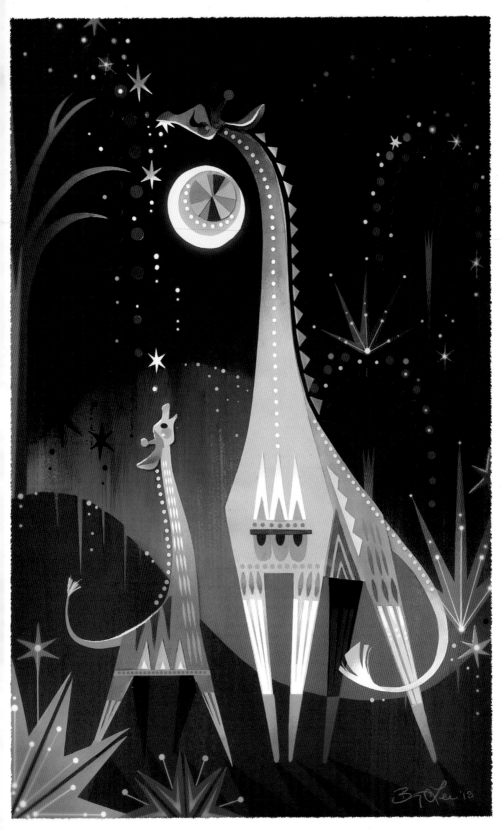

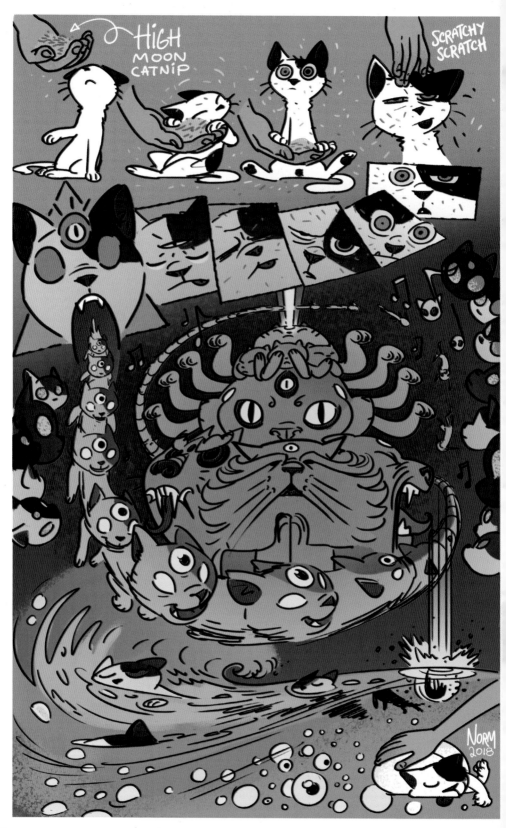

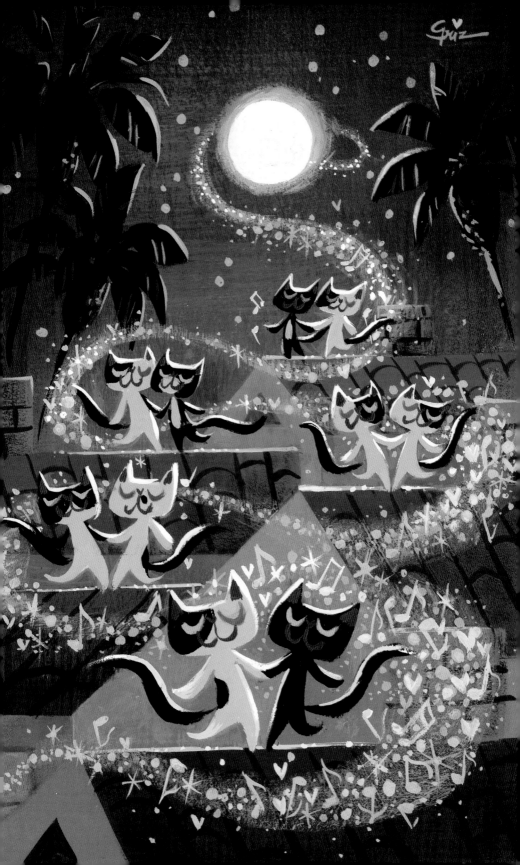

GROW A MOON

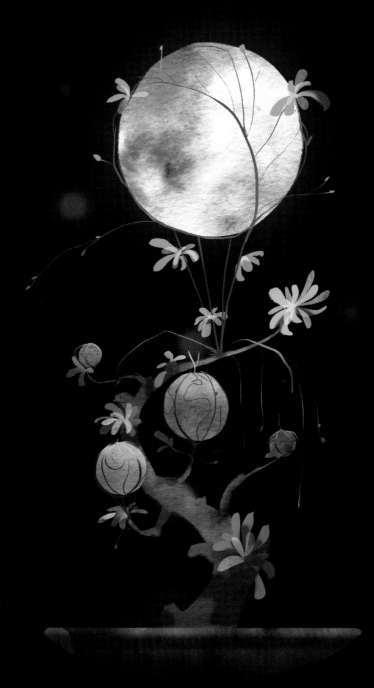

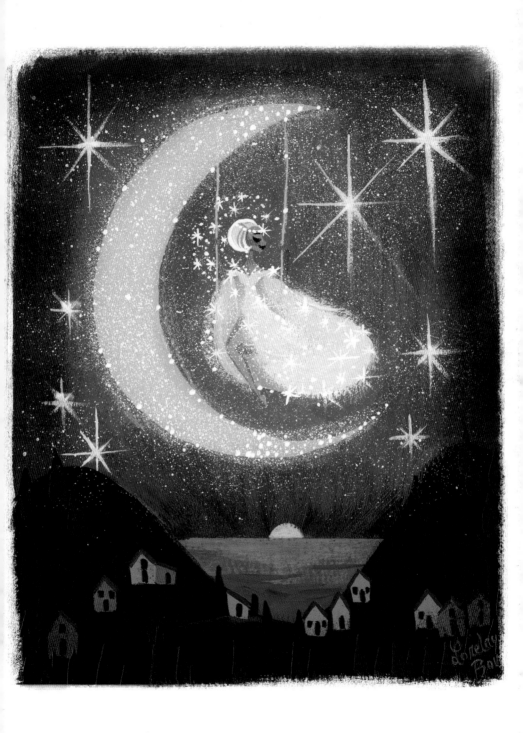

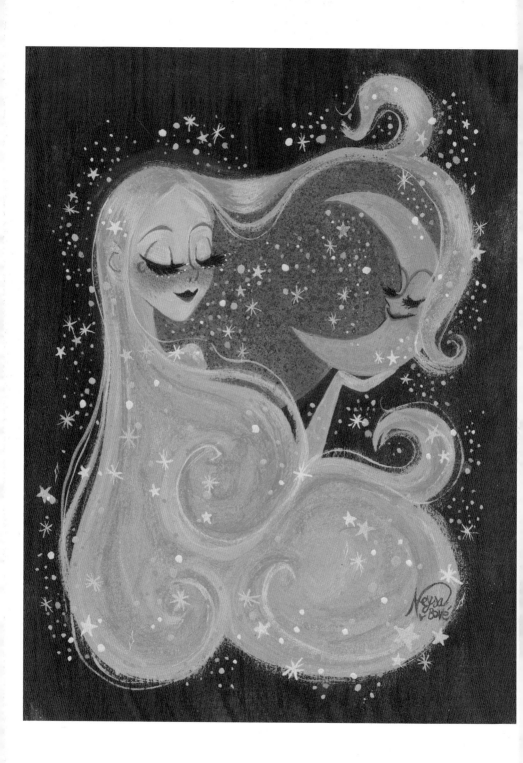

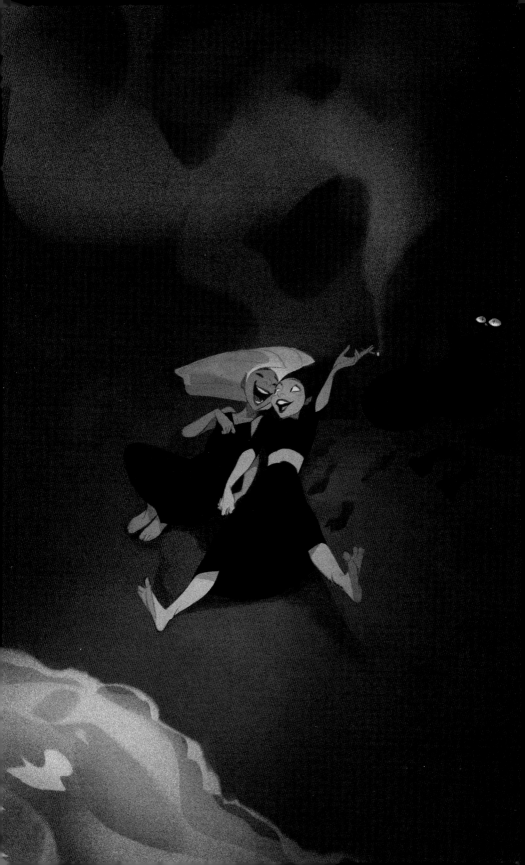

LUNAR ACKNOWLEDGMENTS

1984
@bethanyjayde_art
@findyoursmile
A Webster
A. Hofmann
A. Yegge
A. J. Hennen
Aaron Izek
Aaron Turko
Abby & Erin Ng
Abby MacDonald
Abby Maggie Grace Jones
Abigail Fassbender
Adam Connor
Adam Hoppus
Adam Shephard
Adam W. Martin
Adrianna Diaz
Adrienne Fu Parker
Aiden & Kai Hunich
Airicka Dawn
Aisha Al-Fadhala
AJ Black
AJ Sabino
Alaina & Daegan Goodwin
Al W.
Alan Lodge
Alan Smithee
Albert & Michelle Lee
Aleksandra Daniel
Alex Cook
Alex Gillis
Alex Grindborg
Alex Jones
Alex Vilfort
Alexander & Donovan
Alexandra Naut
Alexis Sadler
Alexis Wallick
Alice Marzioli
Alissa Creno
Alivia & Emalee Dennison
AlJohara AlThani
Alleoci Licea
Amanda & Boris
Amanda Candler
Amanda Haley Bell
Amanda Jane Sharpe
Amanda Johnson
Amanda Kay Davison
Amanda Lee
Amanda Lim
Amanda Panda8ngel
Amanda St Germain

Amanda Weeks
Amber Kay Arnoldsen
Amelia Lorenz
Amelia Meyer
Amna Goochiesaurus Kazmi
Amos Roth
Amy the Panda
Anastasia Hunter
Andrea Walker
Andreas
Andrew J. Kim
Andy Goff
Angel Manila
Angela De Vito
Angela Moffett
Angelica Cordero
Angelina Han
Angie Reiber
Ann Weiner
Anna Babisz
Anna Campbell
Anne "Mrs. Annie Mation" Neyens
Annie Li
Annie Williams
Anonymous
Anthony Oteri
antisocial.ink
Antonio Meza
April Hansen
April Zufelt
Ariana Siu
Ariel Chan
Ariel Hamstra
Ashley R Calkins
Aubz Lyons
Audrey Cueva
Austin M. Salmi
Ayesha Drew
B Lant
Badda Finzi
Barb & Russ Jernigan
Barbara K Stuber
Barbra Pushies
Becky Lau
Becky Smith
Ben Murphy
Ben Norris
Benjamin Lane
Bethany Morse
Betsy Bauer
Beverly Shank
Bill Robinson
Bina Gibson
Birgitte M. R. Johnsen

Blair Mueller
Blaise Hemingway
Blake McAdow
Bobbie Kirby
Boye Simon
Brandon Coleman
Brandon Daniels
Brandon Holmes
Breanna Bowker
Breanna Bowker
Bree Paulsen
Brent
Brett Reighn
Brian Estrada
Brian Gabriel
Brian Gillick
Brian Gleine
Brian Goubeaux
Brian Huisman
Brian Jackson
Brian Kaniela Flinn
Brian R Curry
Brian Randeau
Brian W. Vazquez
Bridget Karteczka
Britni Crankshaw
Brittany Cole
Brittany Saxe
Bubba Toshi
Buttercup
C E Willis
C.G. Schumacher
Calico
Calie Hendrickson
Caliope
Camilo Castro
Camp Alligator Productions
Capone Jernigan
Carlos Iñigo
Carly DeGraw Johnson
Carly Maria Hubbard
Caroline Chiou
Carolyn Livingston
Carothers Family
Carrie meow!!
Caryn Oj
Casey Pitagara
Cassandra L.
Cassidee Trotter
Catherine Andersen
Cdfisher09
Celina Garduño
Celine Kim
Chad Phillips-Jakeman

Charissa Calderón
Charles Thurston
Charlie Parisi
Charlotte Belland
Charlotte Zhu
Chas Coffman
Chelle Budrevich
Chelsea Hougan
Cherie Luras
Cheryl Preyer
Chewy 'BFTD' Chuah
Chloe
Chris & Ashley Sanford
Chris Basler
Chris Craig
Chris Doggart
Chris Kartje
Chris Lin
Chris Roberson
Chris Ryan Olsen
Chris Vodraska
Christina David
Christina Gale
Christine Kwon
Christine Politis
Christopher Wurth
Claire Hummel
Clay Eichner
Clifton Thompson
Clint Jenkins
Coco A. Lynge
Cole Nguyen
Collector's Shangri-La
Colleen River Murphy
Colleen Skerman
Constant Bertram Ng
Cory Adair
Courtney 'Iscy' Tucker
Courtney O'Riley
Crutonia
Curtis Carlson
Curtis Smith
Cynthia Mehrlich
Cyrus Egan
D Bruce
D & J Salter
Dale Baer
Dan
Dan & Rose Z
Dan Bartlett
Dan Eyer
Dan Hammond
Dan Vedda
Dan Weston
Daniel Alain Auger
Daniel Henke II
Daniel Lewis
Daniel Zinck
Daniella Rosu-Ortiz

Danielle Gregoire
Darian Gonzalez-Kessler
Dario Barrera
dasUzzi
Daunell Jean Barton
Dave Lugton
Dave Pryor
Dave the Tenken
David D. Eakin
David D. Marquez
David den Boer
David DePasquale
David Holmes
David Jones
David Kirkpatrick
David W. Sanderson
David Wade
David Wilson
Dawn Bradley
Dawn S. Toles
Dayna B. Meltzer
Dean White
Deb Yan
Debbie Delorme
Debbie E. Haynes
denchen
Denise Ponce De Leon
Dennis Descoteaux
Denyse Mercer
Derek Ortega
Diana Kidlaied
Diana L. Waller
Diana V.
Dietmar Bloech
Diverkiwi
Don & Jan
Dorie McCormack
Doron Kamara
Doug Rednour
Doug Walker
Dr Kellie & Binx
Drake & McTrowell
Draven Kraft
Drew
Drew & Noah Meier
Dustin Foust
Dyan reaveley
Dylan Marrocco
E & M Roth
Eagle Archambeault
Ed Fierst
Eddy Aguirre
Edgar Cheung
Elaine Westfall
Elena Ahn
Eleosia
Elise Francoeur
Elise Scanlan
Elizabeth Daugherty

Elizabeth Leiby
Elizabeth Locke
Elizabeth Thrash
Elle Wyant
Ellen Seevers
Ellie Ryan
Ellie Scontrino
Elsa Chang
ELW ∞ JRL
Em Rathbone
emastrations
Emely Pul
Emilia Hald
Emily Collins
Emily Larrabee
Emily Portinga
Emily Robertson
Emma Weston
Enora Valencia
ENZO & FELIX
Eric & Margie Daniels
Eric Ganot
Eric R. Watson
Eric Reardon
Eric Renn
Eric Sweetman
Eric Wolford
Erika Schultze
Erin Buck
Erin Casteel
Erin K. Murphy
Erin Kowalski
Erin Sayers
Erlinda Sustaita
Etta Golightly
Everett A Warren
Everly & Emmie
Evie Cabrera
Ezra Edmond
Ezra Lee
ezrads psych0rabbit
Faewood
Faith Randolph
Falck Family
Family Kannady-Solel
Fearsmag.com
Felicia and Eric
Felicity Trevino
Fill Marc Sagadraca
Fion J. Lau
Fiona Wong
FlitterKitten
Fowler Family
Francesca Fracassi
Francesca Rocha
Francis de Guzman
Frank Svengsouk
Fred W Johnson
FreddieG

Fyria
G & K Kininmont
Gabby Zapata
Gabriel Schlesinger
Gabrielle Clay
Gaenna Rogers
Garrett Jones
Garrett Taylor
Gary Phillips
Geneviève Dietz
Gil Estrada III
Gil Pedersen
Ginea Merrill
Ginny Higerd
Grace Song
Grecia Santos
Greg R. Haynes
Gustavo R. Murillo
Gwyn
H. Hammond
Haik Schwebke
Haley Gaudette
HaliJinx
Hannah B
Hannah Long
Hannah Wilkes
Harpreet Miglani
Hayes Renguul
Haylee Herrick
Heather Frase
Heather Kieslich
Hector Reynoso
Heidi & Matthew Pridemore
Heidi Nyburg
Henrik Kristensson
Henry Chan
Herbert England
Hilda Tam
Hildur Lara
Holly C
Holly Iossa
House Hubbarty
Ian Butterfield
Isabel Sztelma
Isabel Talsma
Isabella Latell
Isabelle Gedigk
Isaiah Whisner
Izzy & The Harp
J & D Poor
J & I Greig
J'wyl
Jacob Palka
Jacquelyn Murphy
Jaime Chong
Jake & Tifanee Smith
Jake Geiger
Jalin Wilcox
James & Sylvie Bourne

James Han
James R. Crowley
James Romo
James Rowland
Jamie Eiser
Jamie Thompson
Jane Frances Schafer
Jane Shi
Jane Young
Jared A
Jared Bittner
Jasmine Bailey
Jasmine P
Jason Blower
Jason Burchfield
Jason Dillman
Jason Warnesky
Jay Jackson
JChism Studios
Jed Laurance
Jeff D. Wolf
Jeff Lewis
Jeff Lichtenwalter
Jeff Wood
Jeffrey Bower
Jeffrey Bradshaw
Jeffrey Renault
Jen & Joe W
Jen-Brown
Jenessa Warren
Jenni Magee-Cook
Jennifer Bauer
Jennifer Colburn
Jennifer Hjelm
Jennifer Joy Prendergast
Jennifer K Ryan
Jennifer Kuo
Jennifer Miller
Jennifer Stephens
Jenny Tan
Jenny Veile
Jeremiah Kornspan
Jerry & Nina Treiman
Jessica Buczacki
Jessica Giles
Jessica Gutierrez
Jessica L. Bedell
Jessie Diliberti
Jessie S. Johnson
Jett Atwood
J Ha & C Johns
Jill Lytken
Jim Cebulka
Jim Crawford
Jim Demonakos
Jim McFarlane
jimromer.com
Jin Chong
Jmecampos

Jo and Kate Toms
Jo Oehrlein
Joanne Streit
João Moura
João Pedro Sustelo
Jocelyn Carcamo
Jodi Gregg
Jody L. Ransome
Joe Doe
Joe Dube
Joelle Briskin
John Hoffman
John MacLeod
John Ostrosky
John Sanford
Jon-Erick S.
Jonathan Biedron
Jonathan D Phillips
Jordan Colin Taylor
Jordan Levitt
Jorge R. Gutierrez
Joscha
Joseph L. Sanchez
Joseph Nixon
Josh Singeltary
Josh Ziegler
Joshua Taback
Joshua Taback
Josie Ella Gerk
Joy Liberatore
Julia Bae
Julia Nielsen
Julia Reding
Julie Mikesell
June M. Fujimoto
Justin Rodrigues
Justine Andrade
Justine Andrade
Justine Dvorchak-Rodriguez
K. J. Raeside
K. Rydzewski
Kaho Kubo
Kaia Gavere
Kaitlin Becker
Kari Callin
Karin Rós S. Wiium
Karina McBeth
Karisa Callahan
Karly Jade Catto
Kary Coleman
Kasie Lee
kat
Kat Haynes
Kate Chiang
Kate Mergener
Kate Moon
Kate Paisley
Katey Cooper
Katharine Landry

Katherine Schubert-Knapp
Kathie Louy
Kathrann Janca
Kathy Lauscha
Katie Alto
Katie Chen
Katie Cordina
Katie Eberle
Katie Yang
Katlynn Almansor
Kayla Sandvoss
Keith Zoo
Kelly & Clara Oswald
Kelly Butler
Kelly Curtright
Kelly Little
Kelly Simmons
Kendra Witherspoon
KETS
Kevin Peterson
Kim Curler
Kim Hazel
Kimberly Kane
Kimberly Swift
Kip Henderson
Kirk R Thatcher
KM
kre luvs C&H/SW
Kristal Feldt
Kyla Williams B.G.N.
Kyle Davis
Kyle F. Norton
Kyle Gabriel's Beard
Kyle Maddens
Kyler Spears
Kylie Gay
Kylie N.
Kyrstin Avello
L Williams
L. D. Fischer
LadyKya
Lanae Polier
Larry J Ohrt
Laura Hoover
Laura Host
Laura Kwan
Laura Lu
Laura Medeiros Gimenes
Laura White
Lauren Bailey
Lauren Chaikin
Lauren Drapes
Lauren Goniak
Lauren Goniak
Lauren Hetherington
Lauren Holcek
Lauren McCaulou
Lauren Medlen
Lawrence "Rally" Porter

Lawrence Mirando
Leah Latham
Leia Crawford
Leif Rawson
Leon Lee
Lewis Whitman
Lexy
Lidia
Lina
Linda H. Codega
Lindsay Goto
Linh-Tran Do
Lisa La
Lisa Linder Silver
Lisa Sustaita
Lisa Walker
Liz Jarvis
Liz Newman
Logan Swift
Lori Allen
Lorry Ann Shea
Louie Sman
Lucas Reid
Lucia Soltis
Luis
Luis Nieto
Luke & Catherine Osterritter
Luke Ede
Luke Flowers Creative
Luke Robertson
Lulu Ieja
Luna Yeung
Lurch Kopchick
Lydia Cufino
Lynsey Folkman
Lyon Richey
M K Takahashi
M. Yap-Stewart
Maci Hass
Maddie Franke
Maddie Salter
Mandi Kurth
Mandy Figueroa
Marat Oyvetsky
Marc Haworth
Marc-André Laurence
Marco Gallo
Maria Sandmo
Maria Terskikh
Marie Doran
Marie Giordano
Mark Burford
Mark Hirschman
Mark Lennon
Mark Sasaki
Mark Tompkins
Mark Wilson Ramiro
Mark Wingenfeld
Marley Malia

Marnie Warner
Martine
Marty Poling Tool
Marty Trengove
Mary Ann Shuman
Mary Bell
Mary Margaret Crocker
Mary Schmidt
Matt Cipoletti
Matt D.
Matt Flesher
Matt Horter
Matt Howorth
Matt Maguinness
Matt Meredith
Matt Robbins
Mattheus and Zachary
Matthew Dawson
Matthew Kuzio
Matthew Nicholas Noe
Matthew Storrie
Matty Ryan
Max Biggs
Max Cappelletti
Maya Brown
Maya Lior
Mayer Brenner
Meaghan Horner
Megan Lawton
Megan Real
Meghan Crockett
Meghan Molumby
Melissa Biles
Melissa Cousins
Melissa Wourms
Michael Cabuco
Michael Deliso
Michael F. Neidinger Sr.
Michael Ruocco
Michele Hall
Michele Samuelian
Michele Vicchitto
Michelle Busch
Michelle Deibner
Michelle Johnson
Michelle Y Morris
Michi "FlowerBite" Kaioh
Mike Pfefferkorn
Mikey Macasero
Miranda Jelbart
Miss Eliza
mistraldelune
Mitchell Lin
mjoyart
Mohamad Sobh
Monica A. Rocha
Monica Bruenjes
Monika & Mike Cerminara
Monique Boustani

Morgan Witkowski
Moria Trent
Ms.
Mx. Beth Sparks
N. E. Hill
Nancy Villiger
Nandemo Pins
Nash Giles
Natalie Basile
Natalie Tobias
natalie w
Natalie Xavier
Nathan Perricone
Navalta 'Ohana
Nicholas Ellingsworth
Nick May
Nicole Evensen
Nicole Ng
Nicole Stevens
Nieves Almeida
Nikki McCauley
Nikoline M. Smaavik
NM Tucker
Noelle Davidson
Noëlle MacGill
Nolan Reichmann
Nora Johnson
Null Ghost
October Melton
Octopus in a Kilt
Olivia Nutt
Olivia Stout
Olivia Walker
Online Privacy
Owen John Ryan
P Rock
P. K.
Pablo Rivera
Pajama Boy
Pamela Mathues
Pamela Ribon
Pamela Ribon
Patrick Danaher
Patrick Hood
Patrick Johnson
Patrick Murray
Paul Haesemeyer
Paul M. Reynolds
Paul Thorgrimson OBC
Paul Twohey
Paul Washington
Paul y cod asyn Jarman
Paula Z
Peggy Boylan
Pernille Ørum
Pete Slattery
Peter L Brown
Peter Shadix
Peter Stubbers

Phaedra Collins
Philip Haxo
Phillip Studiman
PinkPizazz
Poppy Phlox
PropTartMN
Qadira Stephens
Quiana Hennigan
R. J. H.
Rachael Jasper
Rachel Alley
Rachel Revelle
Raida
Raikou
ralphandbeezle
Randeep Katari
Randi Misterka
randomspontanium
RazéLatte
Real_Atomsk
Rebecca Horner
Rebecca Larson
Rebecca Stein
Rebecca Totman
Reel Ghouls
Remi Wedin
Renée Kools
Rhett Yelverton
Ric Bretschneider
Rich Rockwood
Rob Hunter
Rob Knaack
Rob Santos
Robert Lawrence
Robin Moates
Robyn Sitz
Ronald Olufunwa
Ronda G White
Ronin Morrison
Rosana I.
Rose & Mae
Rosie
Rowan Smith
Roy Cowing
Ruth Latham
Ryan Kelley
Ryan Q
Ryan Regalado
Ryan Rosendal
Ryan Thielen
S. Michener
S. Wilén
Sadie Greason-Edwards
SadieBelle Adams
Sally Warren
Sally Yang
Sam Amin
Sam Arnett
Sam Broms

Sam Fenn
Sam Plumsukon
Sam Robinson
Samantha Martinez
Sammie Gwaltney
Sandra Cox
Santi Casares
Sara Collins Young
Sarah & Alex
Sarah Ballow
Sarah Boyle
Sarah Conradsen
Sarah G.
Sarah Johnson
Sarah McLeod
Sarah O'Malley
Sarah Tussing
Sarah Von Hoene
Sascha
Satan
Sckersh
Scott Saiki
Scott Simons
Sean Connolly
Sean Eoin
Sean McMillan
Seif Abdrabou
Serena Lee
Sermon Donaldson
Seth Crofton
Seth Damoose
Shaken
Shanna Schopmeyer
Shanon Schildtknecht
SHaRK
Sharon Strich
Shatayja Cooper
Shaun Bryant
Shaun Manning
Sheila M. Sofian
Sheng Potato
Shervyn
Shiri Rokshin
Sid Sexton
SilensVigilo
Simone Mijts
Sloan
snaps
Sonia Lai
Sonia Santana
Sophia Karteczka
Sophie Whettingsteel
Stacey Wyman
Stacy Curtis
Steffie Davis
Stephanie Brantner
Stephanie Chiu
Stephanie Haney
Stephanie Ramirez

Stephanie Shapiro
Stephen Duignan
Steve Goldberg
Steve Muench
Steven Barrie
Steven Ng
Steven Schlacter
Stig Madsbakken
STL
Stuart Ng
Sumitta Curtil
Susan Curry
Suzie Duncan-Bendix
Svetla Radivoeva
Sylbi Lee
Tahnee Gehm
Tamara Turner
Tammy Pham
Tammy Wilson
Tanner Lindsay
Tatianna Raspotnik
Teabunniez
Tee Jay Reardon
Terri :)
Terry Wong
Thalia Nalapraya
The Adams + Barnette Family
The Ammerman Family
The Atherton Family
The Barber Family
The Barbott Family
The Beal Family
The Berthiaumes
The Blackwaters
The Braskat-Arellanes Family
The Bridger Hunt Family
The Brooks Family
The Butchart Family
The Calderon Family
The Campbell Clan
The Corgi Coalition
The Daugharty-Parisi Family
The Daughartys
The Daviau Family
The Davis & Kosove Family
The DeVine Family
The Doan Family
The Edmond Medina Family
The English Family
The Farnhams
The Fiersts
The Ford Family
The Garouttes
The Giggity
The Greer Family
The Hamilton
The Harris Ranch
The Harslem Tuttle Family
The Hawes Family

The Heddleston's
The Helfaresi Family
The Henaut Family
The Herzbergs
The Higuera Family
The Jayme Twins
The Jettley Family
The Karp-Haahr Family
The Kolodziejskis
The Lawson Family
The Leggett Family
The Lehr Family
The Mainz/LaFave Family
The Manteys
The Martin Family
The McClusky's
The McKeogh Family
The Morse Family
The Mosier Family
The Mossbarger Family
The Nameless Ninja
The Obrad-Greco Family
The Parks
The Pattys
The Quinn Girls
The Racine Family
The Rasner Family
The Reidy Family
The Richards Family
The Rockenbecks
The Sanders Family
The Saunders Hicks Family
The Schoenthal Family
The Sebskis
The Sevilla Family
The Tanya Borg
The Taylor Family
The Tomlinson Family
The Torres Family
The Unknown Backer
The Vallera-Thompson Family
The Wheeler and Odom Family
The William Toenjes Family
The Wilson Family
The Woblicks
Thea Task
Theo
Thomas Hetherington
Thomas Lee
Thy Than
Tia Rockwell
Tiasha J. García
Tifa Chii
Tiffany C Russell
Tiffany Freund
Tillie Sain
Tim Beard
Tim De Pree
Tim Garbutt

Tim Manhveile
Timothy Stephens
Tinna Guðbjartsdóttir
Todd Good
Todd Martens
Tom Benthin
Tom Booth
Tom N
Tony Swarthout
Tor Harald Blom
Tracey Miller-Zarneke
Tracie Rennolds
Tracy Blincoe
Tricia Lapeña
Troy Nethercott
Tyler
Tyler Rickert
Uehara family
Uncle Bobby T
Vanessa Bodell
Vanessa Hunt
Varoot Phasuthadol
Varsogea clan
Vashti Harrison
Victoria Franzen
Victoria Gonzalez
Victoria Lopez
Victoria Sanocki
Vida Cruz
Viet Nguyen
Vinda Robison
Viola Sponagel
Waller Hastings
Walsh Family
Wanda Aasen
Warrick Walker
Wayne Barber
Wayne Unten
Wee Ninja
Wendy & Chuck Grieb
Wendy Polzin
Wendy TanSW
Wiggins Taserface
Will Mutka
William McKinney
Winry & Kairi Bell
WJW
Wolf family
Wouter Bruneel
Yee Cang Ling
Yining Karl Li
Ymmy
Yue Li
yumi
Zachary D Saylor
Zackary Collins
Zappo Jones
Zoë Moss
Zoe T

"Baby Tattoo," "Baby Tattoo Books" and logo are trademarks of Baby Tattoo Books®.

Sofcover Trade Edition ISBN: 978-1-61404-024-8
Hardcover Limited Edition ISBN: 978-1-61404-113-9

Design by Mark Berry

Special thanks to Laura Monti

10 9 8 7 6 5 4 3 2 1

Published by
Baby Tattoo Books®
Los Angeles

babytattoo.com

Manufactured in China
Fabriqué en Chine